Better Colour With WALTHER BENSER

BETTER

Colour

with

WALTHER BENSER

FOUNTAIN PRESS

46–47 CHANCERY LANE, LONDON WC 2

Fountain Press Ltd.
46–47 Chancely Lane London WC 2A ITU
ISBN 0 852 42400 0

CONTENTS

6

INDEX OF COLOUR PICTURES

To My British Friends

I have written this book mainly for the carefree amateur, because here in my native Germany there is so much talk about the "deadly serious" amateur. As a light-hearted mentor I want to guide you through my book, and hope that by the time I take leave of you I will have fired you with some of my own enthusiasm. I want to help you grow into real amateurs, that is to say lovers of photography in natural colours, and enjoy with me the thrill our cameras offer us day in, day out. Lastly, I want to open your eyes to a deeper appreciation of all the beauty around us.

And you may thank your lucky stars that they have made you amateurs. For a professional photographer must know a lot more and busy himself to a far greater extent with technical details, and since he has to rely on his camera for his daily bread he will often find it hard to remain light-hearted, because he cannot pick up his camera just as the spirit moves him; he has to execute assignments, stick to deadlines, produce props and models, and often play the tune of those who pay the piper.

All this worry is not for you!

To bring home a crop of good pictures you do not need a lot of theoretical knowledge. Some highly talented, successful amateurs produce characteristic curves, threshold values, and Kelvin degrees. I even have a well-founded suspicion that a great deal of theoretical knowledge can stand in the way of practical achievement, because it destroys that carefree innocence which is sometimes essential for success in seemingly hopeless photographic situations.

Nevertheless, one aim is common to all amateurs the world over: to produce good pictures, appealing not only to themselves, but also to others who were not on the spot when the pictures were taken. In spite of this urge they often neglect the best opportunities and do not progress beyond the common-or-garden snapshot. The reason is almost in-

variably that they do not look critically and with discretion through the viewfinder of their camera.

In my slide lectures, which to-date have brought me to more than a thousand places in many countries, I have tried to solve the problem of the snapshot, and to improve its photographic qualities by a novel approach. Deliberately I showed my listening viewers – or viewing listeners – examples of very badly photographed pictures. I went on to demonstrate side by side the same motifs, but photographed better, in comparative projection; I believe that by this method I succeeded in leading many an amateur on the right track. This book is meant to be a continuation and elaboration of my lectures and to smooth the way for better colour photography.

Yours sincerely

Walther Benser

My Camera

Just in case you do not know yet the make of camera with which I take my pictures: – It is a Leica.

If you are already a Leica owner, holding your camera in as high esteem as I do mine, there really is no need for you to read any further because most likely you already know what I am now going to say.

I have been a Leica fan for about forty years, and know exactly the reason why. For the translation of my photographic ideas into pictures I must have an absolutely reliable camera. I must be 100 per cent sure that my film lies perfectly flat in the camera, that the lenses give the best possible definition, and that their aperture ratings are not optimistic, that the focusing is pin-sharp, and the release action butter-smooth. I must be able to rely on maximum speed of action and versatility of use. I regard my Leica in much the same light as a jockey regards his best racehorse. I feel like a racing driver who has hitched his amitions to a car whose every single nut and bolt he knows and which instantly obeys the gentlest touch of his hand.

In addition to all this, I simply can no longer imagine photography without interchangeable lenses. One rigidly built-in lens of only a single fixed focal length would for me be a shackle which might very soon spoil all my enthusiasm for photography. It would be the same to me as a pianist with only one octave to a piano. True, he might manage – but only just – to indicate a tune on it with two fingers, but he would hardly be able to play it, full chords and all.

If you have once experienced how the limits of the angle of view of a standard lens are burst by the short focal length lenses; or hitherto un-dreamt-of creative possibilities opened up with long focal length lenses, you cannot go back any more. You will no longer be able to do without interchangeable lenses.

I must admit, though, that my enthusiasm for the Leica is of course a personal matter. Partly it stems from traditional affection and long

use. It is quite obvious that other cameras, too, are capable of producing good, even excellent, pictures.

One thing, however, is certain: – even the world's best camera does not by itself give us good photographs if we do not know how to handle it, and if the eye behind the viewfinder lacks photographic vision.

The fully-automatic camera has already made its debut. It is the camera designer's aim to relieve the amateur of the need to think. To think? Certainly – about stops and shutter speeds, depth of field and light values. The functional part is simplified, but the mantal process remains. A bell that rings when you pass a good subject will never be invented. For the decision as to what is photographically worth-while and how the subject is approached will always remain the responsibility of the photographer.

This is the point where you begin to feel the joy of being a photographer.

This joy of photography and a reliable precision camera are inseparable. This is why I am a photo-enthusiast and a Leica-fan!

How to Read this Book

This book is no thriller to be devoured from cover to cover with a sneaking look at the last page to find out "whodunnit", or whether the wedding bells are ringing.

Rather, you may browse through it as you would through a tourist guide describing in detail a place you want to see.

Also, you can leave out one chapter or another, because I am quite sure some contain information with which you are already quite familiar.

Again, there is no reason why you should not look at the pictures first, proceeding, with your interest aroused as to how they were taken, to a study of the commentary printed opposite.

You will notice that I have deliberately given a very broad description of each colour plate, for you would derive scant benefit were I merely to give you such titles as "Profile of A Beautiful Girl". That it is profile you will see in any case, and the beauty of the sitter is a matter of taste. In my view much more should be known about a picture: – how, when, where, and why, in what kind of light, morning, noon, or evening, and the part of the world and the season of the year in which it was taken. All this is necessary for exposure data to acquire a meaning and to be of value to the amateur.

Originally, this book was written for my amateur friends in Germany. It is therefore quite unavoidable that text and pictures should have a flavour which is, if not altogether German, at least European. I am sure that my experiences and views will not in every instance coincide with those of my friends in Great Britain. But these cases, I believe, are few and far between. I think that fundamentally photographic aims and problems are the same.

This book sums up my experiences; it is not a photographic encyclopaedia. It is meant to help you rid yourselves of your aversion to the technical side of photography, and last, but not least, to prove that one need not be a genius to be able to produce good pictures. It takes

for granted only your wish to stand out a little from the multitude of dull button-pushers.

To select one's own photographs for one's own book is a difficult task; no less difficult is it to comment on one's own pictures beyond giving the purely technical features. There always looms the danger of self-praise. You have to go a long way till you reach the point where you can view your own achievements as critically as somebody else's. Some people never manage to do this. I shall never forget someone's remark when he showed me some slides: "This picture is not one of mine, but it is also quite good."

Memories of the First Years of Reversal Colour Film

The first colour reversal films appeared on the market some 35 years ago. True, they were not the first colour processes available to experienced amateurs, but the earlier films were complicated and their results not always satisfactory.

A colour reversal film yields positive, transparent photographs, in short, transparencies. They are either mounted in cardboard frames or between glass, and enlarged on a white screen with a projector.

Provided the pictures were exposed more or less correctly, the colours will be reproduced surprisingly true-to-life. The darkened room in which we should view them often makes the projected colour slide look even more luminous and colourful than we remember the original subject when it was taken.

I very clearly recall where and when I saw my first colour projection. It was a memorable evening at Dr. Paul Wolff's, a man whose name is a matchless symbol to the older generation; he was one of the best-known and ablest photographers before World War II.

At that time Wolff had tried out the first Agfacolor film, with a speed rating so low that many modern exposure meters no longer include it in their scales – 7° DIN, i. e. less than 6 ASA. All the same, his colour slides were sensational. Most of the pictures he took with the aid of a tripod; sunlight was more or less an essential condition, and the exposure data in full sunlight and optimum lighting conditions was usually $^1/_{10}$ sec. at f/8.

Paul Wolff made a virtue of necessity, taking many of his subjects even then from a low camera angle against the sky, which did not as a rule have to appear sharp in the picture, at shorter shutter speeds and larger stops. Also, he concentrated much on close-up subjects and "filled his picture frames" with his subject matter, thereby avoiding a disturbing background. His technique, his particular pictorial concept, are even today exemplary. I consider him my great teacher.

ASA and DIN as Yardsticks for Your Exposures

Today, when we take our photographs on colour films at ratings of 80 or 100 ASA without giving it much thought we must remember that this represents no less than a 10-fold increase in speed over the first colour films.

The power of an automobile engine is expressed by the horse-power rating; likewise, photographic materials are described by rating values indicating their sensitivity. In Great Britain and in the U.S.A., ASA numbers are in general use, while European countries on the whole have adopted the DIN system. Until a short while ago, the DIN figures were expressed as derivatives of log. 10 so that the speed was written, for example, 14/10°. This has now been simplified by dropping the 10°, so that it is now give as 14°.

An increase of 3° DIN always represents a doubling of the speed while in the case of ASA the index number doubles along with the speed of the film.

The only snag is that all the speed ratings were originally devised for black-and-white negative films, and since colour films, especially reversal films, demand a vastly more accurate exposure than black-and-white films if they are to yield optimum results, speed ratings must be used with greater caution.

Further, the question whether our picture is dominated by light or dark colours, and particularly the way we use our exposure meter is of decisive importance. I shall return to this point in greater detail later.

The Colour Film – A Miracle of Chemistry

Without concerning ourselves overmuch with the alchemist's secrets of modern photo-chemistry we must appreciate that every increase in film speed raises very difficult problems which must be solved if other essential properties are not to suffer as a result of the increased sensitivity, welcome as this is. We must remember that the colour film

presents us not with a single emulsion, but with three emulsions coated on top of each other.

The film makers' stroke of genius consists of their ability to coat these really extremely thin layers not only on top of each other, but above all with consistent uniformity. Nor must these emulsions ever inter-

fere with each other during coating, storage, or processing in the developer.

I think I can save myself a detailed explanation of the little miracle you trigger off as soon as you release the shutter of your camera. Since numerous text books offer enough information about this point, I would rather not bother you with the description of a subject which has no direct bearing on photographic art. We must only be sure that the colour film we use in our camera is sold only after the most exacting check of each emulsion batch and that no matter where we buy it we obtain a film of as uniform characteristics as possible.

I know that this control, as strict as it is necessary, causes many thousands of feet of film to end up on the scrap heap of the plant every year.

Colour Reversal or Negative Film

In colour photography, two alternative ways are open to us of obtaining a reproduction in natural colours. We distinguish between two colour processes, i. e.

<div style="text-align:center">

colour reversal film, and

colour negative film.

</div>

With colour reversal film, you simply insert the film casette in your camera, and expose the film according to the directions enclosed or with the aid of a photo-electric exposure meter. When you have made all your exposures, you forward your film to one of the many developing stations which return the developed film to you after a few days. You then have your final colour slides.

The term "colour slide", as we all know, means a "transparent picture in natural or near-natural tones and colours". If we pass a strong light through this transparent colour picture from a projector lamp, a luminous, bright picture is produced on a white surface, the projection screen, by means of an optical system.

The real object of a colour slide taken on colour reversal film is its projection, apart from the possibility of viewing it through a magnifier or a so-called slide-viewer.

Colour Paper Prints from Colour Slides

For some time we have had facilities for making enlargements from slides on a paper or plastic base. However, experience has shown that by no means all colour slides are suitable for these enlargements, not even if they project satisfactorily, if a reasonably pleasing standard is to be set for the results. For the enlarging process on paper we can in the first instance use colour slides of low contrast; the second requirement is extreme sharpness.

Colour slides taken, for instance, in contrasty side- or back-lighting, which are reproduced extremely well in their highlights as well as their shadows due to great luminosity of projection, will in most cases produce a paper print which is far too harsh, with its shadows blocked, or its highlights burned out. This is simply due to the fact that the coating characteristics and the development of the colour reversal film are designed exclusively fort its real purpose of projection, and are therefore not generally suitable for reproduction on paper.

This perhaps over-critical approach to colour photographs on paper from colour slides may occasionally be refuted by one or other excellent result. Again, it may also be possible that many amateurs are not quite as critical with their own photos and are happy to have any colour paper print at all. Be this as it may, the colour paper enlargement from colour slides does in no way stand comparison with the possibilities offered by the colour negative material to be described presently. Colour reversal film therefore falls very short of being a universal material for colour photography.

For the time being, however, the colour negative film is superior to the colour transparency because not all direct enlargements from colour transparencies turn out to be satisfactory; after all, the original aim of the transparency is the production of a projected image in the strongest possible colours; this is the reason why its gradation is harder or "steeper". As a result even contre-jour subjects reveal excellent detail on the projection screen; printed on paper they are often disappointing. Since each copying stage has the effect of increasing the contrast, pictures well be produced in which the light portions are rendered too light, the dark ones too dark. The same subject photographed on colour negative film, on the other hand, yields a better enlargement because it is richer in tone.

other hand, yields a better enlargement because it is richer in tone.

Colour transparencies of low contrast, e. g. those taken in diffuse light or in the shadow are of course eminently suitable for direct enlargement. Here the contrast increase contributes to the brilliance of the picture; obviously, certain colours casts can be removed, too. But the most important advantage of this enlarging method is the excellent sharpness it produces.

Everything is still very much in the melting pot where colour enlarging is concerned. Whereas today the colour negative process is almost ex-

clusively used for such pictures – incidentally, the consumtion of co-lour negative film has far outpaced that of reversal film during the last few years – it is quite on the cards that an improvement of the "re-versal-reversal method" will produce paper or plastic bases which make the colour reversal film into a "universal film". I would welcome this development greatly, because it makes the decision which of his pictures he should enlarge very much easier for the amateur.

Such an improvement of the colour reversal paper, with a possible im-provement of its light-fastness, would also considerably extend the uses of the 35mm colour transparency. It is a well-known fact that blockmakers still intensely dislike working from 35 mm originals. Pro-ducing the blocks is more time-consuming and costly than from me-dium- or large-format originals. Many professional photographers would jump at the opportunity so switch over to a high-quality 35 mm camera; at the moment they have to rely on larger cameras in order to remain competitive. The printers' aversion to the 35 mm format would be quickly overcome if they could be offered excellent, and above all sharp, enlargements from 35 mm transparencies.

Duplicate Colour Slides from Colour Reversal Film

The possibility of obtaining good duplicates from original colour slides has improved considerably during the last few years. A great deal of experience is required, so that it will be well worth your money to leave this job to special colour laboratories. The question which imme-diately arises is whether the quality of such duplicates is good: the answer is yes. Certainly, a quality absolutely equal to that of the original cannot be achieved because the copying process involves a slight loss of sharpness, even if reversal material is used without the introduction of an intermediate negative. Expressed in somewhat vague percentage values the sharpness amounts to about 80 per cent of that of the originals, but in some cases it is even superior, particulary if the duplicate and original slide are shown side by side. This applies if the original had a disturbing colour cast, which during the copying process has been removed through the use of appropriate filters. Inferior results are invariably the outcome of contrasty originals which during dupli-cating present the same difficulties that are met during enlarging on

colour paper – highlights and shadows are not very readily accommodated simultaneously. Colour originals low in contrast, even slightly weak ones, can, however, produce such good duplicates that even the expert will only see the difference under a magnifying glass.

Black-and-white Pictures from Colour Slides

To complete my survey I must not ignore the possibility of black-and-white enlargements from colour slides. Naturally, this involves an intermediate negative, with results which are often extraordinary. Their quality also depends on the extent of the brightness contrast of the colour original. I for one have frequently obtained excellent black-and-white pictures from my colour slides, provided the intermediate negative had been carefully exposed and meticulously developed. However, only a very small minority of amateurs will go to the trouble of doing this job themselves unless they have experience. in the development of black-and-white miniature films. The best is the so-called optical reproduction, or projection printing, i. e. without direct contact between the slides and a black-and-white negative film.

As a few photographic laboratories will undertake the production of such black-and-white pictures from colour slides it is best to ask your photo-dealer for details. You will then be in a position to fill your photo-album with souvenir pictures, and especially to please those to whom you cannot give your colour slides, at least black-and-white prints. It must be admitted, though, that the quality of such prints is somewhat inferior to that of enlargements from original black-and-white negatives; they show, under critical examination, the characteristic appearance of a reproduction, much like a print obtained from a photograph of which the negative had been lost.

What, then, is the sum total of the possibilities of the colour reversal film?

The point has been reached of reviewing once more the position of the colour reversal film within the framework of colour photography, since

this also throws light on the discussion following below of the colour negative film and its potentialities: –

Colour reversal film

Slides Projector and slide viewer	*Paper prints* Colour contact prints and enlargements (Agfacolor CT prints)
	Duplicate colours slides (special laboratories)
Black-and-white negatives basis for black-and-white contact prints and enlargements	*Colour blocks for printing* *purposes* (blockmakers)

The colour negative film

In the colour negative film the natural colours of the subject are converted to roughly their opposites. The physicist calls them complementary colours. Areas of blue sky appear a muddy orange, freshly made-up lips blue-green, the delicate skin a blackish blue.

This negative film is usually developed and printed or enlarged in the colour processing station; like the development of reversal film, the process is largely automatic. Printing and enlarging, too, is today a matter for electronically controlled machines, which are of course operated and supervised by experts.

It is the aim of these laboratories to reproduce the colours as true to nature as possible. This is done by means of a filter system whose individual densities, too, are electronically determined. However, such automation makes allowances for any special wishes of the photographer impossible. Part enlargements of the negative, emphasis of atmosphere in a landscape picture by means of deliberately darker printing – wishes easily accommodated in black-and-white enlarging – cannot by entrusted to a machine operating according to fixed standards. They must be left to the manual worker, and have to be specially paid for.

Possibilities of "do-it-your-self"

Unlike the reversal film, which virtually offers no further control by the photographer once it is exposed, the negative film can be manipulated even after the exposure. The negative/positive process is therefore absolutely ideal for the exercise of individual control from the development of the negative right to the finishing of the enlargement.

We might as well admit it: – Having to bow to the necessity of sending the exposed colour reversal film to a processing station is downright humiliating to someone long accustomed to developing his own black-and-white films. While the manufactures of some colour reversal films provide for the option of user-development, the centralization of processing in special laboratories appears to me to be the best solution, since the whole procedure presents too many possibilities of error in the average amateur darkroom in view of the large number of baths, as

well as the need for strict temperature control. Processing of a colour reversal film in a developing tank requires an hour of careful control and making up all the chemicals for a single film would be far too costly. This is plain commonsense.

The situation is different in the case of colour negative film. Processing is comparatively simple, even the layman – provided he adheres closely to the instructions – can obtain flawless results. Naturally, he can also reduce his costs a little if he has more than one film to develop. However, do-it-yourself only makes sense if you do your own enlarging in addition to developing your films. Here, however, most amateurs find themselves rather restricted because they need a darkroom whose complete equipment for colour enlarging inflicts a considerable burden of money on their hobby. But for those who can afford it, the colour negative film is the ideal material for their photographic activities. For the negative provides them with prints and colour enlargements of any desired part of the picture and of any size, as well as with excellent black-and-white enlargements and colour slides of any number and size.

In actual practice colour negative film can be used exclusively for all exposures; some of the results being processed for the album, others for projection, and in the case of purely personal souvenir snaps without special colour appeal as black-and-white enlargements. Filter problems hardly exist, because everything is taken care of later on the darkroom. Also, pictorial composition at the moment of exposure can be modified to a large extent in the enlarger.

What, then can we do with colour negative film?

Colour negative
(user processing or colour laboratory)

Colour prints and enlargements	*Colour slides* directly from the colour negative

Black-and-white prints and enlargements
directly from the colour negative

This table shows us that the possibilities of the negative film are very versatile. This has earned Agfacolor CN17 film the title of "universal film". I must stress this particulary here, because this universal film

has meanwhile been joined by a special colour negative film from the same Agfa stable, called Agfacolor CN17S, which includes built-in masks.

CN17S – colour negative film with built-in masks

Masks are means of improving the colour rendering. They are called masks because they mask certain shortcomings of the dyes in the colour film – either mitigate them or hide them. Colour negative films incorporating these masks are recognized by the intense colour of the entire film, which, depending on the type of film, may be yellowish green, deep orange, or red orange. This layer, which is filtered out at the printing stage without difficulty, naturally makes an assessment of the negative (difficult even when the film has no masks), quite impossible; it can hardly be chosen for its suitability for enlarging before a trial print is available for inspection.

But before you go any further, listen to the observations of a photographic chemist on the value of the masking of colour negative films: "Masking improves colour rendering, the colours are reproduced more faithfully. All masked colour films on the world market are based on the same principle. Their reproduction of blue, yellow, and red hues is superior to that of colour films without masking dyes. Red appears more luminous and less brownish, magenta is less red, yellow is less whitish, more saturated, the hues of blue and blue-green are no longer indistinguishable, but clearly differentiated."

When you read this list of advantages of the masked colour negative film, compiled by someone who ought to know, you will have the feeling that negative films without masks are now obsolete. But my own experience does not bear this out. In actual fact, comparisons show an increase on colour differentiation and saturation, but this is not very evident at small enlargement ratios. With well lit objects I found the brilliance of the maskless CN17 to be almost the same as that of the masked special film. This is not a final judgment, but I feel that the masked negative film is a material mainly for the expert *and* the advanced amateur who wants to make sure of maximum colour intensity in his pictures even in difficult lighting conditions, especially in product photography.

28

A pertinent question: Reversal or negative film?

We seem to have reached the point at which we must answer the frequently asked question whether to use colour negative film or to join the "reversal party". This is what I have to say: If your colour photographs are merely meant to give you pleasure, keep fresh your memories of holidays and everyday family life, if you want to entertain your friends and relatives with an occasional slide evening of a choice of your most beautiful colour photographs in your own home, there is no reason why you should not stick to colour reversal film. The single outlay of a small home projector is the cheapest and simplest means of deriving complete satisfaction from your hobby; because it is beyond all argument that no technique, however ingenious, of colour paper enlarging equals, let alone surpasses, the luminosity and beauty of the colours of projected transparencies.

As you buy your colour reversal film you already pay for its processing, while mounting your slides between glass costs more time than money. When your colour film is returned from processing you know at once which pictures have turned out well. Although wrong exposures and other mistakes are annoying, you will learn from them and do better next time. Possibly the film will have been returned from development so quickly that the spoiled pictures can be repeated. Occasional wishes for album prints in colour as well as black-and-white can be satisfied under certain conditions.

The colour negative film appeals more to the amateur with little or no interest in the projection of his photographs, who prefers to have his pictures more or less enlarged. Colour paper prints can be tucked away in your wallet or stuck in an album, to be shown any time of the day or night. They can be sent away or given as presents. One does not readily part with a good colour reversal slide, while any number of copies can be made from a negative film. The most beautiful or amusing photograph of your youngest, or a pretty family group easily goes in the envelope addressed to the grandparents who, long-sighted as they probably are, would not know what to do with the tiny colour slide anyway.

Amateurs who occasionally want to ride their hobby-horse for professional purposes will prefer colour enlargements: architects show the beauty of their buildings harmonizing with the surrounding landscape,

horticulturalists their flower beds and gardens, textile designers the latest fashion trends. The possibilities of using the hobby of colour photography for profit are so numerous that it is futile even to try to cover them all.

The answer to the question whether you will be converted to "colour negativism" you can now supply yourselves. It is, above all, a question of money and also of your aims in photography. Whatever your decision may be, the time has now come to deal in more detail with problems peculiar to the colour negative film.

How are Colour Negatives Chosen?

We have already been told: the developed colour negative film is difficult, the masked film almost impossible to judge. Nobody shares our pleasure of successful pictures, few are expert enough to be able mentally to translate complementary colours. Looking at our own results we are rather at a loss.

These circumstances would probably suggest that you should obtain small 7 × 10 cm (2³/₄ × 4 in) colour enlargements immediately after the film is processed – you may in any case never want them larger than this album size. The trend in continental processing stations is to reduce the price of these enlargements if they are ordered together with the development of the film. They are indeed easier to handle since as soon as the film is dry, it immediately enters the next stage, passing to the printing room where, incidentally, the electronic eye of the enlarging machine automatically weeds out any "unprintable" negatives. Your photo dealer will hand the prints over to you together with the processed film.

Although this procedure is very practical, personally I am not completely happy about it, because it produces also pictures I would perhaps have rejected after inspecting the negative with a magnifier – since camera

shake, movement blur, etc. are of course not seen as defects by the electronic eye. This is my view of the disadvantage of the mechanical choice of a colour print. However, a photo dealer friend of mine told me that most of his customers are very satisfied with the choice and quality of the machine prints. And he added: 'If all my customers were as cirtical as you, I should have shut up shop long ago".

Often picture quality is based on selection of the suitable negative area

Whichever you prefer, automatic prints returned with your colour negative film or your own choice of negatives, there still remains the question of selecting the picture area. After all, it is a great advantage of the negative/positive process that you do not have to show everything on the print that is on the negative: an empty foreground here, a disturbing detail along the picture margin there. Sometimes the picture may perhaps call for a long, a short, or even an almost square shape.

However, individual tastes – and these include the selection of certain picture areas as much as the creation of a certain colour mood – are ignored by machines; their fulfilment must rely exclusively on the human factor. Manual work, however, has its special price. But I know of a very neat way out: have your films enlarged to the next larger format than you really need, and simply trim the print down to the picture area you have carefully selected by means of masking strips of dark paper.

You may perhaps find the small, inexpensive, wallet-size format completely satisfactory; all the same, do have a particularly successful picture enlarged to a bigger size occasionally. This will make you appreciate the difference in perspective between a large and a small colour photograph.

Once I was asked to submit colour photographs from negatives for possible enlargement to exhibition size for Photokina, Cologne, the Mecca of all photo-fans; after careful selection I entered ten pictures in postcard size. I had them all back with the courteous enquiry as to whether these where the only ones I had to offer. This was a bitter pill to swallow. I then narrowed the returned ten down to three which I had enlarged, money no object, to the much more imposing 12 × 10 in

Children on the Beach
Picture page 33

*A picture out of a series of at least a dozen, all of which were success-
ful. If I only knew the mother of these two so absorbed in their play
at the North Sea resort of Langeoog, I could give her a lot of pleasure
with some of the colour transparencies! This was a case where the ca-
mera had to follow the children unconditionally. They were still too
young to pose, and after a few curious glances at the picture-taking
uncle completely ignored the Leica. The large rubber duck and the ball
were much more important.*

*Unless you pre-arrange your children's pictures on the beach you have
to be content with the surroundings as you find them. A crowded beach
is not ideal, because the background is a riot of colours and con-
tours. However, the closer we take children at play and the more de-
liberately we avoid all disturbing details by a clever direction of our
camera the more concentrated will the final picture be. In this example
I therefore made a point of eliminating the horizon and any unneces-
sary surroundings.*

*I also benefited from the greater speed of the Agfacolor film. In the
late afternoon, the normal exposure time on the beach was $^1/_{100}$ sec. at
f/8. However, I chose the shorter shutter speed of $^1/_{250}$ sec. in order to
avoid movement blur even at close quarters. The iris, with a little push,
was set just beyond f/5.6. and kept at this setting irrespective of
front, side or back light.*

Leica, 50 mm. Summicron, about f/5.6, $^1/_{250}$ sec., sunlight, August, about 4 p.m.

32

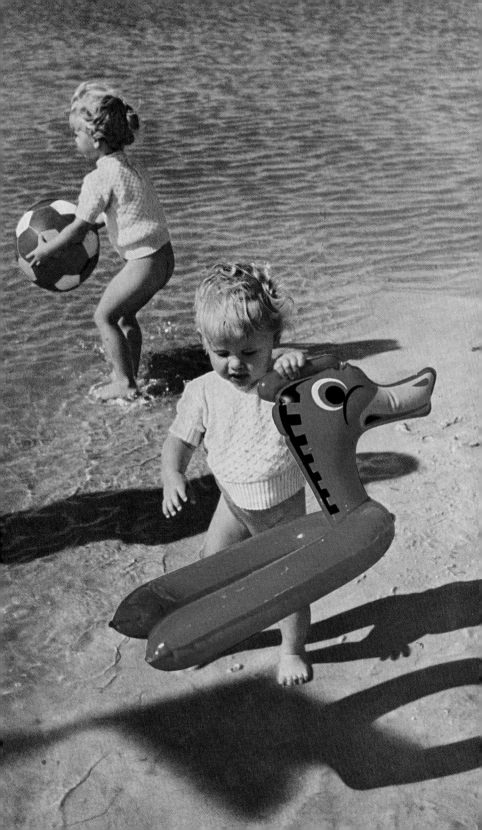

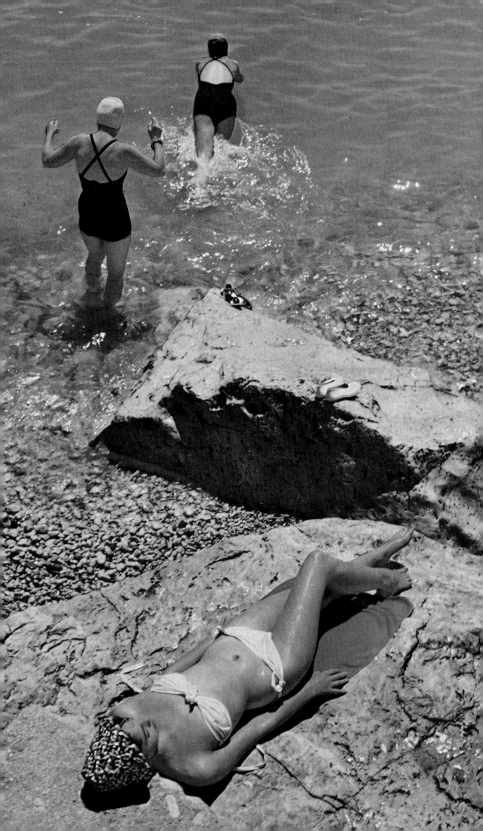

On the Piccola Marina, Capri
Picture page 34

This is Capri for you! Deep blue sea, rocky beach, and – occasionally – very beautiful girls. Such a riot of colour and joy of life tempts the photographer sorely, and his only trouble is how to avoid too great a hotch-potch of colours.

My picture was the outcome of a mixture of accident and planning – a typical case of the "controlled snapshot"!

The red bath towel was our own, as a wise precaution we had spread it diagonally to the coastline and my picture space. It was presently occupied by Anna Maria from Rome, with whom my wife had had the great kindness to establish contact a few minutes before. (It is best always to use your wife as a decoy if you wish to make the acquaintance of strange young ladies!)

One picture had already been taken when suddenly the scene was further enlivened by the appearance of two more water nymphs. Their dark swim suits presented a strong accent in front of the blue of the sea, moreover, I was lucky; without taking the slightest notice of us they stepped gingerly – because of the pointed gravel on the beach – into the water – and into my picture. The camera, ready for action, was prepared for this instant. And as one of the girls threw herself into the water with a determined splash, sending up a glistening spray of droplets, the shutter said softly "click".

You will have noticed that the shadows run towards the front – contre-jour light! However, this is not very difficult on the beach. Sand or bright rocks naturally act as reflectors throwing the sunlight into the shadow parts.

Leica, 50 mm. Summicron, f/5.6, $^{1}/_{250}$ second, June, 11 a.m., Agfacolor CUT 18.

format and mounted in large passe-partouts. The reaction – "Why didn't you show us these pictures in the first place? We want to use two of them – could we have the negatives, please".

Colour transparencies from colour negatives

Also part of the universality of the negative/positive process is the possibility of printing colour transparencies on a special positive film, both at 1 : 1 (same size) and as part enlargements. The colour character of a transparency can also be slightly influenced by after-treatment. If the quality of these duplicate transparencies were about the same as that of the original reversal transparencies, the question "reversal or negative film" would have been long decided for many an amateur. However, reversal transparencies are more brilliant and sharper, whereas duplicate transparencies look a trifle tired. This judgement may change as the duplicating materials are improved. Apparently the possibility of obtaining more brilliant transparencies from masked negative film is particularly promising. You will perhaps be able one day to order a strip of transparencies together with the development of the negative film and show, according to taste, brilliant slides or paper-prints. But for the time being at least the cheapest and most convenient way to transparencies of superb colours is the reversal film.

Will colour photography become cheaper?

I asked this question already many years ago; and my expectation that colour photographs would become cheaper has been fulfilled. How, you will ask, when today you pay exactly as much for a reversal film, as five or more years ago? Well, precisely for this reason: since with few exceptions the price of everything has steeply gone up, the reversal film being one of these exceptions – colour negative films and prints from it have actually become cheaper than they had been years ago – colour photography has become effectively less expensive. Occasionally you will come across particulary low-priced offers, e. g. with discount on processing and a saving of 10–15 per cent on the re-

gular price. However, even colour laboratories want to make a profit, the balance must be restored somewhere, and usually this will be done at the expense of quality.

The exposure

The technological difference between reversal and negative film is great. The reason for this is that the negative film can be developed to a "gradation" quite different from that of the reversal film. Gradation is the tone-value differential of the details of different brightnesses. What is meant by this you will immediately understand when you turn the contrast control on your television set. If the contrast is excessive, the picture will appear needlessly hard, with various steps in the black-and-white range "blocked".

The softer gradation of the negative film is possible because the necessary contrasts need be reached only at the printing or enlarging stage. In practice this means that you can overexpose your subjects on negative film, and the results will be none the worse for it. (Only with underexposure will lack of shadow detail occur with resultant muddy colours.)

Conditions are entirely different with reversal film. It would have to be exposed much accurately; if demands of quality are very high the latitude hardly exceeds $\pm 1/2$ lens stop. Its tolerance is much narrower than that of the negative film.

Exposure latitude

In view of the many technical terms which often confuse the photographer, I think that the term "exposure latitude" has been aptly chosen even for the layman.

If you photograph an average subject of moderate contrast on Agfacolor CT18, which is a colour reversal film, the film's exposure latitude will be ± 1 stop. Assuming your exposure meter reading is f/11 for the bright, f/5.6 for the dark portions of the picture, you will obtain adequate detail both in the bright and the dark parts of the subject if you choose f/8 for your exposure. Even an accidental mistake of about $1/2$

38

lens stop too large or too small would still produce acceptable colour transparencies.

Unfortunately you can take advantage of this latitude and therefore of a certain amount of tolerance in the exposure of the reversal film, only if the contrast of the subject is not excessive. This applies mainly to frontally lit subjects, i. e. when the sun is at your back. I shall explain later why, although this kind of lighting is the simplest for the colour photographer, it is not always the best. I am telling this to you, not to the millions of amateurs who do not find it necessary to read books on colour photography, for their aims are unambitious, all they want is pretty souvenir pictures, where the narrow exposure latitude causes no headaches.

And I am going to take a deep breath and shall come out with the whole truth: What decides the extent of the exposure latitude is the brightness contrast of the subject; there is no getting away from it. It is compounded of the lighting contrast and that inherent in the subject itself. The contrastiest subjects are very often also the most attractive ones. But here, quite as often, the exposure latitude has shrunk to zero; there is only one correct exposure, and no latitude at all.

You will therefore find it necessary to study the problem of correct exposure on the following pages very carefully.

Here you might want to throw in a question that does not seem unreasonable: "Why don't they make the reversal films softer, giving them a flatter gradation? For the flatter it is, the better it bridges the contrast, and the greater the exposure latitude of the film!"

Unfortunately this is impossible. You can't gain on the swing without losing on the roundabout. The flatter the gradation, the less brilliance. This would be acceptable where the subject is very brilliant, but what would become of all the other, low-contrast motifs? Pictures under an overcast sky, in the shade, let alone in rain? Brilliant colour photographs could be obtained in the brightest sunlight only.

Agfacolor CT18, which I know from long experience, is softer than it used to be. It now has a medium gradation, soft enough to bridge certain contrasts, yet hard enough to produce amazingly brilliant transparencies in soft lighting conditions.

Simple exposure tables are not bad

Every colour film is accompanied by an exposure table with hints for correct exposures even without a meter. It is very useful to the beginner or if you have left your exposure meter at home, and perfectly adequate for the conventional, unambitious holiday snapshots.
Perhaps you might care to have a quick glance at the exposure table for Agfacolor CT18 reproduced below, because it will make it easier for you to grasp all the other explanations concerning the subject of correct exposure. The table applies to the "most favourable" time of year, i. e. from 'May to September, and recommends opening the lens $^1/_2$–1 stop during the darker season.

The Standard Exposure Table for Agfacolor CT18
(for the time between 2 hours after sunrise to 2 hours before sunset)
Shutter speeds of $^1/_{125}$ or $^1/_{100}$ sec.

bright sun	f/8–11
veiled sun, haze	f/8
sunlight, in the shade	f/4–5.6
overcast sky	f/4
rain, very dull	f/2.8

In this table certain allowances are already included, which you must consider during your own exposure measurement. Perhaps you will occasionally consult this table, which is a rough-and-ready guide, in order to compare its advice with that of your exposure meter if you are still inexperienced in its use. But I think that once exposure measurement has become second nature to you you will have little use for this table.

The exposure meter as optical "divining rod"

When we compare the modern electric exposure meters with the instruments used 30 or 40 years ago for the measurement of exposures, we can assess the progress made in this very important sector of photo-

graphy. In photographic practice today only photo-electric exposure meters are used.

There are two distinct types: instruments with a selenium cell, and instruments with cadmium sulphide photo-resistors (CdS).

The measuring instruments with selenium cells react very quickly to light impressions, even where the changes between light and dark are very rapid. Selenium photocells are built into the conventional exposure meters, and are above all found in automatic cameras. They need no battery: under the influence of light the selenium cell generates a very weak electric current, which is sufficient to deflect a pointer to produce the measuring value.

To me exposure meters are objects of fascination. The way they are used, and their nervously trembling reaction to differences in light remind me of divining rods with which we look for hidden sources of water.

The second type, the instrument with the photo-resistor, is simply called a CdS exposure meter. It is supplied by a tiny, but long-life Mallory battery. Its current is released as soon as the instrument is switched on for measuring. The light affects the CdS cell in that it reduces its resistance; the degree of reduction is indicated by the pointer deflection (even if this hasn't sunk in right away, you can measure with it).

Unlike the ordinary exposure meters with selenium cells, the CdS instruments require a little "breathing space", a recovery period during abrupt changes between bright and dark. The pointer must be given time to settle before it indicates the correct value. However, this is only a very minor drawback, to which you will quickly become used when you consider that it offers you an incomparably longer measuring range than previous exposure meters. The pointer deflections ar clearly visible even at the lowest light intensities, e. g. in dim interiors.

It is not quite easy to decide which type of exposure meter is the most suitable for you. The selenium-cell instrument is perfectly adequate for the majority of amateurs. However, discriminating workers who want to measure practically in any light seem to regard the CdS instrument as indispensable. For here a second avantage comes into play, presently to be discussed in greater detail: the CdS instruments have a narrower measuring angle.

I am firmly convinced that an exposure meter of whatever type is indispensable to the ambitious colour photographer. For the human eye

is the worst possible measuring instrument because of its slow adaptability to light and dark impressions. When, for instance, we step into bright sunlight from a dimly lit room we will at first be so blinded that we think the light is much brighter than as short time later. This slow reaction of the eye becomes even clearer when we enter a darkroom in which high-speed material is processed. The gay chatter of girls and the rattling of dishes and printers is audible evidence of people busily at work. However, to our eyes everything seems in Egyptian darkness at first. Gradually details will become visible in the blackness, because our eyes adapt themselves.

Even with 30 years of practice in colour photography behind me I am unable always to guess the correct exposure from experience.

Sixtomat x 3 and Lunasix

The Sixtomat x 3 is probably the best known of the exposure meters with selenium cells. I used it for many years with good success.

Today I carry the Lunasix in my photographic luggage; as a CdS exposure meter it not only is more sentitive, it also has a narrower measuring angle. The limitation to 30° makes the so-called "spot measurement" possible, with which it is easier to take readings of individual subject features important to the measurement, and to eliminate surroundings liable to falsify it, such as, for instance, a dark green hedge or shrub behind a person dressed in light colours. With the narrower measuring angle it is easy to take a reading of the person only. I would be equally disturbed by a light background if I wanted to take a portrait of a negro child. I take my "divining rod" along on my journeys, to dark, narrow streets and into dim cathedrals, point it at blossoms and other close-up objects, so that I measure only the back-lit calix, but exclude the green leaves; the same applies to attractive girls' faces framed in dark hair.

"Adaptation" of the exposure meter

In photographic literature you occasionally find the advice to "calibrate" your exposure meter. I said the same in the past. But the term is inappropriate, because it suggests that the measuring instruments had no fixed standard. On the contrary, with the narrow tolerances allowed in the manufacture of exposure meters the amateur will no longer be in a position to carry out his individual calibration. What he has to do is to adapt his exposure meter to the conditions of the camera and of the colour film.

Let us assume that at the $^1/_{125}$ sec setting your shutter exposes only 25 per cent longer or 10 per cent shorter. Your colour film – it could be any make on the world market – is faster or slower by x 1.25 or x 0.8 ASA respectively (\pm 1° DIN), which is the guaranteed tolerance. Several deviations may become cumulative, and your pictures are noticeably differently exposed to your friend's next to you, who is taking his photograph of the same subject and in the same light – perhaps even using the values of your own exposure meter; I am telling you this at some length, because such differences do occur occasionally; especially with cheap cameras, whose shutters do not always remember the speed values engraved on them. However, before worrying unduly about this problem you had better become familiar with the rules of exposure mea-

surement, because faulty results can usually be traced back to faulty use of the exposure meter.

Exposure meters are calibrated on "average subjects"

Here at last the term "calibration" is appropriate. For in the factory the measuring instruments are indeed standardized. The design of exposure meters is based on statistics – of all things. Thousands of colour films were inspected in the processing laboratories in order to find out the what, how, where, and when of colour photography. Apart from the fact that people are the most favourite subject, followed by landscapes, the investigation showed that about 90 % of all colour photographs are of so-called average subjects. What is an average subject? If a photographic subject exhibits no very great brightness differences, it is called an average subject. It includes the vast majority of landscapes, street scenes, groups, persons, and portraits without unusual lighting effects. The very success of the automatic cameras is based on this fact, for their whole function is calibrated for average subjects, and they settle, exactly like the independent (handheld) exposure meters, on a mean value.

Whether the object contains red, green, yellow, blue or black – I am thinking of a group here – the exposure measurement of the mean value of these various brightness will without fail produce the optimum result if the lighting is even, and not too contrasty, for instance frontal. For 90 per cent of all amateurs, though not as many of my readers, I could now close the chapter on exposure measurement except for a few minor tips. Because if you conscientiously follow the rules of colour photography ("sun at your back") you will without fail measure and expose correctly. For the other amateurs and probably the majority of my readers I must continue with a description of the technique of exposure measurement.

The technique of exposure measurement

Photographic exposure data, both of lens stop and shutter speed, can be determined in several ways. The method used depends not only on the

habit and preference of the photographer, but above all on the type of subject and its illumination. For optimum results different objects demand different measuring methods, depending on their brightness distribution.

The two measuring methods are called:

Reflected-light measurement, and

Incident-light measurement.

Reflected light measurement means: We measure the light reflected by the object. Here, the measuring result depends not only on the intensity of the lighting but also on the colours and the intrinsic brightnesses of the object. Even in uniform, i. e. low contrast, illumination, the pointer of the exposure meter will be deflected less in front of dark than in front of bright objects.

Incident light measurement means: The exposure meter "sees" only the light that is incident on the object. Generally the measurement is taken from the object in the direction of the camera. Here the measuring results are of course completely independent of the colours and intrinsic brightnesses of the object.

Opinions differ not only among professionals, but also among amateurs as to which of the two measuring methods, so fundamentally different, produces the better results. There are good reasons why incident-light measurement should often be preferred, especially in colour photography. On the other hand, to the amateur reflected light measurement represents the older tradition. It is, as it were, the stand-in for the camera, because the exposure meter sees, roughly, what the camera is expected to photograph. This obvious imitation of the exposure procedure with photo-electric means has assured the reflected-light measurement enormous popularity from the very beginning. It has been further enhanced by the introduction of the built-in exposure meter, with the automatic cameras relying on reflected-light measurement as the only possibility. A camera as expensive as the Leicaflex also permits only reflected-light measurement.

All these reasons might lead to the premature conclusion that a method of such popularity could hardly be inferior to the other, the incident-light method. In fact, it isn't. But I can assure you that there are many situations in which the method of incident-light measurement is the simplest and often also the only way to determine the exposure.

If you have an exposure meter which permits only reflected-light mea-

surement you can skip the subsequent explanation of what happens during incident-light measurement. You will be interested all the more in the description of the reflected-light method following below.

Reflected-light measurement from the camera position

Most reflected-light measurements are taken from the camera position. We have already said that with this method it is the light reflected by the object that is measured, and that, even if the lighting is very uniform, the measuring pointer is less deflected by dark portions of the picture than by bright ones. At the camera position, dark and light portions add up to an average value. With all normal subjects, reflected-light measurement from the camera position will therefore produce adequate results. A group of people, for instance, is just as normal a subject as the landscape in the same frontal light. However, whereas for the group picture you will obtain the average value by a straightforward measurement of the group, in the landscape the bright sky might affect the measurement more than you want it to if you simply point your meter in the general direction. Better tilt it slightly downwards in order to secure an acceptable average value. If the sun faces you high in the sky with contre jour light, so that it shines straight into the measuring window of your exposure meter you must shade the window your hand. Otherwise you will always get a wrong measurement.

Reflected-light measurement of very contrasty objects

Up to now we have been discussing only average subjects, described in some detail on p 44. Strong contrasts occur in a subject when both the lighting and the reflecting power of different parts of the object vary a great deal.

To a certain extent, even colour-reversal film can reproduce contrasty objects in approximately faithful colours, provided you accept that in some parts of the picture the colours are rendered darker or brighter than natural. The colour reversal film cannot accommodate brightness differences greater than 1 : 32. What does this figure mean? If you obtain, for instance, a lens stop reading of f/2 for the deepest shadow,

and of f/11 for the brightest portion of the subject, the number of aperture steps between these two extreme measuring values will be 5 (2 – 2.8 – 4-5.6 – 8 – 11). The step from one aperture number to the next always means that the light reaching the film is halved (or doubled, depending on whether you stop the lens down or open it up). If you open the diaphragm from f/8 to f/5.6, you obtain twice as much light, if you stop down from f/8 to f/11, only half as much. If the measuring pointer brackets 5 stop values in the measurement of the shadows and the highlights, the brightness contrast of the subject is 1 : 32, because $2^5 = 32$ (don't worry this is as far as we shall go in mathematics). The exposure meter measuring from the camera "sees" both bright and dark, averaging, as you know, both. It may happen that in the finished picture you like neither the shadows because they are already too dark, nor the highlights because they have turned out rather pale and washed out. Only the middle tones are right.

The most satisfactory compromise is reached only if you decide what is very important, important, and less important to you. If you want to emphasize the bright parts of the picture, take your meter reading only of these and expose for them; never mind what happens to the shadows. If the light and medium tones are important, take a reading of both and expose for the intermediate value between them. If it is the medium tones and the shadows, forget about the bright parts and measure the latter two in order to obtain the required mean value. But if you want the shadows only ... well, dear friend, I'd be sorely tempted to ask you "Why don't you leave everything else out, and take a picture of a different area from a different viewpoint?".

With these examples of separate measurements of various parts of the picture we have already left the subject of "Measuring from the camera position". We are now talking about a special case of reflected-light measurement.

Close-up reflected-light reading (close-up reading)

Do follow my advice and measure contrasty subjects from close-up – if at all possible.

Generally you must leave the camera position for this purpose and take the camera with you if you are frightened that it might be stolen and

above all if the exposure meter is built-in. Now take a reading of those parts of the subject that are pictorially important. Generally they will be the lighter ones. It is very important to measure from the same direction from which the camera is pointing at the subject, and that your body does not cast any shadow across the portion to be measured. (Are you smiling? And thinking that this is obvious? But it is a very common mistake, particularly in the absence of shadow because the sun is not shining. Nevertheless, you will very often darken your subject; you should therefore take up a position during the measurement which leaves the view of the object from the eventual camera position unobstructed).

With the close-up reading we also eliminate surrounding fields that interfere with the correct measurement. The suntanned face in front of the light-coloured house, the delicate pastel shades of a face in front of a dark green hedge – in each case the background would strongly influence the result of the measurement. However, if you are not afraid really to close in on your subject with your exposure meter, you will measure only what contributes to correct colour rendering.

Close-up reading of substitute objects

This "close-up business" can be somewhat tricky at times. Sometimes you will be too inhibited, at others it will be practically impossible. Snapshots cease to be snapshots if you have to poke your exposure meter irritatingly close into your victim's face. For almost everybody will instantly assume his camera expression, and the chance of a live, unposed snapshot will have passed. Here a substitute object in identical lighting conditions is measured; the substitute must have approximately the same reflecting power as the subject proper. Unless you are coloured, you can use the palm of your hand as a subsitute object. An entirely dfferent, very interesting method of substitute measurement can be used in very unfavourable lighting conditions. In dark interiors, e. g. of churches, chapels, museums, the deflection of the measuring pointer maybe so small that it is almost imperceptible. This applies particularly to the conventional measuring instruments with selenium cells. Here you can take a close-up reading of a piece of white paper or cardboard – if the worst comes to the worst it can be an open

book or your note-book; this gives you a greater deflection. If you want to photograph relatively bright objects in a dim church interior such as walls, an altar, etc., multiply the meter reading by 4, and darker objects such as woodcuts, pews, etc. by the factor 8. If, for instance, the reading of the white paper in the exposure site is $^1/_{15}$ sec, an 8 x times increase will produce $^1/_2$ sec effective exposure time ($^1/_{15}$ x 8 $=$ $^8/_{15}$ $=$ $^1/_2$ sec). The lighter object of factor 4 requires only $^1/_4$ sec. You will never need this trick? Wait and see. Or tell those others about it who are not the lucky owners of a sensitive exposure meter.

Special case: how to photograph uniformly bright objects

Let us leave the problem how to expose contrasty objects for a while and concentrate our attention on a question the answer to which is extremely valuable. There are many subjects of extremely poor contrast, commonly called "of uniform brightness". The word "bright" seems to me to be a little inaptly chosen and misleading. For the type of objects meant by this is distinguished, strictly speaking, by the flat gradation of its brightness. It comprises snow and snowscapes with and without sun as well as subjects in haze and fog, even grey asphalt on a dull day.

Let us, to begin with, shelve the dark, uniformly "bright" subjects, and talk about pictures in the snow and on the beach. Or about a brightly dressed blond in font of a light wall. All these are subjects of little contrast.

And they must all have more exposure than the exposure meter recommends with reflected-light measurement.This rule, by the way, applies only to colour reversal film; colour negative film may even be given less exposure than the measurement indicates.

More exposure for sunlit snowscapes than the meter says? Sounds incredible. Yet it is true. Why? Because your exposure meter was calibrated for average subjects in the factory, to indicate the mean values of these subjects. How on earth can the exposure meter find mean values in the snow or on the white sands on the beach, which do not offer it light *as well as* dark values for integration? It is not made for it. Thus the exposure meter receives – but only with reflected-light measurement – *more* light, because it can only integrate light impressions.

As a result, the measurement gives too small a value, and if you accept it uncritically, you will produce more or less underexposed transparencies. Snow or beach seem to have lost their sunny sparkle, the highlights are no longer transparent enough, because they are blocked; snow and sand look dirty.

The extension factor for reflected-light measurement varies with the degree of weakness of contrast. A sunlit snowscape generally needs $^1/_2$–1 lens stop larger (i. e. open up), the same snowscape without sun as much as $1^1/_2$ stops, because it is even poorer in contrast. Sandy beaches (with only few people, tents, etc.) or sand dunes require a similar extension; so do pictures of clouds as the main element, perhaps supported by a narrow fringe of horizon.

Now let us turn to the other "headaches" of reflected-light measurement. Any landcape without foreground and without sun, subjects in haze or fog, or in very dull light under a lowering sky all lack contrast. The poorer the contrast of a subject, the more exposure is necessary, or the higher the extension factor of the meter reading. A uniformly dark grey area, which of course is not a photogenic object, under a grey sky will have to be photographed at 2 lens stops larger if it is to retain its natural grey in the transparency. Photographs in the fog also require two stops larger, very misty subjects $1^1/_2$, landscapes without foreground and sun about one. The more the contrast of a uniformly dark (or bright) subject increases the smaller becomes the correction.

When I spoke about this phenomenon, well known for a long time, to an amateur photographer recently who uses an automatic camera, he was quite horrified. He had never heard before that for such subjects he would have to reduce the film speed setting of his automatic camera by $^2/_3$ – $1^1/_3$ depending on the weakness of the contrast. He had never done it before and had always been satisfied with his pictures. A classical instance of "what the eye doesn't see the heart doesn't grieve for". I had a close look at his winter holiday slides. The snowscapes among them were without exception underexposed. That the "automatic" amateur failed to notice this effect with relatively close-up projection was because he had nothing to compare the pictures with, is another matter.

The incident-light measurement

I have deliberately discussed the method of reflected-light measurement first, indeed had to discuss it first, because the overwhelming majority of all amateurs use it exclusively. My argument that the reflected-light measurement is the traditional method, and incident-light measurement became known only later applies only to amateurs. It is true that the method of incident-light measurement – the term "illumination measurement" would be even more apt – was introducted after that of reflected-light measurement, but "illumination meters" have been in existence for much longer e. g. on the film set, where the illumination of the scene is measured in lux.

To sum up: with incident-light measurement all the light is measured that comes from the vast semi-circle on the camera side of the object. This means literally that the light is measured from the object in the direction of the camera. It calls for a basically different position of the exposure meter in reflected- and in incident-light measurement.

To explain it once more as clearly as I possibly can let me summarize the entire measuring procedure from beginning to end:

1. The exposure meter suitable for incident-light measurement is prepared for the measurement when the roller (Sixtomat x 3) is pulled out, and by attachment of the diffuser sphere to the measuring eye of the Lunasix (with other instruments it is simply called "sphere" or "diffuser"). They all have their hemispherical shape in common, and have the task of doing away with the measuring angle of the instrument and to record the entire light falling on the object.

2. Walk up to your subject (portrait, group, street scene, landscape foreground) and point your exposure meter in the direction of your camera. Strictly speaking aim at the camera as with a pistol. The position of the sun is immaterial. At any rate, its light, whether it falls on the object fully or only glances off it, is included in the total light measured by the meter. However, the intensity of the light reflected by the clouds, by the blue skiy, by the wall of the house opposite, and even the very weak intensity of the light from the lawn in front of you is also measured. The value obtained now is often the same as the mean value obtained with reflected-light measurement.

3. You can forget about walking up to your subject, if exactly the same lighting conditions exist there as at the camera positon, e. g. if

the object is not in the shade whereas the camera is in the sun. Here you have to make an about-turn (180°) at the camera position and take your reading in the direction of the extended subject-camera axis. This will very often be possible and saves above all a close approach to people who are to be left completely unaware of your photgraphic intentions.

The advantages of incident-light measurement

Let us briefly summarize those properties which constitute advantages of the incident- over the reflected-light method.
1. It can be physically proved that illumination has a more decisive influence on the exposure than the properties of the camera subject and its reflection.
2. The illumination and its wide variation makes it even more difficult for the eye to guess the exposure than does the intrinsic brightness of the object.
3. There is no problem of surroundings that disturb the measurement. The incident-light measurement will obtain the same result as the close-up reading of the object.
4. Direct light, e. g. from the sun or lamps, reflectors etc. that disturb any reflected-light measurement do not interfere with incident-light measurement. On the contrary, it is the light from these intrinsic light sources that must fall on the diffuser.
5. With reflected-light close-up measurement you will run the risk of accidentally darkening the field to be measured. During reflected-light measurement you will hardly be able to prevent this from happening, e. g. with a flower. With incident-light measurement you can kneel next to the flower, and measure in comfort in the direction of the camera.
6. With objects of a small contrast range (snow, sand, beach, sky with clouds, etc.) you will obtain approximately correct values with incident-light measurement.
7. With objects of great contrast range incident-light measurement will produce a mean value of all the various lighting intensities, corresponding roughly to the same exposure value as that obtained as the mean of the measurement of dark and of bright portions of the picture. How-

ever, if a certain portion of the picture, e. g. the brightest, is particularly important to you, you must correct also the result of the incident-light measurement by stopping down.

8. With contre jour subjects incident-light measurement carried out in the shadow of the object in the direction of the camera will produce that value which ensures good detail in the shadows. If this is undesirable, i. e. if the dark portion of the subject is to appear as a silhouette, reflected-light measurement of the brightest parts of the picture is more favourable.

What incident-light measurement cannot do

To complete the picture I must mention a few further typical subjects, which can be taken to represent other, similar ones, and are not suitable for incident-light measurement.

1. Stained-glass windows, bull's eye panes, ice ferns, paintings on glass. These and similar objects are the exclusive preserve of reflected-light measurement, because what they offer the exposure meter is not a measurable illumination, but *trans*illumination. But you must make sure that your subject fills the entire measuring angle of your exposure meter.

2. Views through windows or portholes of a bright scenery, as well as gateways etc. Here you can rarely approach the subject in order to use incident-light measurement towards the camera. Reflected-light measurement will perhaps record middle tones in the bright background value.

3. Sunrise, sunset, red skies and other aspects of the sky, rainbows. Incident-light measurement is pointless here, because the usually far distant objects together with the dark foreground produce an excessive reading and therefore overexposure. "Atmosphere" subjects of this kind, particularly rainbows, require a correction towards *less* exposure even with reflected-light measurement, because only short exposures bordering on underexposure will enhance the glow and colour brilliance of the various phenomena.

Under 3, I listed typical special cases which call for your experience rather than your exposure meter. If you are particularly interested in the subject of sunsets, you may want to read, here and now, my correspondence with some Swiss amateurs, reproduced on p 158, which you

will find very informative. Similar remarks apply to the rainbow, whose vast surrounding sky also disturbs its measurement; for what is the point of having a dripping wet meadow reproduced in faithful colours, if the rainbow appears too pale, i. e. overexposed? (voice from the back of the hall during one of my lectures: "How about a close-up measurement of the rainbow?").

Conclusion: When in doubt, several exposures

My detailed discussion of the technique of exposure measurement had the aim of preventing you from making mistakes and using your exposure meter incorrectly. I hope I have made it stimulating and instructive enough to have made wrong exposures henceforth a thing of the past for you. I am, however, uneasily aware that there is such a thing as "exposure according to personal taste". Because what one person considers right, the other might find over- or underexposed, too bright or too dark. I know photographers who give colourful subjects a wide berth, contemptuously dismiss any "posterlike" colour composition, and use their cameras only under an overcast sky or on dark days. These are the friends of pastel shades. Others again prefer pictures with saturated colours, gaudy colours are right up their street. Their formula is the deliberately short exposure. They therefore adjust the exposure meter even if the values it offers are perfectly correct, and after stopping down photograph dark yellow sunflowers in front of a deep blue sky, although both appeared much lighter in reality. How can I lay down generally valid rules?

If there are occasions when you are in doubt whether the light or the dark details are the more important ones, whether the slide should be vigorous or pastel-shade, be a devil and take one or two extra pictures of the same motif, varying the lens stop or the shutter speed. To enable you to judge the behaviour of the colours in generous and short exposures yourself, make a test series of your own. Look for a very colourful object with bright as well as dark colours.

The best suggestion I could think of would therefore be a very gaudy billboard. This does not move, and makes no fuss, while offering a rich scale of colours. If it is in the centre of the picture, part of the background can be light, part dark, and this will not unduly influence the

reading; it shows up all the better the differential colour reproduction of our test series.

However, we must take care to avoid an excess of white areas in the poster as well as in the background.

We now approach to within about 7 feet of our subject measuring our own shadow and take a meter reading. Let us assume – this was the case in my own test – the result to be f/8 and $1/100$ sec.. This will then be our initial exposure, around which we shall build a test-exposure sequence.

Now is the time to get hold of a notebook and to record our data. This is much better than relying on one's memory. Now we press the button, having set the correct distance (quite important, this!). The picture is best taken with the camera held horizontally, and with a standard focal length lens the exposure distance will be just right at about 13 feet.

We are now set to start our exposure series. The next exposure is, of course, made without any change of the shutter speed of $1/100$ sec., at half a stop smaller, i.e. instead of f/8 halfway between f/8 and f/11. The third exposure takes place at a further half stop down, i.e. f/11, and if we want to make our test particularly convincing, a further one or two pictures, at half a stop smaller each, would supply us with certain under-exposures.

The same procedure is now repeated in the other direction, that of longer exposures, by first using, for example, between f/8 and f/5.6, then proceeding to f/5.6, between f/5.6 and f/4, f/4, and perhaps even between f/4 and f/2.8. If by now we have not yet made any notes, it is our last chance!

By the way, a thing I quite forgot to mention – unfortunately, we would have to repeat the entire series if in the meantime the sun had disappeared behind a cloud, and we had not patiently awaited its full return.

In order to get our results as quickly as possible, we had better make haste to expose the remainer of our film. The standard exposure table enclosed with every film will give us sufficient guidance to enable us to add this or that colour picture even without complete confidence in our exposure meter. But, here, too, we should never fail to make notes of our exposure data, covering not only stop and shutter speed, but also time of day and the position of the sun.

The assessment of your test series

As soon as your test film has been returned by the developing station make the effort of preparing each transparency for projection; cut off every picture carefully and mount it in a simple cardboard frame, which is available in packets of 40. Immediately write on it the exposure number corresponding to your notes. If the transparencies were returned to you in cardboard mounts ready for projection, embossed consecutive number show you their correct sequence.

During the first projection the completely under- and overexposed pictures will probably end up in the waste paper basket right away, but you should find out how long the light colours will remain acceptable even when they have received only a fraction of the correct exposure, and also how much less pleasant your overexposed pictures appear.

As for the rest, you will be amazed. Perhaps you will at first completely overlook the differences between pictures varied at half stops (rapid repetition of pairs of pictures during projection makes comparison easier). You might even prefer the general colour rendering of the transparency exposed through an aperture smaller by $1/2$ of what the meter proposed to the one accepted as correct. Be that as it may, you will see that the reversal film can stand shortish exposures better than long ones.

Should the deviation of the best-exposed transparency from that exposed exactly according to the meter be as much as ± 1 stop (± 3 DIN,

x 0.5 or x 2 ASA), you would be well advised to have your camera shutter tested. The inspection of your exposure test should be carried out with a good projector without any falling off of light towards the margin on a really white screen. Yellowish walls may lead to wrong conclusions.

The Dreaded "Colour Cast"

Hardly a conversation on colour photography passes in which lively complaints are not thrown into the discussion about "juicy colour cast". I am now adressing the beginner who is not yet stricken with grief, as well as those who have already suffered from recurring colour cast.

Before we go any further, we must distinguish between two basically different disturbances through such colour casts. Their causes, too, are entirely different.

For some colour casts we can blame neither ouselves nor our exposures. They are either due to the emulsion or the development. Colour reversal film in the past has been prone to this fault; it would be foolish to deny this.

The other disturbance, which is not caused by faulty manufacture or development, is basically no colour-cast at all, but caused by reflections from neighbouring coloured objects which light the subject with their own colour.

Having first of all classified my casts in these various groups, let me begin with the ordinary colour cast which is – apparently as well as ostensibly – not our fault.

If the entire film from beginning to end shows a colour cast which not only deprives the transparencies of clarity and luminosity, but also daubs, as it were, all the lighter colour tones with, for instance, a reddish or greenish cast, we must – unfortunately – seek the origin in the material itself rather than in our exposures.

I have already indicated at the beginning of this book what a miracle of chemical and technical work is involved in the colour film with its three inconceivably thin layers. The emulsion is checked by continuous controls throughout the whole manufacturing process on order to produce material which is flawless in every respect.

As soon as the film leaves the factory, where during its manufacture and storage it has been protected against all temperature changes and

other effects it may sometimes – perhaps long before it is used – be exposed to bad influences. I do not wish to blame the storage conditions at the wholesalers nor your photo dealers; however, it is a fact that colour films should be stored at constant and low temperatures of ideally 65–68 ° F. maximum and at approximately 50–60 % atmospheric humidity. Apart from this, never use colour film, whose expiry date has passed.

Let us then assume we start our holidays with a few cassettes of freshly-bought colour film. On our return, we find that all the pictures have a colour cast.

It is sometimes extremely difficult to trace the cause responsible for this. Mostly our wrath is first directed at the developing station, at times the manufacturers accept the complaint and try to make up a little for the damage done, although sending a replacement film does not restore the holiday pictures.

Humidity and temperature changes

To illustrate the subject "holidays and colour cast" I must tell you about a case of my own experience, in which I was myself responsible

for the trouble. During a September journey to Spain, I had my film store, two boxes containing 10 Agfacolor cartridges each, in the boot of my car. I did not always want to open my fullypacked suitcases in order to dig for my films. Easy access in the boot whenever I needed a film appeared to be of particular importance.

Unfortunately, the weather on this journey was, against all expectations, anything but reliable. During the first week high summer temperatures

made me curse my saloon more than once. Occasional parking on shadowless squares made me feel like in an enforced Turkish bath. With windows turned down as far as they would go, and increased speed I tried to cool the overheated interior. The temperature inside the boot I dared not guess. It must have been similar to that a hay box, in which our grandmothers used to keep their meals warm.

During the following weeks we had days with breaks in the weather and temperatures which even the villages elders could not remember. I still recall with shivers the damp beds in unheated hotels, the damp clothes – in a word – horrible!

However, generally Spain was photographically of such ravishing beauty that during the last week I sent a wire home for five more films. All the films, including the last five, came from the same emulsion batch, bearing the same emulsion number. One could not call the results exactly dreadful, but they were disappointing all the same. The films stored in the car showed without exception a green cast which, though is was still tolerable, was noticeable to critical eyes.

On the other hand, the last five, which had been stored at home at even temperatures in a dry cupboard, were perfect!

The useful crop of my Spanish journey thus consisted practically only of the films forwarded to me. Only the comparison between the over-cooked and the forwarded films prevented me from writing rude letters to the developing station or from telling the manufacurers what I thought of their film.

It is therefore important to follow the storage instructions strictly, at home as well as on our holiday.

The eye can be deceived

The human eye is a great miracle, but we must admit that its memory for colours is a little shaky. It can therefore be easily deceived.

Why do we take a sample of material, in order to match it with the sewing cotton, out into the daylight to compare it in order to avoid the wrong impression in the "mixed light" inside the shop?

Or another example – a house has a snow-white finish, yet during the course of a sunny day it shows a wide range of colour tones beginning

with yellowish-red, moving to blue, and returning to yellow according to the height of the sun's position. If we asked anyone, morning, noon, or evening, what colour our house was, he would be certain to reply – somewhat astonished and with a questioning note in his voice "why, white of course"!

The human eye, then, sees changes in the illumination much less objectively and correctly than they are registered by the film. Even considerable modifications in the colour are automatically allowed for; "the eye adapts itself".

You can see this adaptation of the eye particularly well during, for example, the projection of 12 colour transparencies in succession, all with a heavy blue cast. After a time, as picture follows picture on the screen, this cast is no longer found disturbing unless it is altogether excessive. The eye has become accustomed to it! But if in the middle of all these "blue" pictures there appears, accompanied by admiring "ahs" and "ohs" from the viewers, a sunset, its effects will be particularly warm and glowing. And if the blue series is now directly resumed, the eye immediately signals "goodness gracious, how blue!" To avoid such shocks it is therefore an important point to show the slides during a lecture in the correct order. At any rate, it is clear that our eye, far from seeing objectively, sees very subjectively indeed.

The colour reflection

On the fresh grass the family, dressed in light summer frocks, are having a picnic, half in the shadow of a little birch grove. The longedfor sun-tan, as outward evidence of a holiday well-spent, has not yet

been acquired. The picture is so pretty that you simply have to take a colour photograph, but it will most likely have a green cast. Basically, this effect has nothing at all to do with a cast as such. It is the quite natural reflection from leaves and grass which impart their colour to objects and people in the shade. The so-called "local" colours of the skin and the light frocks are modified by these reflections. The eye, untrained in the perception of such colour phenomena, does not notice this change during the exposure, so that later on it is certain to protest against what it calls this "green cast"!

A similar surprise was experienced by an amateur, proud owner of a snow-white poodle. He had photographed the animal on his terrace, and was disturbed by a slight, but nevertheless annoying green cast. The explanation was quickly found; on the low parapet of his terrace stood long rows of green flower boxes which had thrown their reflection on to the dog's coat from all directions.

He was then advised simply to include the cause of these reflections in the picture. He took some more photographs and confirmed, highly gratified, that his poodle's coat was white again! But he did not like the picture, because the flower boxes disturbed him. So he masked them on the transparency; on projection, the coat appeared green again!

A beach beauty sitting on a red bath towel will show, on the part of her body not exposed to direct sunlight, a noticeable red cast, obvious even to the untrained eye. The less sun-tanned she is, the more evident it will be.

People dressed in white will be suffused with a red sheen when passing a brick wall or a Post Office van, for example. A face bent over a sun-lit-piece of material during needlework or embroidery will appear tinted by the colour reflection, depending on whether it is red, green, blue, or yellow. For the same reason, the reader of a newspaper will be properly illuminated with white light, although his face ought, by rights, to be in the deep shadow of *contre-jour* light!

All this is neither a mishap nor a colour cast, but a reflection which, by recognizing it in time, we have to learn either to suppress or, if possible, to exploit.

The example of the "green" poodle has already taught us that we can largely cancel the impression of the cast by showing the cause of the reflection in the picture. If, therefore, we take a portrait in the sha-

dow of a red sunshade, we should not forget to include the shade, or at least part of it, in our picture. Thus the source of the red flood of light engulfing the face is at once apparent. This inclusion of the reflecting source need not always be a compromise – in time, a deliberate technique based on it can produce the most striking effects.

If grass and trees cause green reflections in the shadows, or sunshades result in tomato-coloured faces, how much more powerful a source must the biggest reflector of them all be, flooding as it does everything with an all-pervading colour. The blue sky above us! Therefore, a pure blue sky, particularly during the summer months at noon, far from being the experienced photographer's delight, is a great source of trouble to him.

Colour photographs in the shade without any other direct illumination than the blue of the sky are therefore bound to be in great danger of acquiring a blue cast. And since in many cases we do not include the cause of this reflection in our photographs, we do not accept as true the cool blueness on the white wall and the garden furniture or on clothes and faces.

What then can we do against all these "enemies of the natural colour picture"? Well, we shall soon discuss the remedies in detail, but before we do this, we must submit to a short theoretical detour.

What is the meaning of "colour temperature"?

Unfortunately, (or perhaps luckily!) I can only touch with a few sentences on a problem which is worthy of treatment at great length in a thick volume. The term "colour temperature" occurs so frequently that we should at least know what it is all about. For the question of when and why colour casts occur is closely connected with the "colour temperature".

The many colours of the world we live in have been divided into "degrees". Just as we have agreed that water should freeze at 32° F., we also conceived the notion to establish a scale for sunlight.

When we look at the white sunlight through a prism we can easily see it split up into the colours of the rainbow; this is a well-known phenomenon. Only, the scientist cannot do much with vague descriptions such as blue, green, and red. In order to determine the colour of the light simply, the physicists make use of the familiar fact that glowing bodies change their colours with rising temperatures. We know that an incandescent light bulb running on a low voltage emits a reddish-yellow light, which, however, becomes increasingly white as the voltage is increased. The hotter a glowing body becomes, the higher becomes the proportion of blue in its "white" heat – we only need to think of the example of the glowing iron on the anvil: with increasing heat it becomes brighter, that is less red. Physicists are in a position by means of spectrometry to measure the increase in blue. Thus they can determine, not only at the blacksmith's around the corner, but also in the distant stars, the temperatures of incandescent bodies with great accuracy.

If you really want to know it in detail: – the colour of the light emitted by incandescent bodies depends on their temperature. It was therefore the obvious thing to express the colour of the light by a temperature value. We thus speak of the colour temperature with the Kelvin degree as the unit of measurement.

The scale of these Kelvin degrees begins at —273° C. A black object,

hollow and cooled to this absolute minimum temperature, would thus be at zero degress Kelvin in its light-proof interior. Utter, absolute, black pitch-darkness.

The warmer this "absolute black body" becomes, the higher rises the number of Kelvin degrees. Now this black body of the physicists is only a concept, not a thing to be carried about in one's trouser pocket where (the temperature being at about 98° F., i. e. 310° K) it would not be an ideal black body any more.

But joking apart. We have designed so-called colour temperature meters with which we can determine accurately the number of Kelvin degrees at any moment. Sunlight between 9 a. m. and 3 p. m., for instance, is generally absout 5,800° Kelvin. Therefore, daylight colour film is sensitised for a mean value of about 5,800° Kelvin.

In place of the expression of the light colour in Kelvin degrees the designations mired (= *mi*cro-*re*ciprocal *d*egree) and decamired have recently gained ground. The mired is found by multiplying the reciprocal of the colour temperature by one million; a decamired = 10 mireds.

The simple expression in decamireds is a more practical indication of the power of the conversion filters than the calculation in Kelvin degrees because within the region of low Kelvin degrees (1,800° K – 3,200° K) the light colours of two radiations differ far more at a higher range (4,000° K to 12,000° K). Thus the difference between 2,000° K and 2,500° K is 10 decamired. In the higher reaches of the Kelvin scale, however, a difference of 10 decamired corresponds to a colour temperature difference of 5,000° K (i. e. between 5,000° K and 10,000° K). In practice this means that a filter of 12 decamired alters the colour hue to the same extent whether you use it at 8,000° K or at 2,400° K.

It is customary to express the colour of conversion filters not only by the decamired value, but also with a sign:

+ *filters* shift the colour temperature of the light source towards red, i. e. they have a reddish hue. "+ 6" is therefore a reddish filter of 6 decamired.

— *filters* shift the colour temperature of the light source towards blue, i. e. towards higher Kelvin degrees. A "–12" filter is therefore a bluish colour filter of 12 decamired. Various filter manufacturers have chosen "R" (for red) instead of + and "B" (for blue) instead of –.

Quarrelling Seagulls
Picture page 67

A summer's day by the North Sea. Sun, wind, and clear skies. I was comfortably settled, thinking of nothing in particular, in my beach hut, reading. Suddenly I was disturbed by the ear-splitting screams of seagulls in my immediate neighbourhood, and they winged over the wall of my sand castle on the roof of the hut.

The Leica, although kept inside a rubber bag as a precaution against the drifting sand, was lying fairly handy by my side. It was also of some importance that somewhere in a corner of the hut I found half a slice of bread and butter. As quick as lightning I threw it on the sand about three feet away, and raised the camera to my eye.

The gulls immediately flung themselves on to the piece of bread, and thus into my field of view, tore the lumps from each other's beaks, and, screaming, fluttered about a great deal. I aimed my shots bang in the middle of this war-like scene.

During my holidays by the sea the camera shutter was to all intents and purposes permanently fixed at f/5.6, and $^1/_{250}$ second. It was the new snapshot setting for CUT 18 and good lighting conditions. All I had to do, therefore, was to focus the lens close up and press the button.

Incidentally, the certain capture of such fast-moving scenes (the movement of the gulls is, of course, quite incalculable!) is naturally to a large extent a question of the efficiency of the viewfinder. The bright luminous frame of the Leica M 3 made it easier for me to find my field of view (this is the reason why the rational English call this device "viewfinder" instead of the more pessimistic German "searcher").

Leica, 50 mm Summicron, f/5.6, $^1/_{250}$ second, August, 11 a.m., in *contre-jour* sunlight, Agfacolor CUT 18.

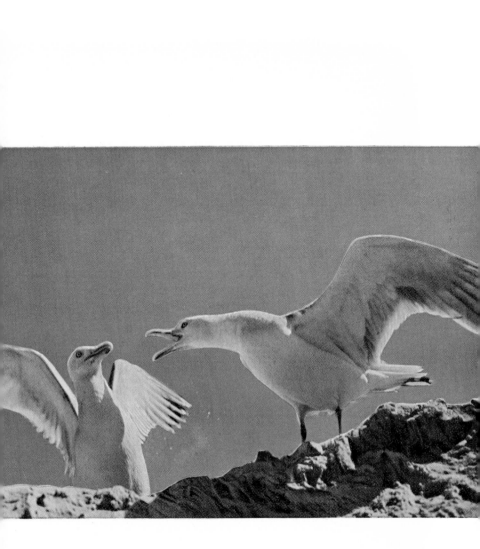

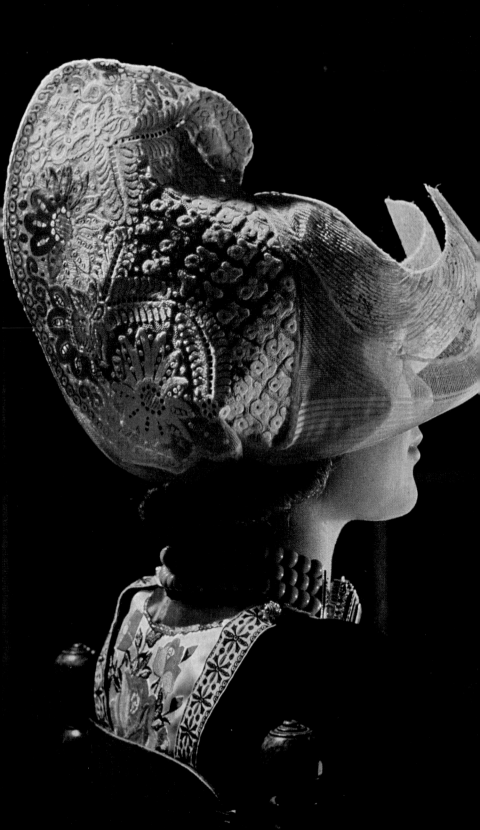

Dutch Folk Costume from Volendam
Picture page 68

To begin with, I must tell you that this portrait from the picturesque little Dutch town of Volendam on the Zuider Zee was not taken in a photographer's studio.

On a dull November Sunday I met the family of a Volendam fisherman having tea in their front parlour, mother and daugther still wearing the old, enchanting folk costume. I was lucky to have brought my electronic flash along in order to be ready for anything, because the available daylight was too poor to permit more than a photographic "tour de force". Outside, however, the wind blew in gusts and it rained – no weather for taking portraits.

If I had lit the young girl with only one flash lamp, frontal or obliquely frontal illumination would have been almost the only feasible proposition. However, as I had an extension flash head, I was free to abandon frontal lighting completely and to play with my lights. I could also avoid the flash coming directly from the Leica picking out the window-frame in the background.

First I removed the main light from the camera, connected it with the longer synchro-cable and flashed it into the girl's face directly from the right, hardly more than 3 feet away. A second assistant balanced on a quickly procured ladder, so that a second flash gave a delicate, oblique glancing light from the very top. Of course, this flash was a little further away, although no more than $4^1/_2$ feet.

The guide number 32 of the Hobby Flash would have required f/16 with the lamp in a frontal position. However, reduction in the light intensity caused by the distribution of the light over two lamps had to be compensated by opening up one stop, i. e. by using f/11.

At any rate, I am delighted to be able to prove with a practical example that if you use an extension flash head you can do without the usually somewhat harsh and crude frontal light, and that the possibilities of varying your flash combinations are very numerous.

Leica, 90 mm. Elmar, f/11, $^1/_{50}$ sec., Hobby Automatic with two flash heads.

You will now also understand why pictures taken at home in the light of chandeliers or standard lamps on colour films sensitised for sunlight always look so yellow. For normal incandescent lamps have a colour temperature of only about 2,600° K to 2,800° K. In order to reproduce the colours in your own home correctly on a daylight-balanced colour film, an illumination of a higher colour temperature would first have to be provided. And this is one reason for the great popularity of electronic flash units which, with their sunlight characteristics, permit the continued use of daylight colour film in the evening at home.

Or, alternatively, we buy the well-known photoflood lamps (the household fuses must be strong enough, or else!!!) which give a colour temperature of about 3,400° K. This is the value for which the artificial light type A colur film is sensitized; at present it is only available as a reversal film. However, if you insist on using daylight film even in this light, you will have to use a conversion filter which adapts the film to the lower colour temperatures (p. 88).

In order to determine which filter should be used in any given case a colour temperature meter is extremely useful. Such an instrument –

together with a set of correction filters in the hands of experts and discriminating amateurs – appears to me to be a fine thing.

In 90 per cent of all cases we will be able to manage with this rule-of-thumb: daylight colours films should be used in daylight, with electronic flash, and blue-tinted flashbulbs, while artificial light colour films should be used with yellow-tinted flashbulbs, photoflood lamps, and ordinary incandescent lighting.

To conclude our excursion into the theory of colour, I would point out that although the scientist, by means of his Kelvin degrees, describes blue as hotter than red, we should, in our amateur language and as our fathers did before us, call the luminous red warm, and the blue sky cool. This is more in keeping with what our common-sense tells us.

The "Warm" Emulsions

We are justified in describing such colour film as e. g. Agfacolor and Anscochrome as having a "warm" tendency which in its colour rendering adapts itself more to the subjective colour perception of the human eye. In other words: In these emulsions this warmer tendency has been deliberately encouraged, and the reproduction of blue repressed because otherwise filters would have to be used during a considerable

part of the day in order to avoid an excessive blue rendering and thus an unatural appearance of the results. It is an established fact that colour films with a warm tendency can be used even during the hours of noon between 11 a. m. and 1 p. m. almost without compensating filters except for exposures at high altitudes.

Although I appreciate very much the exact determination of the colour temperature and the appropriate choice of certain filters for colour photographs, I fear that taking them ceases to be a

pleasurable pastime, a hobby, if we pay too much attention to these corrections. This also has the direct result of a considerable slowing down of the exposure as such, since we lose too much time over choosing the correct filter. I am aware that this point of view is arguable in the face of the almost touching humility with which many of my friends in the States carry three, six, or more filters about with them – but hardly enjoy their photography any more.

I would therefore give you merely the basic advice of carrying only a skylight filter in addition to your haze filter; other, stronger pink filters should only be tried if this appears essential.

Beware of colour cast! Talking about these "compensated" colour emulsions it must be admitted that the clear advantage of the suppressed rendering of blue can turn into a slight disadvantage in the light of the setting sun, when the light itself will become so warm that the inherent tendency of the film is reinforced. Therefore, Agfacolor photography practically comes to an end two hours before sunset, unless we are willing to accept rather yellow pictures and "Red Indian" portraits at late hours.

Naturally, a yellowish-red character is very popular in some photographs, such as pictures of Alpine glow, auroras, or sunsets. However, it is essential that the cause of such colours should be in evidence, even if its only indication were the length of the shadows characteristic of a late hour of the day.

Conditions are quite similar early in the morning within two hours of sunrise. Nor does this blue suppression of Agfacolor mean that we are protected against any kind of blue reflections in our pictures. Suppression does not therefore mean cancellation, because otherwise we would be very sorry if we had to do without the beautiful, blue-dominated shadows in our snow pictures.

You may have noticed that up till now I have avoided, as far as could, the ambiguous term of "blue cast". Basically, everything we generally call blue cast is a reflection. However, the terminological confusion, is too great for me to attempt a solution single-handed. If, therefore, I gave the next chapter its correct title "the blue reflection", later on a thousand helpless readers would look in vain for remedies for "blue cast". I give in, then, and follow the common usage.

The Blue cast

The most frequent, prominent, and hence unpleasant of all "casts" is the blue cast. It mainly occurs during the summer around midday; particularly whenever pictures are taken in the shade under a cloudless sky when the blue sky is practically the sole light source instead of the sun.

I am writing this, trying hard to remain as clear and lucid as I can in a hotel bedroom at Florence; it is the end of March, and compared with our Western climate the temperature is almost summer-like. My room faces a courtyard, full of noisy children. They are playing in the shade. At this time of the year the sun does not yet rise very high in the sky, and in spite of the midday hour does not reach the courtyard. Only for fun and without any photographic intentions I just hold my colour temperature meter against the blue sky as the effective light source for the shady yard. The result: 9,000 ° K. A considerable imposition on a film sensitised for about 5,800 ° K. In spite of this difference I would risk the exposure of the shady yard without correction filter if only it were more attractive photographically. The blue cast present would still be quite tolerably compensated by the colour film, and the saturated red and brilliant yellow of the blouses and frocks would im-

prove matters further, as in fact even bluish pictures can be improved by such colours effects.

If I sat here in July, my instrument pointed at the sky at 12 a. m. would give me a reading of about 18–20,000 $^\circ$ K, and I should certainly have to give up any attempt at colour photography.

But wait a moment – opposite my window rises a high, white wall of a building. Now during March the sun can light only part of it; nevertheless, the reflection is already strong enough to dazzle me. However, I guess that if the sun stood higher the entire wall would be lit up. Most probably a powerful white reflection from direct sunlight would add so much warm light to the blue shadow that a picture of the courtyard would be worth-while.

My apologies for this excursion, but these examples help us solve, I believe, the following question more easily.

The cloudy sky

To begin with, you must distinguish between quite different types of cloud (or cloud cover). There are white and grey clouds, partial and full cloud cover, cumulus, cirrhus, and hazy clouds. They may, or may not, obscure the sun. In each case they change the colour of the daylight in an different way.

Clouds can also play havoc with your exposure measurement. Exposure readings taken only a moment ago can become invalid owing to a sudden change in the cloud situation.

Ideally, white clouds (called cumulus, fair-weather clouds) cover large parts of the blue sky, when the colour of the light will be precisely that for which all the daylight colour films are balanced. There is no risk of blue cast. The colour temperature of daylight will then be about 6,200° K.

Cirrhus and cirrho-cumulus cloud, too, cover parts of the blue sky and reduce the blue proportion of the total light.

Isolated clouds that cover the sun directly hold back the sunlight; as a result, the predominantly blue sky light becomes effective, when the colour temperature may suddenly shoot up to 8,000° K–12,000° K and cause a blue cast.

Under an slightly hazy sky direct radiation from the sun is weakened.

It can generally be assumed that the more white clouds are in the sky and the larger the areas of the sky that take part in illuminating the subject, the better are the shadows lit and the contrasts reduced. The sky acts like a huge reflector screen.

Grey clouds covering the sky partly or heavily reduce the risk of blue cast like white clouds. Without direct sunlight the colour temperature is about 6,800 ° K to 7,000 ° K. Since illumination with diffuse sky light reduces object contrast you may have to increase the exposure of colour reversal film by opening up $^1/_2$ a lens stop.

Hazy weather

Colour photography is also possible in hazy weather. The light is absolutely ideal for close-ups, especially portraits. No softening is required since there are no shadows. But there is no modelling, either. The slightly bluish rendering of the distance, if at all visible, or of the background can be quite welcome. Excellent autumn pictures with real atmosphere come to mind, with isolated trees in glowing colours standing out against the grey-blue veil of haze in the background. Here it would be wrong to destroy the tendency to blue with correction or conversion filters. This can also apply to long-distance views, with the result of a characteristic graduation of near and far objects (aerial perspective).

In hazy weather object contrast is very low. Colour reversal film must always be given *more* exposure than the meter indicates. The increase may be up to $1^1/_2$ lens stops. It must be the larger the lower the contrast. On the other hand, you can use the meter readings without modification if you have taken them direct and close-up (e. g. of a face in portraiture).

Fog

A foggy atmosphere can be very effective. Obviously I do not mean what the long suffering British city dwellers call smog and which forced them to abandon their cars by the kerbside and to grope their way along the walls to the nearest tube station –luckily a thing of the past since the introduction of the Clean Air Act. Although fog with a certain

amount of translucence appears largely monochrome, i. e. of a single colour, it can produce extremely attractive colour pictures. The effect of depth in the subject becomes very striking through the gradual disappearance of the contours towards the background, particularly in street scenes. A clearly visible foreground is therefore essential. If you succeed in producing accents in colour such as traffic lights, railway signals, or car headlamps in the foreground, the pictures will become even more striking because of the contrast between a strong colour and the subdued grey in the depth.

Focus deliberately on the foreground; sharpness may fall off towards the background. Telephoto lenses can therefore be used with great success, even at fairly large apertures. The exposure must in any case be more than the meter indicates, because the lighting contrast is almost completely absent. The increase may have to be up to 2 stops. It should be borne in mind that these exposure increases apply to reversal film only; negative film may be given less exposure.

Very beautiful effects can also be obtained while the sun is breaking through the fog. Here contre-jour lighting is the most beautiful.

The diffuse light in fog has a decidedly warm tone. There is no risk of blue cast because the fog particles hold back the blue portion of the light.

Aerial perspective

Aerial perspective is the falling off of the picture contrast as the distance between the camera and the various picture elements increases. It is caused by atmospheric effects as well as pollution by dust particles. We therefore often find a very strong aerial perspective in industrial regions, whereas in the country after heavy rain it is almost non-existent. (It can also appear in the paintings of the Great Masters). It would be wrong to try to correct it with filters, even if the distance appears very blue.

Remedies Against Colour Cast

When we were talking about the midday blueness in the shade, I mentioned how bright reflections from a white, sun-lit wall can be of help. The rôle of white cumulus clouds, too, as huge reflectors was emphasized. Applied to more confined spaces, this experience means that

a large, spread-out table-cloth can work wonders. We have it arranged as a mirror of the sunlight so cleverly that our subject will be lit up very strongly, without, however, the table-cloth itself becoming part of the picture.

During work in the film studios such sun reflectors are used very often. They consist mainly of large sheets of plywood, covered with silver foil, on special holders which can be turned in any desired direction and fixed at any angle. The larger the surface, the stronger, of course, the effect of the reflection. The closer the mirror is held to the subject, the more intensely will it be lit up. We can easily perform the little experiment ourselves by, for example, placing a person in such a position that, although the face is in the shadow, a book or a newspaper on the lap is in full sunlight. The closer the brightly-reflecting surface approaches the face, the more intense will its effect be. Generally, a noticeable difference will already be achieved with a newspaper at a distance of about 20 inches.

I learned most about the practice of softening heavy shadows and gained a lot of experience shortly after the end of World War II. At that time, in Germany, everybody scratched for a living as best he could. As I had been bombed out, I lived with my whole family in an small village in the Black Forest, where the poor remnants of a once formidable photographic array of equipment also found refuge. This consisted of a Leica of considerable age – it is still in perfect working order today – a developing tank, and a manual-focusing enlarger. (The story of how these "basic means of subsistence" survived the chaos of the first post-war months, carefully soldered into tin boxes, buried in the soil for 4 months, would be too long, nor does it really matter in this context.) During the years of 1945 and 1946 I visited the farms of the Black Forest with my Leica, taking family photographs. Not so much for the family album but because a photograph was essential. However, in order to be able to travel to the nearest town where there might be a chance of obtaining such a likeness, you had to have an identity card. Otherwise the journey could become very unpleasant in view of the numerous controls and checks. It was a kind of vicious circle. The farmers, most of whom lived far from anywhere, were visibly pleased that the photographer himself came into their house, and they and the other members of their families dressed up solemnly for every passport photograph. I have taken many a bad picture in my life, but these beat the lot. For I had to work with long out-dated pre-war films and without any aid of photoflood lamps; into the bargain I had to enlarge on to paper of the same vintage with grey fog along the edges. The lighting difficulties were grave, because it was not always summer, and it often rained. This made me think of how to solve the problem. The first solution was a file cover with a silver paper covering, which in the absence of direct sunlight brought at least a little more brilliance into my dull, grey peasants' faces by reflecting the brighter sky. Later on, I built a reflector of thin plywood, which could be folded up from all four sides, was also covered with silver paper and could easily be strapped to my latest acquisition, a second-hand bicycle. The silver paper came form a few bars of chocolate, received from some French soldiers in barter payment for a few "full length portraits". You see, photographs, too, can serve as a kind of currency.

Sunlight indoors

I also photographed weddings, and when there was sunshine outside, my artistic temperament began to stir. The "sessions" generally took place in the not-very-light parlours, since in front of the door (what with dung heaps and all that) the background was mostly less decorative, and any wind would have disarrayed the laboriously arranged hair-do's and veils of the rustic brides. So I succeeded, with the aid of the eager youngsters, very ingeniously, in smuggling sunlight from the window or even from inside the window or even from inside the house into the front parlour.

At least bride and groom could thus be presented in a favourable light. The effects were reminiscent of Rembrandt!

I hope that this story from the first post-war years has explained to you the value of softening the shadows sufficiently. Beyond question in colour photography we are even more in need of this trick, because every softening of contrast results in an improvement of the colour rendering, especially in the shadows.

Harsh light at noon

Nobody, not even a photographic novice, would attempt without a qualm to take a portrait in a room with a single glaring lamp high up under the ceiling as the only light source shining on the sitter. This

dreary top light is all too reminiscent of railway station waiting rooms, not the most inspiring places to be in at the best of times. In this harsh light that conjures gloomy shadows under your sitter's eyes, not only you, photography itself will not be at its best.

To compare a single lamp high under the ceiling with the sun high in the sky may be a little far-fetched, but when at noon on a summer's day the shadows become shorter and shorter, we also speak of unfafavourable, harsh light. This applies especially to Southern countries, where, however, the very bright surroundings such as sand and white-washed walls act as shadow softeners. But then the heat will be very uncomfortable.

What, then, can you do with your camera at this time of the day? Not very much. I'm afraid, it is best, particularly in the South, to take forty winks. The streets will in any case be deserted because the locals are wiser than the tourists. They are asleep and won't emerge from their houses much before 3 p. m.

It is best to postpone all your photographic plans until after 2 p. m. This will still leave you another 4–5 hours for taking photographs in progressively softening light. And if you take advantage of the early hours of the morning, you will also have excellent camera light between 7 and 11 a. m.

Flash as shadow softener

Although I want to reserve a whole chapter on flash for answering most questions about this light source on p 136, I want to point out here that flash light is a very proper means of softening the shadows and the object contrast. Naturally the flash light must match the colour film on the market. For our daylight reversal film only electronic flash and blue flashbulbs are suitable, whereas untinted flasbulbs at a colour temperature of 3,800° K emit light of too yellowish a colour.

However, even the types of flash of suitable light colour should be used for softening (or "filling in") with moderation so that their effect is only slight and the shadows are not swamped.

Here you must follow the old rule which says that fill-in flash is succesful only when it is completely unnoticeable in the finished picture, the difference becoming apparent only during comparison with a picture without supplementary flash.

It is essential above all with contre jour to make certain that the character of the illumination is not destroyed. Which reminds me: Contre jour does not gain all that much from supplementary flash. Shadow softening in daylight anyway is effective only within a radius of 4–5 yards. Flash will therefore be suitable mainly for filling in with portraits and group photographs.

Filters

Filters play a much greater part in amateur black-and-white than in colour photography. The number of words expended on the significance of the correction of colour films through filters is in my view quite excessive. Advisedly I did not choose the term "colour filter" to head this paragraph: the few really important filters for amateur colour photography are colourless or very nearly so. As for the rest, the colour filters you are familiar with from black-and-white photography, such as yellow, green, orange, and red, are in any case ruled out as taking filters.

Let us to begin by taking note that the Agfacolor film generally requires no filter for ordinary daylight. You have by now read a good deal about the composition of the light; we mentioned the partly cloudy sky with direct sunlight as producing the ideal colour rendering. The amateur who does not use a colour temperature meter is advised not to experiment with any number of different filters, but to use his camera at the time when the spectral composition of the available light is most favourable. Please bear the following points in mind:

1. Use filters only when you anticipate a colour cast. It is to be expected at high altitudes in the mountains, as well as at sea and on the beach at noon, and with subjects in the shade under a cloudless sky; and when a solitary cloud obscures the sun, and the blue of the sky is more or less alone responsible for the illumination.

2. Any overfiltered picture is worse than its unfiltered counterpart. When in doubt, make one exposure with, one without the filter. Such comparisons, incidentally, provide practical experience.

3. If daylight colour film is to be used in artificial light, or artificial-light colour film in daylight, a conversion filter of a suitable colour is indispensable. However, before the amateur enters this filter "jungle", it would be better for him to use the appropriate types of colour film for daylight and artificial light respectively. This also has the advantage of ruling out filters factors with their sometimes considerably longer exposures.

The term "UV-absorbing filter" does not tell you the whole story, it should be supplemented by the reassuring word "colourless". For there are also filters against the invisible ultra-violet radiation for use with black-and-white films; these are not colourless. Haze filters have an effect equal or similar to that of the U.V.filter. I might mention on this occasion that it is not the thing to do to speak of the invisible ultra-violet light, but always of the invisible ultra-violet radiation.

U.V. filters do not call for more exposure, this is why they are so practical. For the same reason they can be left in front of the lens even when there is not the slightest trace of ultra-violet radiation about. Their effect will then of course be nil, at any rate as filters. But they do prevent dust, water droplets (rain, seawater spray) from settling on the front surface of your valuable camera lenses.

However, you must never forget to remove your U.V. filter whenever you photograph straight into strong light (setting sun, night pictures including arc lamps, circus and variety shows) in order to avoid any reflections it might cause.

The UV filter comes into its own not only at altitudes above 6,000 ft; UV rays will be present in the plain when the weather is very clear, and above all by the sea. And since here you are exposed to sand and water anyway, do not venture there before you have this filter safely in front of your lens.

You might object that I am contradicting myself here since I told you at the beginning that in normal light Agfacolor film can be used without a filter. But I trust that you have by now realised that the UV filter is an exception.

A word about the haze filter, which I said has the same effect as the UV filter. This is so only if it is completely colourless. However, if it appears slightly pink when you look through it, it will have the characteristics of the so-called skylight filter, which generally has the designation R 1.5 or 1A. It is also called pink filter. It is indeed very weakly pink, but its effect is greater than you might expect of this modest indication of a warmer colour rendering. Exactly like the UV filter, the skylight filter absorbs UV, and is also a valuable protection against dust. However, in addition it counteracts blue cast in the shade and the general tendency towards blue around midday, partic-

ularly under a sunless blue sky. Now you might want to know why there is all this fuss about the UV filter, since the skylight filter, too, is almost colourless, suppresses UV radiation and visible blue *and* affords protection against dust. Well, with average subjects I find the skylight filter a little too warm for Agfacolor film. This is *my* taste. Yours might be different. To make sure, take comparison pictures at various times of the day, with and without the skylight filter, which, anyway, should be part of your outfit.

"Cold" and "warm" lenses

The effect, by the way, of these filters varies individually. The reason for this is that some lenses render the colours "colder", others "warmer", because according to the number and type of their components they absorb ultra-violet rays to varying extents. Mostly these differences are apparent only if a camera is used with interchangeable lenses.

Many an amateur has been working for years with his "Elmar", "Tessar", or "Xenar" without the slightest idea that these four-component lenses belong to the "cold" types which respond particularly well to the use of a UV-absorbing filter. Others, for example those owning a Leitz Summicron, have a "warm" lens without being aware of the fact. The high-quality elements pass much less UV radiation. In spite of this inherently welcome property – in popular language we could almost speak of a built-in UV filter – my pictures were never the worse for being taken through a UV-absorbing filter even with this lens.

You may be interested to know in this conncection that all my lenses are permanently fitted with UV-absorbing filters. Not by any means out of fear of Ultra-violet, the Invisible, but in order to protect, once and for all, their highly valuable and vulnerable front elements from any possible damage. It simply must be accepted that the glass is very easily touched by mistake, and a finger mark is caused. With care it can be removed with a very soft cloth, just as dried-up water marks, and any possible deposits of dust are removed from time to time with soft chamois leather or a sable brush. As long as this is done gently, you need not be afraid of causing any damage.

But I believe that the way I proceed during a quick interchange of len-

ses is not always correct. In order to waste no time, a lens will occasionally slide into a trouser pocket to join company with a bunch of keys and loose coins; in such a case the UVfilter permanently screwed in is an ideal window, behind which the precious eye of my camera is protected as in a glass case. After all, such a UV filter is much cheaper than the repair and the repolishing of a lens.

You see, I even photograph with a guard against UV when it is not necessary.

The polarizing filter

I now want to talk about a special filter, which is not essential, but has such interesting effects that it merits detailed description. If you want to use and to take full advantage of what it has to offer you need a little practical experience. The whole secret of the polarizing filter (the term polarizing screen is scientifically more accurate) is that it removes reflections from shiny surfaces (except polished metal) – i. e. it extinguishes them. Examples of such surfaces are water, glass, plants, varnish etc. Removal of these reflections is more or less complete depending on the angle of incidence of the light, and the curvature of the surface. Why? Because these reflections consist of polarized light, which in its plane of vibration behaves differently from nonpolarized light. The polarizing filter stops polarized light, but lets nonpolarized light pass through.

Most probably we need a detailed explanation in order to understand this phenomenon. However, my passing mention of the properties of polarization is merely meant to jog the memory of all those who paid attention during physics lessons instead of shooting paper missiles at their classmates with rubber bands.

Luckily even those who happened to be away from school at the time will be able to recognize the action of the pol-filter plainly without knowing anything about the physical process involved. All you have to do is to ask your photo dealer to demonstrate one to you in front of his shop entrance. The reflections which are always present in the shop windows – which make us walk up to them more closely during daytime in order to see the display without disturbing reflections – are extinguished if you look through the pol-filter. Rotate it slowly round

its axis, as you would a genuine cut diamond you wanted to examine for its "fire".

However, you will experience this phenomenon of extinction only at a certain angle. You must stand on one side. The removal of reflections from specular surfaces is only one of the visible effects of the polarizing filter, which is also eminently suitable for the removal of blue cast – or, here more accurately blue reflections. After all, the open sky reflects its blue light on to flowers and leaves, meadows and fields, shrubs, woods, tiled roofs and streets. As with a magic wand the polarizing filter can eliminate all these reflections and restore their original colour to these objects. Fortunately you can observe its effect directly by looking through it – which you cannot do with the correction, UV, and skylight filters. Rotate the polarizing filter around its axis until you observe the maximum effect, and place it on the camera lens in this position.

"Dramatized" sky

Blue sky, too, is partially polarized in certain regions of the sky as you can see by looking through the polarizing filter. This filter can thus also be used for rendering the blue sky darker; above all this shows up the clouds much more effectively. The clearer the atmosphere the stronger the contrast. It is at its strongest when the portion of the sky in the picture is at right angles to the sun. Again, look through your filter and rotate it till it shows maximum effect. If you find extinction excessive,you can reduce it simply by rotating the filter for less than maximum effect. The mounts of most polarizing filters, by the way, have figures engraved which make it easy to transfer the filter from the visual position to that on the camera lens without its setting being disturbed. If you are the owner of a single-lens-reflex camera, you will find work with the polarizing filter considerably easier, because you can observe its effect directly through the lens simply by rotating the filter in front of it.

Obviously you must reset the polarizing filter every time you change the direction of your camera or change from vertical to horizontal views and vice versa. This is sometimes overlooked with viewfinder cameras.

Increased exposures

Since the polarizing filter absorbs much light, naturally the exposure must be increased beyond what the exposure meter indicates. Depending on the type of filter, the factor varies between x 2 and x 4. It will be stated in the operating instructions accompanying the filter. Generally an increase of $1^1/_2$ stops will be adequate. If you forget to increase your exposure, which can happen easily, you might obtain, in certain conditions, the most beautiful night effects as in moonlight. If you want to enhance this night character further e. g. a white building in front of a dark sky, give even less exposure than that indicated by your meter. At two lens stops smaller the sky becomes blue black.

Reflections are not always disturbing

At the beginning I described the property of the polarizing filter of extinguishing reflections from specular surfaces. I should like to enlarge this remark by saying "disturbing reflections", because evidently you cannot want to eliminate reflections completely in each and every case, because the picture might easily lose some of its brilliance. The removal of reflections from sheets of water can go so far that you can see the bottom of whatever it is that the water covers. This may be welcome with a goldfish pond, because you can at last photograph the beautiful fishes in their enchanting colours. But when you turn the polarizing filter to full effect on the blue Mediterranean the sea will suddenly appear unnaturally green. Likewise, the extinction of highlights dancing on the water, which in any case is always only partly successful, will rarely be welcome. On the other hand, you will appreciate your polarizing filter when you photograph water lilies, especially because the usually strongly blue-cast leaves will have their own colour restored to them. Here, too, the filter is an excellent "colour-cast eradicator".

The conversion filters

Unlike the almost or completely colourless correction filters discussed so far, the conversion filters are true colour filters. The power of a filter to convert a light colour (the conversion power) increases with the strength of its colour. Very strong blue filters are thus able to convert the red-yellowish light of photofloods, so that it is possible to use daylight colour film. Weaker conversion filters change the reddish daylight of a sunset into "midday light" – should such a conversion ever be necessary. However, the difference between the various filter colours is not stated in Kelvin degrees, but in mireds. You will find the reason for this in the chapter on colour temperature.

The + conversion filters are available in the grades R 1.5, R 3, R 6, and R 12. The weakest of them, R 1.5, I classified on purpose among the almost colourless correction filters, but as a member of the conversion filter series it is useful for combination with the stronger filters. Thus, if filters R 1.5 and R 3 are screwed together, their combined strength will be 4.5. You will perhaps see that playing about with these conversion filters can easily turn into filter-mania, and you would soon be completely lost without a colour temperature meter. Unless you are a "very serious" amateur I can only repeat my advice to be prepared for no more than an occasional change from daylight- to artificial-light colour film. As far as colour negative film is concerned, you can in any case forget all about conversion filters, the colour printing station will relieve you of any worries you might harbour on this score.

At the end of my discussion of conversion filters I must remember to point out that every filter should, if possible, be screwed into the camera lens. Filters in push-on mounts may have the same effect, but they usually rule out the possibility of attaching a lens hood as well. Which presents the opportunity to talk about a very important requisite of photography.

A few words about the lens hood

We all know that the lens hood is used in order to protect the lens against stray light rays not emanating from the subject; otherwise light directly entering the lens might spoil the picture. This naturally applies also to artificial light and flash exposures. Yet another incidental function of the lens hood is the elimination of side light, which mischievously tries to enter our lens even from outside the field of view of the camera. It is not necessary to establish this fact physically, as it is a frequently experienced and often lamented occurrence.

Even pictures made in full front light without a lens hood could yield weak results with distorted colours. This happens especially easily in snow and beach scenes, because "stray light" (I know no better description) plays havoc here. Thus, in the absence of a lens hood, we will not only obtain flat pictures, but also lack of sharpness caused by "illegitimate" refraction of rays inside the lens which are not involved in the formation of the image.

Moreover, the lens hood guards against raindrops, splashes of water, snowflakes, etc., and also reduces a little the unavoidable deposition of dust on the front element of the lens.

Admittedly, the lens hood is yet another gadget to be tucked away here or there in the heat of battle if it is no longer needed. I am no better than my small son, whose pockets, every night, disgorge pieces of string, pocket knife, pencil, and pennies, except that with me the list of contents includes a lens hood. Where on earth can one put it, if the ever-ready case can not close when the thing is stuck on the lens?

Leitz have devoted a lot of thought to the problem, for which they have recently found a really ideal solution. The lens hood is fitted with spring-loaded tongues which after light finger pressure engage in the front rim of the lens so firmly that the whole Leica could be picked up by the lens hood if you were so inclined. After use the handy little gadget is simply turned round and pushed over the lens like a slouch hat. Thus, we are at long last able to accommodate our universal and essential metal tube in an ever-ready case.

Naturally you need not stop taking pictures because you have forgotten your lens hood, although I have prophesied flat and unsharp horrors. A house doorway, the shadow of a tree, an umbrella, and in an emergency, even a hat or the hand of your companion held above

the lens can take the place of the lens hood – but all these remain only makeshift measures. And you must take good care that the makeshift measure does not appear in the picture!

Memories of Dr. Paul Wolff

Hitherto I have tried to create the technical basis for your own practical colour photography. I have chosen this sequence with some forethought. For what use to you would all the advice for better (better in the sense of "original viewpoint") pictures be in the following chapters, if you were not sufficiently familiar with terms such as colour cast, reflected light, exposure measurement, and contrasty lighting?

When I began to take photographs some 35 years ago, I wanted to reach the top quickly – in double-quick time! I admired the "big shots", was fascinated by the pictures of Paul Wolff, made the round of all photographic exhibitions within reach, swotted through books and, of course, had a strong urge to become just as good in the shortest possible time. I watched and was amazed, as one is amazed about a balancing act in a circus, at whose seemingly playful weightlessness we forget too easily the amount of work, training, and knowledge involved in its complete mastery.

Thus my first pictures were bound to be disappointments. The first ones? For years and years I pushed the button in my own sweet way and was, indeed, for a long time convinced that lack of basic knowledge could be made up for by a more expensive camera. I thought it would be enough to give my pictures a personal note by simply taking them lying down on the ground instead of from the usual eye-level. I used a red filter, because I had seen impressive photographs in which white clouds towered into a pitch-black sky. The attempt to save the completely underexposed negatives foundered in the incorrectly made-up intensifier. I visited places where someone else had made good pictures and in despair looked for the viewpoint of my successful predecessor, without a clue that the position of the sun and the season were against me. I considered the lens hood a troublesome precaution and proudly dispensed with the tripod at one tenth of a second, because I had hit several bull's eyes at a shooting competition. In short, my memories of that period show with painful clarity a very

precocious and rash novice of photography. That I was on the wrong track I learned from Paul Wolff.

When once I showed him my pictures, he patiently explained to me all my mistakes without, however, discouraging me.

Abroad with Paul Wolff

On another occasion, on a cruise togehter, I served him as a caddy, as it were, like a little boy carrying golf bags with different clubs after his master. Of course, I was pleased to be able to do this, because during the daily contact with his work I could learn a lot.

On this trip Wolff had a clearly defined task. He took black-and-white and colour photographs of the life on board and during shore trips from our ports of call. We took the little Chinese boys in the ship's laundry by flash, immortalized beef carcasses on film, shivering in the deep-freeze compartment, and, pestered by flies, picked our way warily through Eastern bazaars, grateful for every spot of cooling shade. We stood by the quayside in the black of night, in order to photograph the white liner framed in light, at six minutes' exposure time; the glowing cigarette was our only light source for setting the stop or looking at our wrist watches. My alarm clock would rudely awaken me from my dreams at 6 a. m., because Wolff wanted to be the first ashore, as the way to Castello X was far more comfortable with the sun still low.

Of course, everyone on board ship soon knew who the prominent passenger was, and I did my best to polish his halo even brighter, basking (without any right to do so, I am sure) a little in his reflected glory.

During our work we were constantly surrounded by a crowd of enthusiastic holiday makers with cameras. But, of course, it was the more active amateur photographers on board who were particularly interested. They were fascinated by our activities, and more than once I was pumped for detailed information about stops and exposure times. Naturally, they also nibbled at our subjects.

However, everything depends on the man behind the camera. The following example, which occurred again and again, is an amusing illustration of this.

In the "script" of our cruise we had picked a scene which repeated it-

self every morning as the symbol of relaxation and the comfort of a pleasure cruise. About 11 a. m. a steward appeared on deck in a snowwhite uniform serving dainty, appetizing sandwiches on a large tray. He was followed by a colleague with iced fruit juices the mere sight of which made you gulp thirstily in anticipation. The passengers, however, were lazily reclining in their deckchairs against the background of the vast, blue sea.

Without much understanding at first I followed Wolffs' method of preparing his pictures. At least half a dozen times he would step back, checking everything through the viewfinder, judging picture area and colour distribution. Here a chair was moved a couple of inches, there a colour distribution. In the background a ship's officer, specially detailed by the Captain as a "model", talked with passengers and had to step back a little in order to reveal the name of the ship painted on a lifebelt. Or the steward, with softly tinkling glasses, bent a bit lower still to a deck chair, because otherwise some feature in the background would appear to grow out of his head. Also, the hand of the model being served with sandwiches and slowly warming fruit juices was raised in an expectant gesture. Even the position of the plate was changed: "a bit further over, just a little more, hold it now!"

I suffered in silence and watched apprehensively a cloud which threatened to darken the sun just at the vital moment. But nothing would disturb Wolff. When he had finished his pictures and thanked his sub-

jects for their general co-operation with a few friendly words, the others, the photo-poachers, had long walked away with several photographs in their cameras.

On board there was not only a staff photographer, but also a assistant who had to develop and print the amateurs' snaps. Often at night I sat with him in familiar surroundings, wreathed in the well-known darkroom smells which, worse luck, during rough weather drove me to the railing more than once. Nothing encourages seasickness quite as much as a rolling, badly ventilated darkroom!

Well, this was my opportunity of having a look at the photographs of the others. Here it dawned on me why Wolff carried out his work with such meticulous thought. His pictures, which later appeared as the best advertising photographs of the Hamburg-America Line, were, from the viewpoint of his, but only his, camera, perfect and balanced to the last detail. But everything that the others took to the right or to the left of him or even over his shoulder, although it represented the same scene, often showed disturbing intersections or perspective exagerations. Naturally, the harmonious distribution of horizon, sky, the sea, and so on, also differed widely.

Here you might object that such scenes, posed with much effort and patience, have little to do with live snapshots which the amateur loves. But please do not forget that these were commissioned pictures in which in a lively and pleasing form everything was to be seen that the future ship's passenger had a right to expect of a pleasure cruise. (And because it is sometimes so difficult to achieve effective publicity with objective photography, many advertising agencies retreat into commercial art, because this permits beautiful simplifications.)

Not all Paul Wolff's pictures took so long to create. Often he saw the right field of view without looking through the viewfinder. The camera still hidden behind his back, his decision was already made about viewpoint, vertical or horizontal picture. With the utmost concentration he quickly pounced with his Leica. Watching him at work you realized that he had gone through a good (and hard) school!

Wolff, by the way, used to be a medical practitioner in Alsace. Not until after the first World War did he become a photographer, and soon made a good name for himself in Frankfurt-on-Main, his new home, with pictures made with large plate cameras – and great physical efforts, because exposure material and equipment in those days were really heavy. It is one of the strange coincidences that the Grand Old Man of the Leica achieved results with as large camera, which one day earned him a Leica as a competition award. At first (it was in the year 1926) he did not take the "little thing" very seriously, and used the Leica only as a "scrapbook". The idea of expecting his fastidious customers to accept Leica enlargements instead of contact prints from plates did not occur to him. Nor was it, in those days, technically possible with the films available.

Only a few years later did the photographic industry produce fine-grain films of considerable sharpness, and the term Leica film, still in use for 35 mm. material today, was created.

The technical basis was thus established – and the rapid rise of Paul Wolff began. At long last, the laborious approach of the old-time photographer was a thing of the past, and he was really able to go after his subjects with his camera. The live Wolff photos introduced a new style.

It is Dr. Paul Wolff's great merit to have discovered "photography without shackles" and to have spread it far and wide. Heavy cases of equipment and sparing use of material gave way to the miniature camera in the trouser pocket und the successful attempt to approach difficult subjects gradually by means of exposure series. And the best picture from such a series was the fascinating, exuberant Wolff photo. A technique which even today has not yet seen any basic improvements.

From Button Pushing to Photography

It is a moot question whether photography is or is not an art. Nor can the taking of photographs be narrowly defined as a craft or a playful sparetime occupation.

Photography, my friends, can be more than a pastime or a craft. However, the first stage is indeed mostly pastime; the capturing of pleasant impressions, the recording of pleasant memories. The word "snapshooting" expresses this very appropriately. However, this is by no means meant in a derisive sense. After all, haven't we all passed through this stage, or, perhaps, are still in the middle of it? The first school outing with group pictures, confirmation, an afternoon in the café garden with our once adored first love by our side (oh what funny hats!). Then the wedding, the christening, summer holidays at the seaside, then again groups, groups, followed by yet more groups. Here and there single pictures and even portraits, which, however, unfortunately hover a little lost above the bottom edge of a horizontal print.

And among all these many photographs there are only very few which attract the attention not only of the author or those who "had their picture taken", but also of others; here the picture of a foggy autumn morning; there a sunset with reflections dancing across the water; or winter's first snow with a few footsteps losing themselves in a lonely background.

With such pictures, which are not run-of-the-mill, we have captured something. Perhaps it is due to the atmosphere of the photograph affecting us, maybe it was our mood which expressed itself here? Yes, here we tried – unconsciously perhaps – to make a statement, and we succeeded! These are the first faltering steps to express ourselves with a camera, to make ourselves understood. And here is the dividing line between button-pushing and photography.

Some never reach the other side of this critical boundary. They never progress beyond the snapshot collections of photographic memories,

indifferent to every pictorial composition and expression. But photography can be turned into a genuine hobby! Exactly as with growing flowers, the first consideration is the desire to create something original. However, in order to draw from the abundance of photographic possibilities, we must learn how to see. This is not only a matter of talent, it can really be learnt, if only there is a spark of enthusiasm and the wish to make better pictures.

However, in time every hobby demands increasing expert knowledge if it is not to become monotonous. In order to become a painter you need more than a velvet beret and long hair; a chromium-flashing camera with umpteen lenses alone does not turn you into a good photographer. And, if possible, your equipment should keep in step with your increasing knowledge. The ambitious photographer should consider this – above all, everything depends upon the man behind the (good) camera. Let him be an amateur by all means. But he must feel his vocation.

Photographic vision

Experience and observation show us that the impression received by the eye is something quite different from the picture recorded by the camera.

Naturally, one of the most important reasons for this difference is that in contrast to the one-eyed camera we see with two eyes, that is stereoscopically.

Apart from this, the camera records the picture rigidly in an oblong or square frame. And this limitation, together with lines, shapes, and colours, forms an integrated whole which in turn forms the picture. On the other hand, our eye scans a field of view which is not confined within any frame with fixed limits. It perceives, in rapid sequence, a large number of individual pictures. Through a complicated thought process they are integrated into a general impression.

Perhaps you might like to try your own experiment. You only see sharply whatever you happen to look at the moment. Due to the speed with which you change distant and near focusing points, you will be hardly aware of this integration. (How quickly we can do this I remember from school. During examinations our master used to stand by the window, apparently looking outside impassively, until

suddenly his voice rang out: "Benser, your copy book lies in front of you, not in front of your neighbour!")

If visual impression and camera expression were not something basically different, every picture, correctly exposed, would automatically become a good photograph. All we would have to do would be to take up position where there was an atractive view, press the button and leave the rest to the colour film.

Instead, we very often produce only a thoroughly disappointing copy of reality ("you cannot imagine how beautiful the peach- and almond blossom were that year"... "quite possibly, but on your transparencies they looked like trifle!") I am afraid that more than 90 per cent of all who take photographs in colour succumb again and again to this deceptive visual impression. My admission that very often I commit the same error even today is by no means based on false modesty. It happens particularly when I am in a hurry or not in a photographic mood.

Please understand me correctly. We do not, of course, want to apply strict judgments to every souvenir snapshot. When we record some funny incident during a holiday trip, we need not call at once for creative photography. Likewise, an occasional panoramic view as a souvenir or a memory prop will be quite justified.

I am sure that every button-pusher has the wish to take better photographs. He wants to be able to present his creations even to critical eyes unconcerned with the emotional aspect of the pictures. For we see our own pictures with our emotions, a thing we cannot expect of the uninvolved viewer. He sees more with his intellect, besides having more distance!

It is part of taking better photographs to look carefully through the camera viewfinder ten times more often than one takes a picture. Viewfinder – and ground-glass screen image – do not both isolate a part from the large field of the eye? This cutting-out thus compels the eye to obtain an approximate idea of the future photograph.

The more accurately and clearly a viewfinder shows this frame, the easier it can be judged.

Since not everybody is the owner of a Leica whose new bright-line field-of-view frame represents a type of subject viewfinder which would be difficult to beat, we must also look for simpler aids which force the eye into a frame. They are designed to help us arrive at a firm decision as to whether or not our subject is worth pressing the button. It is generally known that it becomes easier to imagine the subject without disturbing surroundings, or even to eliminate them altogether, if an oblong formed by thumbs and index fingers of both hands is held in front of the eye. With some practice and imagination this expedient is of some value. Even better is a piece of black cardboard with a postcard-size window cut out of the centre. One eye is closed to exclude stereoscopic vision and the future picture assessed within its margins.

I must confess that I have often recommended this somewhat antiquated trick without having tried it myself until quite recently. The thought of wandering about with a sizeable piece of cardboard in my hand while everybody turned round with amusement did not appeal to me greatly.

In the end I made this "idiot's subject viewfinder" after all and realized with shame and wonder that the cardboard frame is nothing

Golden Gate Bridge at San Francisco

Picture page 101

I do not claim that this picture is the incarnation of America. However, if with half a dozen or a dozen pictures you want to convey a typical impression of the phenomenon that is America, the series will be incomplete without the Golden Gate Bridge. It spans the Golden Gate, the bay of San Francisco. It is a symbol of the optimism and drive of the citizens of the New World and of the achievements of their engineers. (It is perhaps surpassed by the grand view of New York's skyline seen from the Hudson River.)

Many photographs have been taken of Golden Gate Bridge. Most of them show this wonder of twentieth-century civil engineering in its surroundings, as a connecting link between the two high banks on either side of the bay.

However, I conceived the idea of photographing the bridge in complete isolation. I wanted to show the elastic strength of the concrete ribbon suspended, as it were, from giant spider's threads, carrying six lanes of traffic. I imagined that it must look fantastic from above, if the camera could be pointed from one of the pylons of the bridge at the depths of the blue-green water. Don't ask me how I got up there! The special permission necessary was easy to obtain. Again and again I was amazed as well as pleased at the helpfulness of the Americans, (even of their authorities). A short phone-call, a handshake – okay! There is a lift, but not for sightseeing tourists, only for the maintenance workers: a narrow, dark iron cask, recalling notions of submarines.

But the ascent is worth-while: – the view from the top is breathtaking and makes you dizzy. Photographically the impression is enhanced by the use of a wide-angle lens, because it makes depth appear even deeper.

Leica, 35 mm, Summacron, f/11, $^1/_{100}$ sec., April, 3 p.m., sunlight.

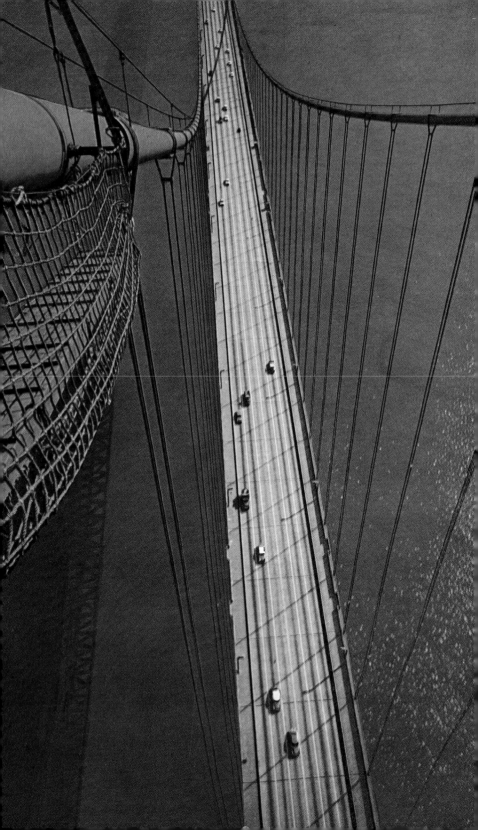

Chicago Nightclub

Picture page 102

Some friends of mine, real "photo-fans" from Chicago, took me to a nightly stroll. Of course – the Leica accompanied me.
This picture was made in the noisy atmosphere of a night-club. I was really sceptical, not only because the light was so dusky. On the little stage there was such a confusion and terrific movement, that I could not expect to get a clear shot.
The multicoloured projectors gave such a quick-changing light, that I could scarcely follow – I got dazzled by the flashing lights.
My friends sneered: "Hey – your famous Leica – does it strike?"
What should I do? I supported the camera on a piano, and without breathing I made the exposures with open focus, changing the speed from $^1/_{15}$ to $^1/_{25}$ seconds.
The picture shows the same result as certain other exposures which have a sort of unsharpness due to movement: the atmosphere and the artistic effect of the light is even augmented by the blurred outlines of the object.
The yellow-cast of the day-light film is surprisingly unimportant. In my opinion this is due to the different grades of the lighting, of which the colour-temperature can hardly be defined.

Leica, Summilux 50 mm, f/1.4, full opened, $^1/_{30}$ sec., Agfacolour CUT 18.

less than a marvellous gadget for compelling the eye to critical judgment before the exposure.

Naturally I do not expect you to enlarge your photographic equipment by half a square yard of cardboard. The use of my own is confined to my own back garden. But do try it out if you want to demonstrate particularly strikingly either to yourself or to others the difference between visual impression and camera view. (By the way, the postcard-size window will indicate with great accuracy the field of view of a standard lens if you hold it away from the tip of your nose at the distance of the outstretched fingers of your hand – cocking a snook, schoolboy fashion.)

Whether we use cardboard frame or optical subject viewfinder, they alone do not protect us from disappointments, unless we acquire some more experience in colour photography.

There are still quite a few hurdles to be overcome!

We do not, with standard cameras, take photographs stereoscopically and according to our visual perception – our eyes are capable of looking "around" objects. This deprives the pictures of something which I can only describe as "airiness". "Airiness" should by no means be confused with the presence of the third dimension, because even well-taken stereo pictures are still without this quality of airiness.

Furthermore, neither the colour transparency nor the colour print on paper are capable of reproducing light contrasts as vigorous as the eye can see them in actual fact. Nor can even the best colour film under the best possible exposure and processing conditions equal Nature completely in its colour reproduction.

All we can do is to make the best of it. Only very critical assessment of the potentially photogenic subject, forethought supported by previous experience, observation of the light and its colour composition and finally the choice of the correct viewpoint, are, roughly speaking, the most important signposts of the way to the photographically conceived picture.

All this sounds a little like the opening speech of a headmaster to his new First-formers. On reading it through I relive even now my feelings of apprehension. But perhaps it will reasure you a little to know that with every colour film I receive back from the developing station I always make a resolution, in the face of my mistakes, to do better next time.

But let us return to the subject. It has often occurred to me that the picture field appears more colourful to the eye through a window from which I have stepped back a little. If I approach the window more closely, with the frame, as it were, receding, the picture often tends to become paler.

If, for instance, you travel through the countryside by car, looking to the left and right of the road for subjects, you will perceive the rapidly passing scene or landscapes differently, more compactly, that is, within a frame. Since it would obviously be impossible to make an exposure during the journey, you will stop the car here and there in order to walk back a few yards. Arrived in front of the just-discovered picture, you will be disappointed because it is not as interesting as it had promised to be after all.

Why is this?

Because the frame is lacking, and the surroundings interfere. Do not despair in such a case, take a little time, and look, at your leisure, for some demarcation. Often a branch is sufficient to frame a landscape and to give you back your lost subject.

You determine the picture area

If you have ever taken black-and-white pictures you will know the strong effect of a cleverly chosen picture area. An enlargement can separate essential features from unessential ones and achieve afterwards what we failed to achieve during the exposure.

This is the main reason why enlarging in one's own darkroom is such a source of pleasure. The pleasure behind the

camera is continued in front of the enlarger. You can cut off boring, empty foregrounds and omit disturbing details at the picture margins. A small change in the format, a tiny increase in the ratio of enlargement, and the snapshot becomes a photograph.

The situation is different with colour reversal film. Here we must decide the picture area before we make the exposure. The colour transparency with a yawning, empty foreground or an excessively high, overpowering, pale sky, at times demands radical masking before projection, no matter how perfectly it was lit and exposed.

It is completely obvious that the closer we are to the subject, the larger does it appear not only to the eye, but also to the camera. However, what looks to our eyes still reasonably clear in the middle ground of the picture will be reproduced at a diminished size with a camera with a standard lens.

Fill your frame

I do not know what prevents so many amateurs from showing what they want to photograph really large.

Just watch your fellow hikers at a beauty spot. See how they mutually "take" each other: in front of a statue, for instance, for all the world like the Field Marshal up there on his prancing steed in expression and posture. Maybe they really wanted to take home the proof, black-and-white or even in colour, of having been there; photographic evidence, as it were. But if you do want evidence, at least it should be clearly recognizable.

Instead, Mr. and Mrs. Buton-pusher retreat about 30 to 40 feet with the laudable intention of not cutting off the statue's head and start shooting. If these good people only knew how much clearer the faces of their fiancées, aunts, and uncles would turn out if they arranged them at a maximum distance of 12 feet from the camera! They would then achieve their ambition: the picture of the sightseeing attraction *and* Aunt Elizabeth's friendly smile!

Please do not take this as a personal attack! Even more I wonder why the majority of all amateur pictures is taken in the horizontal position, when it really ought to be obvious that these very subjects cry out for a vertical frame. But no, our friends walk back, further and further, until at last everything is "in it", wasting space to the left and wasting

space to the right which really has no business to be in the picture at all.

It is an old experience, and often mentioned, that in colour photography, too, the pictorially essential features should, if possible, fill the frame, or at least dominate it. This should not be taken quite literally; it will be perfectly satisfactory if the surroundings are hinted at. Don't we often want to know where we had been at the time, whether on an Alpine meadow, the beach, or in our own garden? If it is our object to take a full-length picture of a person, we should make sure that he – or she – takes up about two thirds of the picture height (vertical position!). At a camera distance of 9 feet it will be just about right. Have you ever taken colour photographs of a carnival procession? Or a village fête? In most cases this is done from ground level, although the better – and photographically more favourable – viewpoint is obtained from a raised position. And haven't you also had the experience that such a view of many fancy dresses and folk costumes in frankly a little disappointing in most cases? If once again you take a close-up picture of a particularly attractive figure, perhaps only head and shoulders, you will prefer this photograph, if you look at it critically, to those showing mass scenes.

Naturally, there are also very impressive views of whole fancy dress groups and processions. However, their special appeal invariably consists either of their having been taken against the sky as the dominant background, or from an elevated camera standpoint. For this gives us a certain compactness of forms and colours.

Here we have one of the most important secrets of successful colour photography. Far too few of us know that large quiet areas of colour have a far more convincing effect than many small colour dots and splashes distributed at random all over the picture.

A good example of the validity of this experience may be a visit to Holland during the famous tulip blossom time. This very beautiful display of flower growing raised to a fine art annually attracts more than a million sighseers. At Easter, or even as late as Whitsun, flower lovers meet in a relatively small area, hardly larger than that occupied by a medium-sized large city. On such days the throng of people and cars filling the roads leading through the fields is downright frightening! The seat on the upper deck of a bus is often the only chance to see anything of the gorgeous show of tulips and hyacinths.

Things are much the same in a famous large park called Keukenhof. From April until the end of May this enchanting piece of earth glows with a multitude of horticultural works of art. Thank Heavens, cars are not permitted there. Nevertheless, on sunny holidays the number of admiring, happy sighseers assumes fantastic proportions.

If you are lucky enough still to be able to see the flowers, you will soon enter a state of inebriation (perhaps the intoxicating scent of the hyacinths has something to do with it). One can see amateurs, who normally husband their resources of colour film very carefully, acting without any restraint at all. Otherwise it would be inexplicable that a photo dealer, who was clever enough to secure the sole rights of vending his wares in the park up to 1972, sells up to 1,000 colour films each Sunday. His little counter is as much the centre of activities as the ice-cream parlour next door. People who have run out of colour film queue up, with their change ready, spurred on by their photographic obsession.

And then, they shoot general views as far as the clusters of tourists permit. I have even watched one who could not penetrate to the front row hold his camera above the heads, taking pot shots, for good luck, in the general direction of the flowers.

It is no sign of photographic snobbery if we decide to put our camera away in such a situation; or make a virtue of necessity, and take only photographs of the people acting in such a strange manner. Naturally,

there are also quiet days during this fine display of flowers. During weekdays the stream of visitors becomes a trickle, and we can work without disturbance, but these precious and pleasurable hours should not only be spent on experiments which with others before us have been failures: experiments such as taking pictures of the apparently limitless expanse, stretching almost to the horizon, of the fields of blossom. Certainly there are some days – they are, however, few and far between – when the dome of the sky with broken-up cloud formations stretches across the flowering fields, promising by itself a worthwhile picture. If in addition you have found an raised standpoint – something rather unusual in the Low Countries – you will be able to obtain some impressive pictures thanks to the vast, homogenous areas of colour.

How fortunate the birds are, circling with jubilant song above all this beauty. From their view – or that of a helicopter – we should most probably be able to get ideal pictures! As it is, we have in most instances to be content with an angle of view lacking the oblique or downward approach to essential in this case. So only a very small proportion of our colour film should be used for the large fields.

Close-ups instead of general views

The closer we approach our general views the better the chance of success. A few rows of flowers, diagonally cutting across the picture, will have a far more impressive and convincing effect than those pictures extending to the horizon. Or only a few flowers, maybe only a single flower, large in the picture – this is the photographer's conception!

Now we come up against the limits of the camera ranges. Without a near-focusing device or supplementary front lens we cannot deal with distances below three feet. If you have such accessories with you, when taking only a single flower filling your picture you have to stop down a good deal, otherwise your depth of field will not be sufficient.

Stopping down, however, means long exposure times – this is where the gremlin of movement – camera-shake or subject – begins to play tricks! Moreover, flowers on the stem outdoors are almost never really still. The whole problem is indeed a subject apart and so interesting that I shall treat it in more detail on p. 162.

Perhaps you will understand me fully only after you have made the experiments yourself. Photograph a general view of a mass of flowers, and then, on the same film, a close-up picture; then project both types of view, which you can, of course, vary at will, directly one after the other. I bet that you, too, will find the close-ups more satisfying!

Well, what is valid for flowers can equally be applied to other subjects. Above all where masses of people are concerned. Admittedly a bird's-eye view, from a tower or a rooftop, of the milling crowd on the market square can be very attractive. The round, colourful umbrellas above the vegetable stalls form quiet islands in the motley of colours and shapes. However, you will be at least as successful if you descend from your vantage point and, at close quarters (about 3 to 6 feet) isolate individual scenes. For proximity creates large areas of colour in place of a gaudy patchiness.

Close in – step back!

We really should make it our habit to proceed from the close-up picture to the general view instead of the other way round. Take our near subjects first, and go back step by step afterwards. Even during the preliminary judgment of the scene it is better to choose an exaggeratedly close-viewpoint at first, and to increase the distance slowly after. If you do this you will find in many cases that every additional feature in the picture tends to spoil it.

If, nevertheless, the restfulness of a picture is destroyed by a disturbing background, there are two alternatives to restore it. Either we restrict the zone of sharpness present by as large an aperture as possible

and close-focusing of the lens, thereby throwing the background out of focus. Or we look for a different camera viewpoint. Sometimes it will be a view from above, sometimes the camera direction will be decidedly from below. Here, the blue sky can work wonders as a neutral, large-size backdrop.

Let me once more return to the subject of the successful close-up picture; there are two different types of close-up. Fruit and vegetable markets with many stalls, taken as general views, are often unfortunately

very disappointing as subjects. Even if we step nearer, looking at only one stall with our eyes and viewfinder, we cannot yet be sure that the restless impression has been cured.

I experienced something like this on a sunny morning at Merano, when I took a picture there. The shopwindow which delighted my eyes displayed veritable cascades of juicy fruit. The row of polished, shiny apples and bunches of grapes sparkling in oblique *contre-jour* light were only a fraction of this gorgeous sight. I did everything possible to match visual impression and photographic expression, but I simply did not succeed. I stepped closer still, and, lo and behold! the less there

was in the picture, and the more temptingly the fruit grew in size in my viewfinder, the more convincing became the subject. Thus, in this instance, a distance of 9 feet from the fruit represented a general view, and only the still life "pulled in" from 5 feet with a tele-lens conveyed the impression of plenty, paradox as it may sound. As so often, here, too, the Latin phrase "pars pro toto" hits the nail on the head; freely translated it means: "a part expressing the whole thing."

After all this, you may have gained the impression that the close-up picture alone is the best approach for colour photography. No, not always, but very often.

But you need not think that you ought to leave all long-distance subjects alone during your trips and rambles. It would indeed be ridiculous only to be able to point one's camera at daisies by the wayside in the face of wonderful panoramas. If you like the lighting, and the haze so often prevalent does not reduce the distant features to a flat stage-background only, you should not allow yourself to be deterred from having a look round. Maybe a suitable foreground will break up the sometimes empty expanses of sky and meadows. Perhaps a light footpath will wind its way into the background or a large storm-swept tree offer a suitable frame. The more your have enquired into the reasons for the appeal of close-up pictures in the past, the more easily will you find the means of establishing a harmonious relationship between nearness and distance. In this context I have a few more suggestions on the tip of my tongue, but I would rather reserve them for the subject of "landscapes".

However, since we are already in the mountains, flowers blossom even in an Alpine meadow. Generally we must not pick them – with the camera, however, we should! The intensely blue gentian, the Alpine roses, perhaps even the very rare Edelweiss. Do take your rucksack off for a short while and take your time. For good pictures are born of a leisurely mood.

Then you will hear the crickets chirp, feel the soft summer breeze and will become part of the great stillness. Isn't this the climax of a holiday?

Playing about with the depth of field

Depth of field is the depth of space of which a sharp image is formed on the film. The more you stop your lens down, the greater the depth of field; it increases more rapidly towards the rear than towards the front.

The depth of field depends on the focal length of the lens and its stop; and on the camera distance. The longer the focal length, the shallower the depth of field at a given stop. And the smaller the lens stop, the greater the depth of field at the same focal length and the same camera distance.

If you photograph an object through lenses of different focal lengths and vary the camera distance in such a way that the image of this object is always of the same size, you will always obtain the same depth of field at the same lens stop irrespective whether you use a lens of a very short or a very long focal length. The fact that you obtain "more depth of field" with short than with long focal lengths will apply only if you take your object from the same camera position through lenses of different focal lengths.

The extent of the depth of field from the plane focused on is mostly greater towards the rear than towards the front. At a focal length of 50mm the depth of field, when the lens is being stopped down, extends about $1/_3$ to the front, about $2/_3$ to the rear.

Stop down wisely

If the lens is now focused on longer distances, the increase of sharpness in depth is considerably greater. If, for instance, you want both the distance (i. e. infinity) and a figure in the foreground e. g. at 3 m (10ft) sharp, it would be wrong to focus the lens on infinity and to try to "pull the sharpness forward" by means of radically stopping down. It will be more effective here to use the so-called hyperfocal distance setting: Focus on twice the distance of the near point, i. e. about 6 m (20ft) and stop down until the near point at 3 m (10ft), is in sharp focus. The depth of field will then extend to infinity. This method will enable you to obtain the depth of field, which at the infinity setting would have been obtainable only with the minimum apertures, at a larger aperture.

This trick of the "economical" hyperfocal distance setting is used above all with landscape and architectural subjects when persons or groups in the foreground are to be included in the picture.

Almost all cameras have a depth-of-field ring on the lens, which indicates the depth of field for whatever lens stop has been set. It also shows very clearly that the depth of field shrinks the more you open up your lens stop. This also makes it necessary to focus fast lenses used at large apertures with great accuracy, for with close-up subjects depth of field is often a matter of centimetres (an inch or two).

Balanced sharpness distribution

Wherever you see pictures, in black-and-white or in colour, in books, journals, exhibitions etc., which strike you as photographically outstanding or particularly impressive, you will find that the pictorial effect often rests on the blanced sharpness distribution. The background, whether of a close-up or of important foreground motifs, is often kept slightly unsharp so that the outlines, although recognizable, appear as behind a thin veil.

This technique is particulary well suited for black-and-white photography. Whereas a more or less blurred background in black-and-white can have the effect of a decorative pattern, in colour photography it is rather disturbing. In my experience this happens so often, although not always, that I should advise you either to include the background within the depth of field so that its features are really recognizable, or, by focusing on the foreground and using a relatively large aperture, to blur it to the extent that its contours appear more or less completely dissolved. Sometimes the contours dissolved into large circles of confusion can be very attractive, on the other hand they can occasionally be disturbing. It entirely depends on the individual case.

What in black-and-white photography is appreciated as "artistic unsharpness", in colour photography often irritates the eye. The less realistic (because unnaturally colourless) black-and-white photograph appeals to the beholder's imagination. What is expected (at least by most of us) of colour photography is absolute realism. But the eye does not accept a "certain unsharpness" as natural.

How can you overcome this difficulty? Well, try to avoid any com-
promise and photograph the foreground motif, if it is the only impor-
tant feature, as close-up as possible, with a longer focal length lens if
you have one available, in sharp focus, and, by choosing a large aper-
ture, blur the middle distance and background completely. This almost
without exception applies to heads, and if you take pictures of human
figures and are therefore unable to focus on a very close distance, try to
find a restful or as neutral as possible a background, because here its
total dissolution can be achieved only with lenses of long focal lengths.
With the shorter focal lengths at any rate the background rendering
will hardly ever be satisfactory. Even if at a setting at 5 m (17ft) and
a large aperture the depth-of-field ring promises you that sharpness
decreases already between 6 and 7 m (20 and 23ft), the middle distance
as well as the background is not yet blurred enough that it will no lon-
ger be found disturbing. Here are the following widely different so-
lutions: Try, if possible, to find another camera position, by squat-
ting or even lying on the ground, thereby placing your subject against
the sky or another neutral background, or by assuming a raised stand-
point, mounting a chair or table, climbing a ladder, or a hill; this cuts

off both background and middle distance. Now the ground, the meadow, the terrace or the sand will be your neutral background which, although sharp, is so uniform that your subject will stand out well against it.

Now photograph a head, a whole figure, ar even a group, as close-up as possible, so that it fills the film frame more or less completely. Thus the larger the rendering of the pictorially important elements), the easier it will be to overlock the background even if it is not entirely blurred.

The single-lens-reflex camera as an aid to photographic vision

When you look through an ordinary camera viewfinder, which of course only frames the area of the picture, but does not indicate the depth of field, you will have to develop some imagination and use your experience in order to be able to judge the relationship between sharpness and unsharpness. This makes the trend towards the single-lens-reflex camera understandable, because the judgment of the pictorial effect, especially with longer focal-length lenses, is made considerably easier. Here the image is formed by the camera lens on a groundglass screen or a ground field lens via a mirror, and its various aspects can be readily assessed. Even the Leica, a typical viewfinder camera, can be converted into a single-lens-reflex camera through the attachment of a reflex-mirror housing; the groundglass screen permits a satisfactory judgement of the varying depth-of-field conditions at the various lens stops.

Selective focusing

Some prominent workers have for some years taken their colour photographs presenting, through a focusing trick, portraits, whole figures, but also objects in the middle distance and background completely sharp, whereas the foreground is rendered more or less unsharp. The best know examples show, for instance, branches, twigs, and leaves so blurred that their contours can scarcely be guessed, as a framework for the main subject, which is sharp owing to selective focusing. Such effects can be produced particularly well with large-format cameras, because the very shallow depth of field of these cameras permits a very accurate

judgement of the zones of sharpness. This effect is more difficult to achieve with miniature cameras as long as you work with short focal lengths, whose relatively great depth of field allows a complete dissolution of all details closely in front or behind the subject only if the lens has and is used at a very large aperture. But even if you succeed, for instance by using a light giant such as a 50 mm f/1.4 lens at full aperture, in compressing the depth of field to a few cm (one or two inches) in the close-up range, you will sometimes find the speed of the colour film a handicap. You would have to use a shutter speed higher than 1/1000sec. Here the use of longer focal lenths at apertures of f/2.8 or even f/2 will produce better results.

Obviously the concept of selective focusing extends also to those pictures in which a foreground object is separated from the background by means of close-up focusing and the use of a large aperture. Here selective focusing means placing the focusing plane through the object in the near foreground and blurring the space behind it by the use of the full lens aperture. This can succeed even with short-focal-length lenses provided the illumination does not demand too short an exposure time; with longer focal length lenses it is easy.

Conjuring with Perspective

However, there is yet another way of influencing pictures according to our wishes. Is it not strange that this possibility, although it has existed ever since interchangeable lenses were introduced, is so little known? Even amateurs with several lenses only rarely use this opportunity.

Perhaps you will contend that the purpose of interchangeable lenses is well known. With a tele-lens, for instance, we can obtain a section of the general field of view, pull in the distance, or represent nearby features still larger in the picture area, because with medium-long and long focal lengths we can almost extinguish the background, and the any disturbing detail. You have only to remember the many good landscape photographs which only became possible by rendering the mountains large in the picture by, as it were, jumping across the valleys. Or usually extremely difficult colour photographs of high, brilliant stained-glass windows in churches, which, taken through a tele-lens, can fill the entire picture area, while through a normal lens they would be no more than little splotches of colour in the general darkness of the interior; not to mention convergence of verticals to which the shorter focal lengths are prone on such occasions.

Yes, certainly, we all know about these things.

On the other hand it is largely unknown that we can also strongly influence the apparent perspective effect of a picture according to whether we use a wide-angle, a standard, or a tele-lens. In other words, it is possible after all to "move" subjects, which are obviously immovable, according to our wishes. We can soften the rigidity of the conventional rendering and modify the proportions according to their importance. We can reproduce the foreground large and reduce the background to insignificance. Or, conversely, deliberately render the foreground smaller and have the background dominate the picture completely. And all this with the aid of interchangeable lenses of varying focal lengths! At any rate, this teaches us the following facts: ′

If the foreground has the right proportions and occupies in our picture the dimensions we had anticipated for it, while the background plays more or less the part of a frame or backdrop only, a picture taken with a standard lens will probably satisfy us. All we have to do is to see to the correct camera position, so that nothing in the background grows out of somebody's head, or other intersections disturb the harmony. But if foreground and background are equally essential to the picture, there is only the one possibility of moving the foreground closer to the background. People can change their standpoint, fixed objects such as houses, trees, and so on cannot.

The background becomes larger

Here we have "conjuring with perspective". Using our tele-lens we step back until the foreground appears at the same size in the viewfinder, in spite of the long focal length of our lens, as during the setting with the normal focal length. The distant subject appears closer and is reproduced larger.

Even with a 90 mm lens in place of the 50 mm, this trick will reproduce the background at almost twice its original size. However, with a focal length of 135 mm, the dimensions of the pulled-in background will be almost trebled, and be exactly four times with a 200 mm lens, such as the famous Telyt for the Leica. In this case, our distance from the foreground, if it is to be reproduced at constant size will be, for example, 20 yards instead of 5 yards with the normal lens.

In many cases, therefore, a longer focal length is a suitable means of producing better, more impressive pictures by a deliberately larger rendering of the background compared with a normal-sized foreground.

Believe me, dear friends, this possibility is downright exciting once we have grasped its significance! Only then will the purchase of a longer focal length lens be really worth-while. And it will also pay to think about what further consequences will result from this juggling with interchangeable lenses.

We want the background smaller

There are, however, opposite cases too. Let us assume the background as taken with the normal lens is too large. We would not like to miss it altogether because after all, it shows where we are, but the foregrunds should more or less dominate the whole picture.

We then approach the desired foreground very closely with a shorter focal length, that is a wide-angle lens, so that it appears in the picture at the same size as if it were taken with a standard lens. The background will thereby be automatically reduced in size!

This case in with we wish to make the background appear smaller on purpose occurs quite frequently. Often the background is overpowering, without our being able to make it disappear. This is where the change in the proportions – large, emphasized foreground, small, subsidiary background – will be a welcome method of improving pictorial composition.

What do you do, for instance, if the background appears large enough even with a normal lens, but the foreground seems far too prominent and dominating in front of it? Imagine yourself standing in a wide valley in front of a church, where the spire, dominating everything, soars into the sky, while the neighbouring mountains, although large enough, do not really look as prominent as they ought to. (Perhaps your standpoint is too far down the valley, that is, your view is wrong.) If you want to improve matters by taking up a position further to the back, such as on a nearby hill, the church will indeed look smaller, but so will the mountains in the background. However, if you go back with a long focal length lens (the longer the focal length the better!) far enough until the mountains in the background are again as large as they were before with the standard lens, the church will now fit in with its surrounding instead of dominating them.

If the background has the desired size, but the foreground is to be reduced and subdued, we use a longer focal length, walking away from the background until it assumes the same size again as with the standard lens. This automatically reduces the foreground.

I would not like to conclude this conjuring session without making the following point: – It is common knowledge that the shorter focal length results in a wider angle of view. Expressed in numerical values, a standard lens, e. g. of 50 mm focal length, has an angle of view of 46 °, the shorter 35 mm focal length already as much as 64 °, while the new 21 mm super-wide angle (21 mm Angulon f/5.6) even offers an angle of view of 92 °!

It is obvious that we must work with the shorter focal length if the angle of view of the normal lens is no longer sufficient and there is no possibility of obtaining a picture by increasing the distance between camera and object. This is a very frequent experience when travelling, and having to miss a picture is sometimes very sad. For interiors, a short focal length is indeed an absolute necessity. But I must warn you against doing too much of a good thing by calling in the super-wide angle, omitting the 35 mm lens. It is true that with the 21 mm focal length the coverage of the camera is astonishingly wide from a close distance, however, the extreme shortness of the focal length demands very meticulous work with the camera because the slightest tilt makes the verticals converge, while in the hands of a layman perspective distortion can assume downright grotesque forms.

A wide-angle lens of 35 mm focal length continues to be much more useful for amateur purposes; it must be stressed as a particularly attractive feature that its speed has been increased to f/2 in the new Summicron, so that is has become a real rival of the fast 50 mm lens.

The Make-believe Lens

In connection with the exaggerated perspective of wide-angle pictures there comes to my mind a story, half annoying, half amusing, concerning the wide-angle lens. Many years ago I took my family to a holiday resort, attracted by the profusely illustrated prospectus of a *pension* in the mountains. Our imagination ran riot as we studied the excellent photographs. They not only showed an attractive white house, with large trees in front of it, but also views of a spacious garden with a fountain in a small pond; deck chairs inviting us to rest were gener-

ously spaced out; a park promising peace and quiet, and privacy from other guests.

The interior of the guest house, too, apeared no less generous and spacious in its proportions. A hall with a reading room, a palatial dining hall, and a winter garden in which one could almost take a walk. The place was the very thing for us.

When we arrived – to make matters worse is was raining cats and dogs – everything was different and a big disappointment. It appeared to me as if I had returned, after many years, to the haunts of my childhood, where one remembers everything much larger than it is in reality. Not only were the rooms tiny; the dining hall was narrow, too. About the park I would rather say nothing at all, it was no more than on outsize allotment, with a little pool in the centre instead of a pond.

What had happened? The perspective rendering of the pictures did not correspond with the natural impression, because they had been taken with an extreme wide-angle lens. I had frequent occasion to think of this example in later years whenever I wanted to exaggerate the feeling of space in an picture in the interest of its general effects. Ever since, my wife has dubbed the wide-angle lens the "make-believe" lens.

Cleverly taken advertising shots are based on this property. What does the owner of a small factory do if he wants to impress his customers a little with "views of our works?" He shows us vast halls with machinery and lathes, an exterior front losing itself in the far distance, everything betraying a dynamic spirit and enterprise. All these are, of course, merely views taken with an ultra-wide angle lens, which makes a strong impression on anyone not familiar with photography. All you have to do is to count the windows in the building receding rapidly into the background, in order to be "in the picture". A forgery? Hardly. Rather, conjuring with the focal length.

Which focal length first?

In the face of so many examples I hope I have convinced the amateur of the effect of interchangeable optics. Logically he will now want to know how to go about extending his equipment in the direction of the "camera system":

Venice: Along the Grand Canal

Comparison pictures on the centre pages 128 and 129.

Here are two examples of "conjuring with perspective" explained in detail on p. 118.
Both pictures show the same subject, but how different is the treatment.
Let me tell you at the outset that the picture on the left is a wide angle shot (35 mm. Summaron) while the one on the right was taken with the long focal length 135 mm. Hektor lens. The only difference between the two pictures from the taking point of view consists of the fact that I took the left exposure at a distance of about 13 feet, and the right hand one of about 50 feet from the lamp-post.
I did not even have to measure the distance; all I had to do was to walk back, looking through the luminous frame in the Leica viewfinder, until the lamp-post on the right had regained its original size.
However, you will see the effect: the church has been "pulled in" and has grown in size. Even the three lamps on the slender lamp-post have changed their perspective. This is quite obvious, because if I take them close up from below with the wide angle lens, they are bound to present a different aspect to a long distance view with the tele-lens.
Thus, the old saying that it all depends on your point of view does not always meet the situation completely; the perspective, and, therefore, the focal length, too, play their part. I feel we should far more often take such radically different pictures of the same subject. Only then shall we be able, as proud owners of several lenses of different focal length, to make full use of the potentialities of our cameras.

In order to infuse life into, and compose, this view of the Grand Canal, the splendid candelabrum seemed to me to offer a suitable foreground. By placing the "lampione" as the Italians call it, close to the picture margin and letting it occupy almost the entire height of the picture, it satisfied my intentions most effectively. This required a distance of about 13 feet with my wide-angle lens on the camera.

Thus there was still some space left in the picture field to the right, permitting the view of some more candelabra in the background. But on the left, the eye was able to roam freely across the vast expanse of water and sky to the church of Santa Maria della Salute.

This created the impression of a vast space, the canal was like an inlet of the sea (which is, of course, an exaggeration), crowned by the wonderful, blue Italian sky.

Picture page 129

I had the urge to take a second picture, a more intimate one as it were, concentrated entirely on the structure of the church of Santa Maria della Salute.

The Leica looked through the long focal length 135 mm. lens as through a field-glass. The lagoon shrank to a narrow ditch, the background became livelier. It moved closer, and the camera even took notice of the colourful life going on on the broad steps of the church. Really, it was like a fairy tale!

However, for all this I did not want to do without my candelabrum. Moreover, it was hardly less important for the pictorial composition than in the wide-angle picture. From my original viewpoint I would, of course, either have obtained a small section only of the lamp-post, or better still, would have had to do without this foreground altogether. I, therefore, had to walk back, step by step, eye glued to the viewfinder, until my lamp-post again appeared in the foreground at its old size.

Page 128: Leica, 35 mm. Summacron, f/8, $^1/_{100}$ second, Agfacolor CUT 18.

Page 129: Leica, 135 mm. Hector, f/11, $^1/_{50}$ second, September morning before 9 a.m., sun. Agfacolor CUT 18.

125

Venice

Picture page 127

An example how in photography, too, the rule "Pars pro toto" can be applied to advantage. It means roughly "representation of a typical part in place of the whole thing". Often it expresses the essence of a subject more poignantly.

The two pictures on pages 128 and 129 of the Grand Canal and the church of Santa Maria della Salute are – good or bad – views of Venice. This, however, is a little piece of the heart of Venice.

Only a strip of this proud and picturesque architecture, more hinted at than seen in the background, is enough. The reflection of the palazzo grows into the reflected blueness of the Adriatic sky.

Here, too, the symbols of this city, the black gondolas dominate the stagnant water of the lagoon as sombre ornaments – redoubled and enlarged by the reflections.

I must mention as a technical point that for this "shot into the water" I needed a longer exposure time than for a comparable direct view of the sun-lit canal front. (The pointer of my Sixtomat jumped back almost two stop values when I tilted the meter downwards.)

With this deliberate direction of the camera towards the water, the problem is solved of bridging such a large contrast range as exists between "top" and "bottom". The – unavoidable – over-exposure of the narrow strip across the top is not harmful. Naturally, the gondolas had to be at least suggested in the original; the black reflection alone might perhaps have produced an interesting puzzle picture but not a convincing picture of Venice.

Again, the wide-angle lens was necessary in order to cover from a close range the largest possible expanse of water reflecting the sky.

Leica, 35 mm. Summaron, between f/5.6 and f/8, $^1/_{50}$ second, September, 2 p.m., Agfacolor CUT 18.

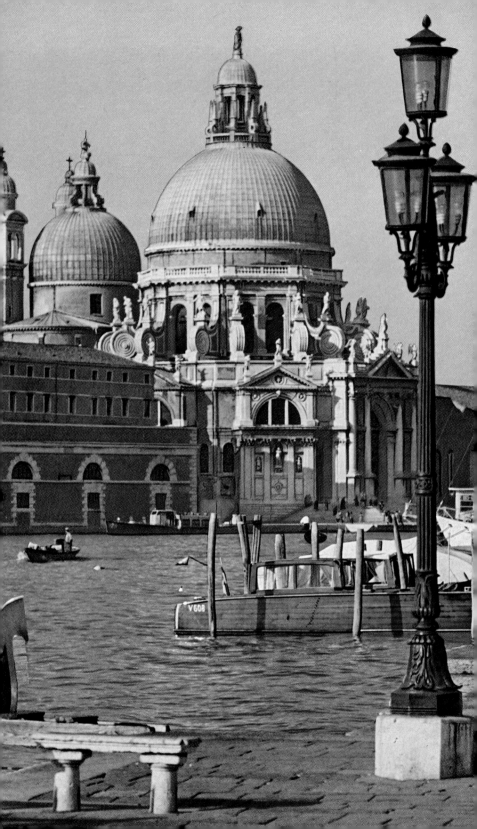

Siesta

Picture page 130

Everyone who has been to Venice knows the meaning of this picture. The gondolieri are having their siesta on the Piazetta in front of the Palace of the Doges. Every day at noon you can see them sitting there, lazily stretching themselves, with their feet up comfortably on empty chairs, busy with their fingernails or just having a peaceful nap. The very essence of Dolce Far Niente!

All this is enacted in the narrow strip of shadow cast by one of the two famous columns. Every five minutes, the row of sleepers stirs, because the shadow moves on, and one must follow it across the square.

I was very keen on a picture of this scene alone, which is so typical of Venice. However, from a normal viewpoint I would never have been able to isolate the group from the crowds on the Piazetta and the restless background. I therefore mounted the five or six steps of the base of the column, stood on my toes to gain the last inch of height, when I just succeeded in getting this group of eight men diagonally on my film. Thus the shadow of the column, too, played its humorously illustrative part.

It is advisable to operate without much fuss and to get your pictures quickly, because it would be a pity if the natural and relaxed pose of the Gondolieri were spoiled by attracting their attention. But as you see, I was lucky. None of them noticed me, and I was able to capture, the sleepy atmosphere prevailing at the height of a southern day.

Leica, 50 mm, Summicron, between f/5.6 and f/8, $^1/_{50}$ second, sunlight, about 1 p.m., Agfacolor (15 °DIN).

Whether the right thing to do is to buy a wide-angle lens or a longer focal length after all?

I am sure not everyone will have either the enterprise or the cash of the American photo-enthusiast at Kansas City who, on the morning after one of my lectures, surprised his photo dealer with the impatient words, "I should like to buy the whole equipment and all those lenses with which this fellow works"!

I believe the first step to enlarge your scope should be the purchase of a lens of longer focal length. This does not mean that you should go too far, deciding on an extremely long focal length. It is better to take that lens with which you will become familiar most quickly. For a Leica man, then, this would be the 90 mm Elmar, Elmarit or Summicron. Of course it could also be the 135 mm Hektor, but in this case you will often miss the intermediate focal length which in my opinion is called for more frequently. Moreover, the danger of camera-shake is less with the 90 mm than with the 135 mm. You should bear in mind that the longer the focal length, the more critical the danger of camera-shake.

Once you have learned to work with the long focal length lens, the next addition should be a wide-angle, and it is preferable not to jump immediately to the ultra-wide angle but to the 35 mm Summaron or Summicron instead. Incidentally, experienced photographers confirm almost unanimously that apart from exceptional cases, the order of the most frequent use of their various lengths is roughly as follows:

1. Standard focal length 50 mm
2. Medium focal length 90 mm
3. Short focal length 35 mm
4. Long focal length 135 mm
5. Ultra-short focal length 28 mm
6. Ultra-long focal length 200 mm

Due to the recently introduced 35 mm Summicron f/2 wide-angle lens the picture may, however, change in time in so far as many Leica fans have begun to do without the normal focal length altogether and to promote the shorter 35 mm lens to the rôle of standard lens. If you handle it with skill and do not attempt to photograph portraits, you will be able to avoid the impression of perspective distortion and come to appreciate the advantage of greater depth of field even with large apertures.

We sometimes are told "pinsharp pictures can only be obtained with f/8 and smaller stops". People who hold this opinion photograph too little and read too much.

"Rubbish" is the only correct, if rude reply to them. Naturally, camera lenses vary in their quality. But le us consider the class of the Leica lenses sparkling in the bluish sheen of their coated surfaces. If we have such first-class, and therefore expensive, lenses in our camera, there is no harm in opening up our stops as far to the left as they will go, operating, at it were, at full throttle. We focus for maximum sharpness with the coupled rangefinder, when we can expose, even under poor lighting conditions, $1/50$ or $1/60$ sec. respectively at f/2, out of hand. We could repeat the exposure for comparison purposes at f/4 and $1/10$ sec. – which, as we know, amounts to the same in practice. However, if the second exposure is also hand-held, I would bet that the first picture will be sharper!

Which brings us to the basic purpose of the large stop. The high speed of a lens is, above all, an insurance against the dangers of camera-shake and subject movement under unfavourable light conditions.

By the way, did you know that an f/2 lens at its maximum aperture is less susceptible to so-called internal reflection (ghost images of the iris diaphragm) than when it is stopped down?

Try to photograph into a bright searchlight or headlamp at full aperture. You could do it in the circus or on the road at night. Unless you stop down, you will see these ghost images only very rarely, if at all.

Let me return once more to the fallacy that smaller stops result in better image sharpness. Perhaps this is due to a confusion of depth of field with general resolution. We all know that great depth of field affects the picture from foreground to background in its entire depth. On the other hand, the sharpness of the lens is tested in the plane on which it is focused from one picture corner to the other. In this connection, we are naturally also interested in the colour reproduction. If the corners of the picture become darker we talk about "vignetting". This can be rather unpleasant if a perfectly exposed landscape picture shows a fall-off in brightness towards all four corners, particularly in the sky. I know these regrettable effects – but only from pictures

taken by others, never from my own (unless I had used too long a lens hood)!

How much shall – or can – we stop down?

Occasionally we read or hear that although the performance of a lens improves with stopping down, it deteriorates again after having reached its optimum at a certain stop.

This is correct, but it always depends on the type of lens. In addition, in order to prove this ascending and descending sharpness curve, very complicated and critical test exposures are necessary. In practice you can safely stop Leica lenses down to f/16 if the depth of field requires it. You will be unable to detect any loss of sharpness due to this stopping down.

There is still the question at which stop the maximum of general sharpness is reached. According to the type of lens the maximum sharpness generally lies between f/4 and f/8. My statement that very intricate tests of the famous Summicron lens have shown this maximum to lie at f/4 will, I am sure, amaze you, because for a fast lens this is an astonishingly early peak. You will hardly be in a position to check this, because the transition from the surprisingly good sharpness already present at full aperture to the still greater sharpness at f/4 is almost imperceptible. It cannot be detected even with a strong magnifying glass.

My standard: f/5.6 or f/8

Nevertheless, this value should not be adopted as the standard stop, although the resulting short exposure time is in many cases a great help. On the other hand, the depth of field is not sufficient with near subjects, so that for all normal-exposure subjects f/5.6 or f/8 should be accepted as the most favourable stop.

Wide-angle lenses generally reach their optimum performance only later apart from the pronounced tendency inherent in the nature of short focal lengths towards vignetting. This is less evident in black-and-white than in colour photographs, because here a sky darkening

towards the corners clearly shows up the disadvantages of lenses prone to vignetting.

A wide-angle lens can be used at full aperture without difficulty whenever the camera is not pointed at an open landscape, but is used for snapshots of all kinds. The astonishingly fast 35 mm Summicron f/2 can therefore be opened up fully without trouble if poor lighting conditions make it necessary. With satisfactory light we stop down in any case to medium apertures of, say, f/5.6 or f/8, so that landscape subjects are not exposed to the risk of vignetting.

In the case of the super-wide angle, the 21 mm Angulon, though, a stopping down to f/8, or better still, f/11, is recommended for subjects with uniform colour areas, particularly sky.

It must be mentioned in passing that in the field of fast and ultra-fast lenses everything is still in a state of flux. Only a few years ago it was thought absolutely impossible to compute efficient lenses of short focal lengths at such large apertures. New types of glass and the advent of electronic computers, however, have led the way to astonishing results.

Flash technique

Modern flash is an important aid, which even in colour photography opens up new vistas. Like any other accessory such as a filter, flash, too, can be misused, when it will be more of a hindrance than a help.

I feel that flash should be recommended only if it is not possible to take colour photographs with available light sources, or when it is indispensable to the achievement of a special effect.

The answer to the question whether flashbulbs (expendable flash) or electronic flash should be used depends on the following considerations.

You will decide in favour of flashbulbs if you

1. do not use flash very often and tend to leave colour photography alone when lighting conditions are poor

2. when travelling, e. g. by air, have to limit the volume of your photographic equipment. Even a large number of flashbulbs weighs comparatively little and takes up little space; neither does a small flashlamp with reflector, which is in addition independent of the mains. Flashbulbs can be bought almost everywhere

3. often have to light large rooms with flash and therefore depend on the use of special large flashbulbs. This applies particularly to owners of cameras with focalplane shutter, which limits the use of electronic flash to some extent. Rapidly moving subjects (sport, reportages of all kinds) which need supplementary flash at any time of the day, even in sunlight, are a preserve of the large flashbulb.

An electronic flash unit will be the answer if you

1. use more than 100 flashes per year, for instance if you want to take photographs of your children also during the winter months independently of the daylight, and above all to use flash in your own home

2. take many photographs professionally and have to be independent of lighting, time of year, and existing sources

3. prefer several sources of flash by using two or even more flashlamps in order to obtain particularly good illumination, and want to couple several flash units in order to increase the power of the light

4. often have to light very large rooms by means of the so-called open-flash method, firing twenty or more flashes in succession at the – stationary – subject.

5. travel a great deal by car and do not mind carrying additional luggage. However, volume and weight of the modern electronic flash units have now been reduced sufficiently so that even prolonged carrying is not considered tedious any longer.

Electronic flash units can also be plugged into the mains and recharged provided the country you are visiting is not too backward.

You must know the guide number

Every flashbulb and every electronic flash emits a certain light energy. Naturally, the exposure meter is quite unconcerned when the flash fires at $1/30$–$1/1000$ sec.; it is redundant. For the light energy is determined by means of guide numbers, which have lately become very reliable and are published in instruction leaflets for colour films of various speeds.

By dividing this guide number by the distance between the flash and the object you obtain the lens stop. If you divide the guide number by the lens stop number you want to use, you will obtain the distance you should keep between the subject and the flash.

Please bear in mind that in this context distance always refers to the object and the flash, not to the object and the camera (this hint shows you that I am secretly thinking of the many types of lighting for which the flash is not directly mounted on the camera, but held separately).

Let me give you a few practical examples how to use the guide number. Assuming it as 28 for the 18DIN (50ASA) CT18 film, and the flash-object distance as 5 m; $28 \div 5 = 5.6$ (f/). (If we convert the distance into ft. – 17 – the guide number would be $95 \div 17 = 5.6$ (f/). Or, the other way round: $28 \div 56 = 5$(m) ($95 \div 5.6 = 17$ (ft)).

Obviously, when the stop value is calculated, intermediate values, "odd" stop values such as 5.1 or 7.3, will often be obtained. Here one simply chooses an intermediate setting between the engraved figures.

If the light energy is distributed to two flash holders in order to obtain a more even illumination with electronic flash the total efficiency of the flash does not become higher but lower, since part of the flash is usually fired fom a longer distance. The lens stop is then calculated on the

basis of the flash lamp nearer to the object and the result adjusted by means of opening the lens by one stop.

Stop corrections

However, even the most reliable guide number does not altogether absolve you from the use of a little thought, because it applies only to "standard" situations: flashing in ordinary bright rooms, in which the boost by reflection from the walls can be taken for granted. A correction of the stop value becomes nesessary if pictures are to be taken in large rooms with ceiling and walls of poor reflecting power. This applies above all to photography outdoors at night.

Stop corrections are also called for when the colours of the object are particularly light, and in very light small rooms, such as a bathroom. In practice you can use the following little table for correcting lens stops calculated with the guide number.

Exposure conditions	Increase or decrease in stops
At night outdoors	open about 2 stops
Large hall	open 1–2 stops
Wide-angle reflector	open 1 stop
Against the ceiling or bright wall, allowing for the longer path of the furniture	open 1–2 stops
Very bright rooms, bathroom, kitchen, laboratory, with little light (bounce flash)	close $^1/_2$–1 stop
Supplementary flash in daylight	close 1–2 stops (depending on the intended amount of flash)

The stop calculator

This paragraph really ought to precede the long explanation of how to use the guide number, for some recent electronic flash units have a practical stop calculator engraved on the flash holder, which after the speed of the colour film and the flash distance have been set directly indicates the correct stop. These stop calculators are very reliable and are based on the values applicable to ordinary rooms. The table above must be used in special conditions.

Only a "pinch" of flash

For my own colour transparencies, occasionally requiring a little flash to supplement the daylight, I prefer a mere hint of flash, which I also like to call a "pinch" of flash. I have already said elsewhere that the viewer should not be able to see at all that flash had been at work, it should look like a completely natural illumination reflected by some light-coloured wall.

Usually the danger of overdoing it is greater than that of too little flash support. Modern electronic flash is so intense that "dabbing" a little flash onto the shadows requires a certain amount of experience. The table has already told you that you should close your lens down 1–2stops for supplementary daylight (fill-in) flash after you have found the flash-object distance with the guide number or the flash calculator. With Compur shutter cameras you can change the associated lens stop/shutter speed values almost at will, whereas with focal-plane shutter cameras the highest possible shutter speed is usually $1/50$ sec. This may in certain conditions force you to stop your lens down to f/8 or f/11 in daylight with 18DIN–50ASA film because of the intensity of the daylight, which could reduce the effect of the flash to zero on objects 4–5 m (14–17ft) away. This, then imposes limitations. You will have to resort to the expedient of separating the flash lamp from the camera by means of an extension cable, and thereby of approaching the object more closely from the side. Cameras with Compur shutters allow the use of higher shutter speeds as a means of reducing the effect of the flash when this is necessary.

Here is a very intriguing trick I have learned from an American reporter. Hold the top part of the reflector high into the air in your outstretched left hand in the direction of your sitter, and place 4 fingers in front of the reflector, with your thumb gripping the back. With this method a large part of the light intensity is screened. You are able to increase it step by step simple by spreading your fingers more widely, or lifting some of them as if you were playing a flute.

Two flash lamps are better

I am most reluctant to work with only a single flash source when flash is the only light. Frontal illumination naturally is adequate for souvenir pictures, but they will never be more than "colour photographs with flash": a little flat, with cast shadows on the wall, rapid falling off of the light intensity and therefore also violet-brownish degradation of the background colours. You can of course greatly soften the light of a flash by using it indirectly. This "bounce flash" technique requires the reflector to be pointed at the nearby ceiling or wall of the room so that advantage is taken of the reflection. However, this uses up a lot of light intensity so that it is generally necessary to open the lens up 2 stops.

A better method relies on a second flash holder, which enormously extends your possibilities of "playing with light". However, these second and even third flash heads are not available with the simple electronic flash units but only with the considerably more expensive units of correspondingly higher light output.

All the same, let me give you a few tips on how to divide your light energy.

1. The light intensity is decreased due to the splitting up of the power between two sources, even if the quality of illumination is improved. This is compensated by opening up one stop from the value obtained from the guide number.

2. The distance valid for the calculation of the guide number (guide number divided by flash distance = stop number) is always measured from the flash head nearer to the subject.

3. Obviously the two flashes should not be fired from the same direction. The effect would be scarcely different from that of a single flash. Instead, we must give pronounced side or even back-light with one of the flash heads. Invariably with this arrangement one flash should be fired closer to the subject than the other. In most cases, an assistant will do this with the extention flash head at the end of a 17-foot cable and, therefore, with much freedom of movement. If, for instance, you work with your camera and attached flash head from a distance of 10 feet, the extension flash head is best placed at a distance of 5 feet from the subject (distance ratio of the two lamps 1 : 2).

4. Very smoky rooms can cause a puzzling blue cast. To avoid this, you first open the window to let out the fug before taking flash pictures in the room. On the other hand, thick smoke behind your sitter, magically lit up from the back by the second flash, can yield surprising

effects. An efficient pipe- or cigarette smoker might perhaps kneel behind the model, producing as much smoke as his lungs will alow. Then is the time to press your button.

5. Watch your assistant with the extension flash like a hawk. Often he becomes so absorbed in what you are doing that he does not notice that his reflector points anywhere but at the subject.

6. A lens hood, as we all know, should always be used. Particularly in this case to prevent the light from a flash held to one side of the picture from sneaking into your lens unexpectedly.

7. The effect of the flash is no longer intensified to any marked extent by decreasing the flash distance below 5 feet. If you have to approach very small objects to be flashed from 3 feet or even closer distances, the guide number calculation should not be based on inches, but as if the flash distance were 5 feet. However, it is useful to know that very bright close-up objects will invariably be very successful at f/11 to f/16.

8. When taking small children and subjects which do not keep still, it is best to determine beforehand a fixed distance with your assistant and to try to keep to this distance. Therefore you should follow the movement of the object, which at the same time gives you the advantage of not having to adjust your stop every time.

The ideal case: the bathroom

Someone once wrote: "in the bathroom there are plenty of subjects... a rich field of activity... with one or two photoflood lamps one could..." The whole thing had the title: "Where to snap our youngest?"

Whoever he was gave a very dangerous piece of advice, at a time when we did not yet have flash safely packed in bulbs or tubes!

You see, these photoflood lamps aren't really to be recommended. Not only do they bring us into conflict with the law, but also, on occasion, with 240 volts, because most bathrooms are earthed very well; the photoflood lamps not so well. A tiny loose contact, a bare wire – and you have taken your last bathroom picture (if it is not your last picture altogether!).

This is the reason why our electrical regulations are so strict: no electric

points are allowed, and electric current should not be brought into such dangerous localities, not even by means of extension cables. Quite apart from all this a tiny splash of water on the red-hot bulb makes it burst into a thousand fragments with a loud bang, scattering innumerable pointed glass splinters. This, incidentally, is also my own experience.

Paradoxically enough, you can work in the bathroom with a high voltage without any fear if it is as safely protected as in the electronic flash. Flashbulbs can, of course, also be used, since $22^1/_2$ v. are completely harmless.

And now a few flash tips for the bathroom. It is very light – unless you are the owner of the "posh" type with black tiles. Thus you can make full use of your guide number without modification. Indeed, this is perhaps the one place in the whole house where you may use half a stop smaller than the calculated value.

If possible, avoid pointing the flash at right angles to the tiles; otherwise you will discover the reflection of the flash in your transparency.

Always point it at the wall at an oblique angle; it is easy to try it out beforehand with electronic flash, which costs nothing. Bathrooms are so light, and most of them also so narrow, that even a flash bounced from the ceiling will be effective. The considerably softer light will then be sufficient at f/4, since in any case we were able to photograph the splashing little devils at f/8 in direct flashlight. (You would, of course, get a terrible green cast if you made use of green-tiled walls for your indirect flash light. Here, only direct flash light should be used.)

Here is a tip which may lead you to the crowning achievement of all your children's pictures. When one of your progeny is having fun under the shower, first turn on the cosy warm tap. As soon as your ca-

mera is ready for action, one of the parents unkindly and suddenly turns it on cold, and the resulting cry is the signal to shoot. I can guarantee that your portrait will not lack expression.

Close-ups with flash

Without wanting to anticipate the chapter on general close-up photography I merely wish to point out that the lighting intensity of the flash does not appreciably increase any more when it is brought closer to the object than 1.5 m (5ft), because the flash, as a light cone of various widths, will partly bypass the small close-up object since the light cannot be bundled. The guide number calculation no longer applies below about 2 m (7ft). For small objects approached to within e. g. 80 or 50 cm (32 or 20 in) f/8–11 will be adequate with the usual small flash units and f/11–16 with units of medium power. Here, too, the

extent of stopping down depends on whether the colour of the object is light or dark.

Flash pictures of children

I am embarking with a purpose on the subject of "flash and children", for pictures of children, who ought not to be posed, are completely different from portraits of grown-ups. The most attractive results will of course be the snapshots showing children in a wide variety of activities. And since children never sit still it is best to focus on a certain distance beforehand, which is either always roughly maintained according to estimate or checked on the rangefinder image. Small babies still unable to walk, but crawling on the floor all the time to make up for it, will leave you no alternative but to lie down yourself and join in the crawling – a form of locomotion beloved by German drill sergeants before the war. The essential point of the exercise is always to maintain the camera distance, which has also determined the lens stop, without fail. Simply follow your victim. It would, after all, be impossible every time to change the lens stop.

Really close-up

I have an unlimited admiration for those with unlimited patience. To them I raise my hat in reverence. Lest you get the wrong idea, I do not mean those who on an icy winter's day wait for hours getting cold feet, hands, and noses, looking skywards and praying for a tiny ray of sunlight. No, my admiration goes out to those amateurs who are able to work for hours and days for a single exposure. At times their reward is indeed only one, but then a really great, picture!

Walter Wissenbach is one of those patient souls I am talking about. His pictures of bats on the wing are photographic gems. Or those close-up views of freshly-hatched birds, being fed by their parents with flies and worms – all that can be seen of the tiny fledglings are their expectantly gaping, pink-lined yellow beaks. Or bees, whose whirring wings cannot even be recorded sharply by the $^1/_{1000}$ second of the electronic flash, sniffing at a flower – almost all of us know such pictures – and cannot help admiring them. I believe that only very few others have succeeded in taking such subjects.

Far be it from me to belittle the achievements of these patient masters of the camera, but I would say that close-up pictures up to the region of extreme macrophotography (i. e. objects appearing larger on the film than their natural size) are not quite as difficult to produce as it would seem. Detailed knowledge of the habits of wild animals and insects and, above all, patience are, of course, two important requirements. The third condition is purely technical – it can be bought in a shop. You must be able to extend your lens far out in front of your camera, whether by means of a specially long focusing mount, intermediate rings, near-focusing devices, bellow extensions, or the like.

A question of fractions of an inch

Close-up photographs are, of course, possible with supplementary front lenses, so that even amateurs owning cameras without interchangeable lenses can pursue this intriguing subject to some extent.

It is best to be able to judge the picture on a ground-glass screen because the depth-of-field zone shrinks to a minimum in close-up pictures. After all, we no longer deal with yards and feet here, but with inches and fractions of inches. To return to our example of the bee in the flower, it is already quite a feat to get even the bee and the rim of the flower completely inside the depth-of-field zone if you work at almost double the extension of your lens. At the extremely small stop of f/16, and a 1 : 1 reproduction ratio, the depth-of-field zone measures less than one tenth of an inch! You will therefore have to be quite satisfied if the bee is kind enough not to protude its abdomen into the picture, but offers a side view, nicely in one plane!

Increased exposure times

If you are interested in the extremely fascinating photography of close-up subjects, you would be well advised to study the very detailed description of the Leitz bellows unit. Here you will readily see that pictures closer than 3 feet invariably demand a longer distance between lens and film plane, that is extra lens extension. Quite apart from the rapid decrease of the depth of field in spite of our progressive stopping down, the exposure time becomes longer, too. It makes a noticeable difference whether we take pictures with a tele-lens at infinity or at 3 feet. Indeed, as I have already mentioned, we must open up by about half a stop at such close distances. However, the further the lens is moved from the film, the longer we must expose, even though the stop is unchanged. If we take photographs at samesize reproduction, the lens speed decreases to a quarter of its normal value, hence we must expose four times as long as our meter readings indicate.

However, I do not wish to fill this book with tables. They are obtainable without difficulty from your photo dealer, as they are part of all leaflet on close-up focusing devices.

It will be no surprise that hand-held exposures with these small stops and prolonged exposure times are impossible, no matter how good the lighting conditions. If ever there is a case for a tripod, this is it!

Electronic flash, too, is a wonderful supplementary aid. Close-up views in sunlight, which, stopped down to f/11 and f/16, demand $1/25$ sec. and longer in spite of increased film speeds can then be exposed at at least $1/50$ sec. The electronic flash assumes the rôle of main light source, while the sun, which we can, if necessary, dispense with, becomes the fill-in light.

Walter Wissenbach's pictures of small and very small animals have almost invariably been possible only with the aid of electronic flash. His "sitters", in any case, do not normally nest in open, sunny places. On sites to be reached only with difficulty, hidden in the depths of undergrowth of shrubs and trees, he arranges his Leica and flash unit and takes up position himself with a yard-long cable release, so that the shy animals do not sense any danger.

Still life first

The close-up subjects that I take and which I think every beginner could master are situated not so much in the deep undergrowth of inaccessible forests, but in our immediate surroundings, about the house and in the garden. Any-

thing you think might make an attractive close-up photograph, you can obviously take in colour too. For example, a polished copper bowl filled with flowers, the geranium pot on the window sill, the tulips in the front garden, luminous in back light, as well as the little pansies.

Flower pieces indoors are not a difficult sub-

ject, they move less than blossoms and flowers outdoors; for even when the air appears to be absolutely still, there is always some very slight movement about. Even a cloud obscuring the sun causes a momentary slight "shivering" of the plants. We notice it clearly when observing the image on the ground-glass screen.

I should therefore advise you to take your first close-up photographs indoors. Incident daylight near the window as main light source and a white reflector, sheet, or paper, or even a mirror serve to soften the heavy shadows. Such experiments can give you much pleasure, and your best friend is the tripod.

Naturally, you could make hand-held exposures, too, under very good lighting conditions. However, the tripod also has a task other than the prevention of camera-shake: since the observation of the field of view is based on fractions of an inch the camera must, if possible, keep to the intended picture field. A tripod leaves your hands free to manipulate your subject at will and to experiment with your reflecting aids. Moreover, you will soon find out for yourself that you will need more depth of field.

Neutralizing the background

But how about outdoors? Of course, larger objects such as the sunflower are easy, due to their tall growth. All we have to do is to take up a low position and the brilliant bloom will be pictured clearly against the sky; and we are doubly fortunate that the two complementary colours, blue and yellow, contrast so very well.

On the other hand, daisies, dandelions, and the like usually grow in luscious meadows in the immediate neighbourhood of sorrel, sage, and other intruders we do not wish to include in our picture.

Take a piece of cardboard, a small cloth (of one colour, dark, and neutral, if possible), and let someone hold it about 6 inches behind your flower "model". For once it does not matter that all the other grass and plants are pressed down, if you focus your camera accurately. Here, too, ground-glass screen control by means of the Visoflex will prove particularly useful.

Now the depth of field should not be so great as to include the cardboard, too. However, the distance of 6 inches is large enough, so that

it cannot be recognized as cardboard any more. Very ingenious people make doubly sure of absolute unsharpness by having the cardboard moved to and fro a little during longer exposure times. (An assistant is almost indispensable here, but we must be careful not to cause any draught!)

Dark cardboard or sheets are better as neutralizing background than light, not to mention white material, indoors as well as outdoors. We must always bear the colour reflections in mind; on a green meadow, a colour reflection is bound to occur on a white surface. This again leads to the grumble: – you see, green cast! Grey, and, above all, black backgrounds absorb colours and are therefore immune to colour cast.

On every one of these occasions you will improve your close-up photographs by using supplementary flash. The heavy shadows will acquire

nice detail, and a picture, taken perhaps without sunlight, will appear to all the world as if the sun had shone from a cloudless sky.

Photography of objects closer than 3 feet is the perfect therapy for nervous and worn-out people whom sudden relaxation and inactivity tends to make even more nervous. Photography ought to be prescribed for such people, it acts like a tonic, except that this remedy is a stimulant rather than a tranquillizer.

Copying, Miscellany

There is no reason why copying should be ruled out within the close-up range. The photograph of a stamp at natural size on a transparency is both a close-up picture *and* a reproduction. But there is this essential advantage over swaying flowers and buzzing bees: the objects have little depth, are usually very flat and raise no depth-of-field problems. I am sometimes asked how pictures large and small can be copied in as faithful colours as possible. I shall therefore atempt to give you a few tips in a concise form, which even an amateur without a home studio can follow. The greatest difficulties are presented by pictures under glass on walls, especially huge paintings in a museum, because for copying the camera must be aligned absolutely parallel to the picture and its optical axis to the dead centre of it; for converging verticals will earn you no credit in copying as they occasionally will in architectural photography.

I consider a single-lens-reflex camera ideal for copying, because it is not afflicted by parallax, and it allows a check of parallelism of the planes of the film and the original.

The light must reach all parts of the original uniformly. For small areas, say quarto size, two photofloods are sufficient; they should be set up at either side at an angle of $45°$, so that no direct light can reach the camera. Larger areas call for more photofloods, because a long time exposure is liable to cause reciprocity law failure. In my view the amateur will have reached his limits if more than two photofloods become necessary. Let us therefore look round for other possibilities of illumination.

There is, for instance, sunlight. Copying is possible in direct sunlight, but diffuse sky light is better. Neither alternative, however, applies in-

doors or to museum halls, because the reflections from the walls, usually not painted white, produce colour cast. Copying in sunlight, then, will be limited to conditions in which you can set up your originals on a balcony or garden terrace. For indoor work you are thus probably left only with flash – on the assumption that you have a single flash holder only.

If the original is entirely free from reflections, the flash can be fired next to the camera without any difficulty. However, conditions which make this possible are few and far between. Even unglazed pictures may show reflections when photographed. Oil paintings are very prone to reflections, so is the fixative painters use to protect their crayon drawings. You can always avoid them by arranging the lights so that they produce oblique illumination. However, since this illumination must also be uniform, you must fire at least one flash each from the left and right. And if you have only one flash lamp, you must darken the room to exclude any daylight which would produce additional illumination during the successive firing of flashes. The correct flash position is best determined by means of two desk lamps adjusted so that no reflections at all are visible from the camera position. Now the distance between the light source and the original is measured so that the lens stop can be calculated on the basis of the guide number. Since you are firing two flashes in succession (walking from one side to the other), and the flash unit recycles meanwhile, the intensities of two flashes are added together, and you must stop the lens down one stop.

The camera – mounted on a tripod of course – is set at time exposure preferably with a cable release with a clamping screw, and the shutter released. Manually fired, the two flashes light up in rapid succession from the directions of the focusing lamps. In the completely darkened room somewhere in a corner behind the camera a weak lamp may burn to let you maintain your bearings. (Its light does not affect the exposure.)

Constant lighting distance for different originals

If you want to copy several originals of various sizes you need not go to the trouble of changing the position of your lamps every time you photograph another original. The best method is to place a table each, of the same height, to the left and right in front of the wall on which

the originals are hung, and always to fire the flashes from a distance of 2 m (6ft 8in); it enables you to copy pictures large and small in a sequence, always at the same lens stop.

If your transparencies are required as originals for the production of colour blocks, you will have to obtain a colour chart with a grey step wedge, to be included in the picture along the unused margin. The colour chart can be obtained from the film manufacturers. And please note that commercial exploitation of picture postcards, book and other illustrations, etc. is prohibited. As long as you confine the use of such copies only to titles for colour slide series to be shown to your friends, no objections will be raised.

Fruit at Merano
Picture page 155

If you ever have the pleasure of strolling through such a fruit market, you will have to admit that Tyrolean apples and grapes are not to be despised; they not only tickle the palate, they are a delight to the eye. And if you take colour photographs you simply cannot resist their camera appeal. However, some patience and a little enthusiasm are necessary in order to look for a nice still life in all this colourful plenty. Here, a quick snapshot is not good enough in the majority of cases.

I, therefore, got my tripod out and screwed my Leica with the 135 mm. Hektor on it. I then looked at the delicious display at my leisure through the viewfinder at close distance, about 5 feet away. The shop-windows received the glancing light from a still fairly low sun, and everything seemed to be perfectly set for a successful picture. All that was left for me to do now was to stand at the correct angle and to arrange the camera, that the cross-lit fruit appeared in diagonal rows in my viewfinder.

The friendly Tyrolean fruiterer helped me with much understanding to rearrange the beautiful grapes a little. But I was forced, owing to the long focal length of my lens and the nearness of my subject, to stop down to f/22. The exposure time of $^1/_5$ second was a little longer than my Sixtomat had indicated. However, such close-up photographs through a long focus do need, obviously, a generous exposure.

Leica, 135 mm. Hektor, f/22, $^1/_5$ second, September, 10 a.m., glancing sunlight, Agfacolor (15 °DIN).

The Queen of Sheba
Picture page 156

In the famous "Keukenhof" a Dutch tulip breeder showed this lily-like tulip to me. Proudly he called it the Queen of Sheba.
With the natural gracefulness of its shape it stood in the middle of a group of other tulips in a bed which I was, of course, not allowed to step on.
A black cloth as a neutral background, laboriously draped behind this one tulip, made it stand out alone, eliminating the more or less blurred welter of blossoms in the background. The flaming fieriness of the flower was also particularly well brought out in its ornamental effect. The drawing page 150 shows better than any words could describe how we separated the "Queen" from her "entourage".

Leica, 135 mm. Hektor with bellows unit, f/22, $1/_5$ second, without sun in a hothouse, April, 11 a.m., Agfacolor CUT 18.

When the Sun Sets

Gabriele R. Baden near Zurich

D e a r M r . B e n s e r ,

A few months ago you gave us so much pleasure with your
lecture at Zurich, that not only did we buy a Leica a few
days later, but also started with colour film right away.
If you want to know what caught our particular fancy, it
was your sunset pictures, because from our home here we
can see a marvelous sunset almost every day. So we tried
immediately to do as well as you. But our results were
deplorable. They were indeed so bad, that we enclose them
with our letter to enable you to put us on the right
track. (You need not return them, the waste-paper basket
is the only place for these transparencies.)
The pictures, then, are far too pale, and the sun only
looks like a tiny dot. Moreover, yellow splashes of light
appear in the foreground on all pictures, so that we
suspected a fault in the camera. But friends of ours
think that they are due to internal reflections in the
lens. Does this always happen, and how can we avoid it?
When will you come to Zurich again? We learned much last
time, but not enough, or else we would not have to write
to you now. Yours sincerely, N. N.
P. S. We also have a good exposure meter. However, with-
out doubt it has given the wrong reading of the sunset:
1/2 second at f/5.6. Isn't this far too much?

Walther Benser Düsseldorf

D e a r M a d a m ,

Here is my reply. Yes, your transparencies are without
exception greatly over-exposed, but your exposure meter
is not at fault! For your exposure measurement — using
the so-called direct reading method — gives you, as it
were, a cross-section of the brightness of the measured
object. Thus, in your case it covered a part which was
unimportant to the picture — your garden and a vast por-
tion of the more or less silhouette-like landscape. The

sinking sun and the evening sky, then, contributed at
best only 50 per cent to your measurement.
I believe it is invariably better with such pictures to
rely on one's own or someone else's experience. This, at
any rate, says that in such instances the average ex-
posure time ranges between f/5.6 and f/8 and 1/25 second.
I would even be inclined to cut down on the exposure
further still, depending on the sun's position, the
brilliance of the background (lake, or river), because
nothing could be worse here than a generous exposure.
And now a word about the reflections in the foreground
(you have the sun not once, but as many as three times
in your picture). This is a phenomenon which is un-
avoidable so long as the sun still dazzles as much as it
has done on your pictures. You ought to have waited a few
more minutes until it had sunk a little lower, when the
dazzle would have decreased very rapidly; you find again
and again that shortly before sunset you can look
straight into the fire-ball even without sun-glasses and
without squinting. This is the moment when you can take
your photographs without fear of disturbing reflections!
Now it is not always possible to get a good picture of
the sun at the very last moment. This depends a great
deal on the weather. Sometimes you will find that a layer
of haze above the horizon swallows up and obscures the
sun. Let us maintain, then, that the correct moment for
our exposure has arrived whenever we are able to look
into the sun. There are even hazy or misty days, on which
one can photograph straight into the sun even at mid-day
without the risk of reflections. If you insist on taking
your sunset pictures from your balcony, please await the
right moment patiently next time. However, you must
remember that the landscape in the foreground will only
show up as a dark shape, that is, as a silhouette. But as
your foreground does not appear to be particularly
interesting — I do not, by any means, wish to imply that
the view from your house is anything but lovely — it
would be preferable to tilt the camera a little upwards
and to displace the foreground to the bottom margin of
your picture, where it will only show as a dark fringe.
Have you bought a tripod yet? If not you can use your
balcony as camera support by pushing a slightly wedge-
shaped piece of wood under your Leica. This will guard
you fairly well against camera-shake, because a hand-held
1/25 second is a little risky. May I give you yet another

tip? You know Lake Zug, don't you? The lake promenade
directly leading out of Zug is in my opinion a downright
classical spot for sunsets. The golden light track of the
setting sun will lead right up to your feet if you go
close enough to the water's edge. And if my memory serves
me right you can even take weeping willows into your
foreground, and a few rowing boats as silhouettes. A few
years ago I passed the place and saw at once what I could
have photographed. However, a lecture at Lucerne made any
break in my journey impossible.

Lastly, sooner or later you will make up your mind to
acquire a longer focal length lens. Not only because it
enables you to pull in your selected picture areas far
more effectively. Naturally, the sun, too, will appear
larger, and the 90 mm. Elmar turns the tiny dot into a
sizeable blob. The picture out of my lecture series you
admired so much was taken with the 135 mm. Hektor, which
reproduces the sun at almost three times the size of the
"normal" picture. Hence the striking effect! If I am not
mistaken, I even mentioned the exposure data at the time
(25 ASA) 1/50 second at f/4.5. You see, it must be far
shorter than you tried yourself.

I will be very pleased if I have helped you a little with
these tips.

How about bringing along your new sunsets and showing
them to me at my next lecture? Hope to see you at the
"Kaufleuten".

When the Moon Rises

Many amateurs will find it unlikely that one can really take colour photographs by moonlight. As a matter of fact, they are so sucessful that at excessively long exposure times, photographs are obtained which are almost undistinguishable from those taken in hazy sunlight. However, such an experiment could not be our aim. Instead of "collecting" moonlight for 20 minutes from a tripod it is easier and quicker to obtain a colour picture in daylight at $^1/_{100}$ sec., and it will be more brilliant into the bargain!

On the other hand, things begin to become interesting when the colour film only receives sufficient moonlight for the twilight impression to be preserved, and the moonlight atmosphere of the picture is recognized at first sight.

To begin with, I would distinguish between two basically different kinds of moon pictures. Firstly those in which the moon itself can be seen, and secondly where it stands behind or above us in order to illuminate the subject. And you will even be told in this chapter how to "plant" the moon where it has never been.

Only 1/500,000 part of the sunlight

Moonlight is reflected sunlight, more precisely $^1/_{500,000}$ of the sun's brightness. Purely from an arithmetical point of view, three to five minutes at f/4 would not by a long stretch represent a sufficient exposure.

However, it is a fact that long after sunset there is still twilight about, which is no longer registered by our eye. It helps to reduce the exposure considerably.

Another piece of incontrovertible, though pictorially not so effective evidence of a night picture are the stars. Depending on their brightness they form short luminous tracks in the sky during the minutes of our exposure.

Obviously, the best illumination is available on a night with a full moon. A night before or after full moon will also be satisfactory. However, when the moon is clearly waxing or waning, the exposure times will increase considerably. Full moon does not, as we should expect, reflect twice as much, but fully seven times as much light as the moon at the first or last quarter, because during full moon the sun's rays fall fairly perpendicularly on the surface of the moon visible to us, while during half-moon they reach it at an oblique angle, so that the high lunar mountains cast shadows on a large part of our satellite.

It is better not to rely on what you think you see, or on the romantic exclamations of your girl- (or boy-) friend as to whether or not the moon is full. The calendar is far more trustworthy.

Nor, unfortunately, can we always be sure of the weather. If you intend climbing a certain peak on February 14th at full moon in order to take the Moonlight Picture of Your Life at four minutes' exposure time, you may be frustrated on that very day by rain or snow, and photography will be completely out of the question. Overcast sky would not be so bad, because the light from the moon still illuminates the landscape sufficiently through high, perhaps a little broken-up cloud.

Let me tell you of my friend Roland Bühler, postmaster at Mürren, Switzerland, and in his spare time a photo fanatic with a kind of obsession which makes him undergo any hardships in order to obtain pictures. He has been trying for more than two years now to achieve the ideal moonlight photograph. He even has the good luck to live only a few hundred yards from the most outstanding vantage point of the whole mountain world.

With a bit of luck there is continuous snow from December to April at this famous winter resort; the chalets, too, are covered by quaint snow caps, so typical of a mountain village during the winter. Thus, the moonlight idyll with Eiger, Mönch, and Jungfrau in the background will only occur about five times a year. However, poor old Roland has been trying desperately for two years to get a decent picture, and for two years it simply could not be done, because either fog or snow during full moon made photography impossible.

Finally, during April of the second year, everything seemed to be set fair. However, the full moon – scheduled to rise at 8 p.m. according to the calendar – happened to dawdle so much on its long path behind the high mountain range that it did not appear from behind Eiger until after 9 o'clock. It took a further two hours to detach itself from Eiger and to climb into the sky so that it would not look like a fat, white line in the picture. But during this time of waiting one light after the other went out in the village, except for a few lighted windows of some late hotel guests, who unfortunately were far too much in the background.

It would, of course, be useless to include the moon in the picture and to expose for six minutes. In as short at time as two minutes the moon travels through the distance of its own diameter, and instead of the beautiful, large, golden yellow disc, the photograph would show a not-so-beautiful golden yellow cucumber. Furthermore, the light intensity of *back-lighting* from the moon – there is such a thing, too, you know – is too weak. (How quickly the moon moves on its course we can discover with the naked eye when it emerges from behind a mountain ridge.)

In addition, to take a "portrait" of the moon alone at as short exposure is also rather pointless. Since it betrays movement after a minimum exposure time of 15 seconds showing a bulge in the direction of its movement, you may well succeed in a picture of the moon, but the intriguing contours of the beautiful nocturnal snowscape will not come out at all.

Moon at dusk

Only one, relatively rare, opportunity exists of recording moon and landscape at the same time and at sufficiently short exposure times: if the moon rises at dusk, shining within the angle of view of our camera, and a few thumbs' breadths above the horizon. This will give us lighting from the back from a sky (aurora) so bright that we can photograph the landscape bathed in moonlight – perhaps a lake with lit-up houses along its shore – at exposure times from 5 to 15 seconds. I found that the favourable conditions – dusk and rising moon – occur during November and December.

However, who guarantees us reliably a brightly-reflecting blanket of

snow and broken-up cloud during this part of the year? And on the following evening it no longer works out! (Consulting your calendar you will notice that the moon rises three-quarters of an hour later every day!)

Trick photographs with the genuine moon

I thought out a picture (just for fun) which, although it involves a little cheating, is still possible with the genuine moon and a genuine landscape. This, then, is my imaginary picture:

On a ideal Full Moon night I stand in front of an ideal brightly-reflecting subject, with the moon high in the sky behind me. Whether the subject is a snowcovered village in the mountains or the white huts of an Arab town is immaterial, as long as light shines from the windows, and the houses are close enough. The exposure time is known; f/4 (and, of course, from the tripod – hand-held pictures are out of the question!) and about 3 minutes' exposure. (This is the correct time for a 50 ASA film. You will need about double this exposure time for less sensitive colour films. Incidentally, a few minutes more do not make a great deal of difference here.)

Now at the end of the exposure the shutter is not closed. Instead, I put the lens cap or my hand over my camera lens, when I can turn the camera on its tripod through an angle af 180 ° without any trouble; I arrange the moon through the viewfinder or on the ground-glass screen above Arab huts or the mountain village.

The lens cap is removed, I count two leisurely seconds, and the full moon is safely in the picture by means of a double-exposure trick! By the way, the full moon will be on the film even at $^1/_{10}$ sec., but over-exposure does no harm at all in this case. Hardly anyone will notice the forgery afterwards, though they could prove it by means of the shadows cast in the wrong direction.

If, in addition, you are the owner of a long focal length lens, or even a fat, long tele-lens, you will be able to approach your subject with added ingenuity; you can photograph the buildings with a shorter focal length lens and replace this (at some speed, since the shutter must remain open) by a longer focal length lens (covered by the lens cap!). Now the camera is turned round, and the moon arranged in the appropriate position. Finally, another two seconds' exposure for the moon –

which, due to the longer focal length lens with which it was taken, will be reproduced at a convincing size. The whole trick should be patiently repeated several times.

Collecting light effects by stopping down

And finally a few brief words about f/4 which I mentioned in connection with my moonlight pictures. Why not, say, f/5.6. or even f/8? (Let me tell you about the subject "sharpness through smaller stops" in the next chapter.) Back to our moonlight in bitter winter cold, I repeat, cold!! This first and foremost was the determining factor for my choice of f/4. A smaller stop, such as f/5.6, will perhaps increase to its maximum the general sharpness of the wide-angle lens used. Here, however, it was my chief concern not to have to expose for prolonged periods, because f/5.6 demands twice, f/8 four time the exposure time of f/4, that is twelve minutes. And as on such occasions I am

never content with one picture only, it would take me too long to get them all finished.

Why, then, did I not shorten this cold time of waiting even further by opening up my stop yet more? Assuming I would have had a sufficient angle of view with the standard focal length lens and used its maximum aperture of f/2: Obviously, this would have been possible, but it would have represented the other extreme; I would have found the exposure time of about one minute insufficient on account of the lit-up windows in the village.

You see, down in the village, the people are sitting down to their supper, turning the lights on in their dining rooms, switching them off in their kitchens. Here a blind is drawn there another one is opened. A shop door opens for a second... yet another dot of light in my picture, and so on and so forth. The longer we can expose, the more lights will therefore be collected in the photograph.

In twilight

It may sound paradoxical: the best time to take *night* pictures in colour – above all in large cities – is during twilight. The time in which car headlamps are being switched on and shop windows and street lamps are lighting up. All this happens while there is still daylight about!

The weak daylight also helps you to avoid the big, dark "holes" in the picture that are inevitable in total darkness. After all, houses without any bright windows and not illuminated from outside make no impression on the photographic emulsion at night. And the later you take your photographs the fewer brightly lit windows you will find.

Twilight, on the other hand, creates much more favourable conditions. The residual brightness of the evening sky sees to it that even the darkest parts of the pictures retain some detail, its bluish reflection sets up a harmonious contrast to the yellow-red of the artificial light.

It is a pity that in our latitudes the time of twilight is so short. It lasts no longer than 30 minutes during which the correct mixture will exist between daylight and artificial light. After this the artificial light will be dominant in the picture, and although you can continue using your artificial light colour film, the photographically interesting subjects will have disappeared.

December – the most favourable month

The great opportunity for twilight photography occurs during December afternoons. Naturally both the end of November and the first half of January would also be suitable. Why? November and December herald the coming of Santa Claus and Christmas. Big business, which unfortunately threatens to become a Christmas racket, has veritable cascades of light switched on for your benefit. Endless lamp chains form luminous ceilings above the shopping streets. In addition it may be raining – for which the photographer will be profoundly grateful – so much during those weeks that the whole flood of light will be mirrored in the asphalt.

Above all, dusk falls so early during that time of year that the people will still be at work in offices and shops. Thousands of brightly lit windows right up to the top floors illuminate the building fronts; the evening sky, slowly fading into deep blue, crowns the whole scenery.

Precautions against camera shake

For townscapes and whenever you consider the sky a pictorially important element, point your exposure meter at the evening sky. This gives you a convenient shutter speed of $^1/_{30}$ sec at full aperture which will just enable you to take a hand-held exposure. As soon as slower shutter speeds are necessary you have to look for a firm support for your camera. A rigid tripod is alway the best proposition, but I admit that at least four out of five amateurs prefer their mobility as long as they have a chance to manage without a tripod. In a city or town you can always find a substitute support on which to release the camera shutter at the slow instantaneous speeds down to $^1/_2$ sec without camera shake. A parapet, a railing, the corner of a wall, even a lamp-post can be used for this purpose. For upright pictures I firmly press my Leica against the support with the base plate. For horizontal pictures I prop it as firmly against the post in the right angle enclosed between the lens and the front wall of the camera at the side that allows an unobstructed view through the viewfinder.

But these are only makeshift measures. A tripod is better. Here, too, we have several variations to choose from. The possibilities of the table-top tripod are far too little realized. It had to be given a name some-how, although its use is by no means restricted to the top of a table. It will work admirably when pressed against a vertical wall. However, such a table-top tripod is a somewhat pri-mitive affair without a ball-and-socket head which alone will enable us to ad-just our camera at a mo-ment's notice for vertical and horizontal exposures. If we want to leave our large tripod at home, we simply unscrew our ball-and-socket head from it, transferring it to our table-top tripod.

Once in New York I want-ed to take twilight pictu-res from the platform of the Rockefeller Building where the use of tripods is prohibited. I used the table-top tripod as a perfect substitute, pushing it far to the front on the broad parapet, offering my Leica a view of the yawning depths below. In this way, an exposure of 6 secs. presented no difficulty at all.

Daylight- or artificial-light colour film?

As long as even a trace of daylight remains to contribute to your night pictures, these will strictly be in the category of twilight pictures and can be taken on daylight colour film. I already said that yellow-red

and blue-grey make an attractive pair. However, as soon as the daylight has disappeared, you will get a definite yellow cast. This colour shift is only to be expected, for you are using a film balanced for a colour temperature of 5,800° K in the light of filament lamps of 2,800° K or of fluorescent tubes equivalent to about 4,200° K. We remember all these lights as "white", whereas the colour film "sees" them more objectively.

When all the daylight has gone it is better to use artificial-light colour film. I recommend this in spite of the fact that occasionally pictures of a quite fantastic effect are taken on daylight colour film.

At night

Whether you photograph whole streets or only a hot-dog stand at the Christmas Fair, the city at night offers you an abundance of subjects simply waiting to become colour photographs. Here as elsewhere it is important to fill the frame with the pictorially important elements, i. e. to approach the subject closely if it consists of an individual scene. The speed of the artificial-light colour film (CK 20 = 20 DIN = 80 ASA) enables you to take a large number of hand-held pictures – obviously at full aperture with selective focusing.

It is a great pity that so many scenes are no longer bathed in the cosy glow of light from filament lamps, but illuminated by daylight-fluorescent tubes. These tubes must not be confused with neon lights, from which they differ fundamentally.

Neon lamps employ high voltages of up to 6,000v, whereas fluorescent tubes are run on 240 v. Furthermore, neon lamps are used mainly for advertising in various colours such as red, yellow, blue, and white, whereas fluorescent tubes serve for lighting – which grieves me very much indeed. Because their colour temperature *is not*, it merely *corresponds to* 3,000 or 4,000° K. Because their spectrum shows gaps, to which the colour film reacts with horrible colour falsifications invisible to the eye. Subjects lit by these lamps appear greenish yellow on daylight, bluish on artificial-light colour film. All this is beyond redemption, and as to the skin tones of a human face as a criterion, the less said the better. There are filters which improve the discontinuous spectrum emitted by fluorescent tubes. In fact, there is a whole series of them. I

have in front of me a long article in an American trade publication that explains their use. I think you will be better off without experimenting in this field, and to accept, or rather resign yourself to, the occasional presence of light from fluorescent tubes.

Candles as light sources

It is quite possible to take photographs by the light of a candle. If you skilfully arrange several candles, e. g. in a candlestick, you will even be able to illuminate a nearby sitter. My experience with CK20 suggests $^1/_4$–$^1/_8$ sec at f/2.8. On daylight colour film candlelight appears very yellow, even artificial-light colour film reproduces it in a reddish glow, because the colour temperature of a candle at 1,600° K is still far below that for which the artificial-light colour film is balance. Yet the flame of the candle will come out in a quite creditable white. However, in order to preserve the contours of the candle flame you must protect it from the slightest draught, close all doors and windows; even the person you have asked to look dreamily into the nearby candlelight must be able to hold her (or his) breath at your behest.

With a CdS exposure meter it will be possible to obtain a reading of sufficient reliability with a close-up measurement of the illuminated subject.

Circus, music hall, and theatre

It is very difficult to take photographs in the theatre, primarily because it is not usually allowed. And this is as it should be, for would it not also irritate you, as a member of the audience, if someone in your neighbourhood raised his camera to his eye every few minutes, clicking the shutter? It is every bit as disturbing as people pulling sweets from rustling cellophane bags during the performance.

Also, it is not very rewarding to take photographs from a front row seat if we can move neither to the left nor to the right. Whether or not we like it, we shall always have more or less the whole scene in our well-exposed colour pictures of sufficient sharpness are possible at the maximum aperture of f/2 and with a gentle release of the shutter at

$^1/_{10}$ to $^1/_{15}$ sec. If ever the artificial colour film offers an advantage over its daylight brother, it is here.

Better pictures than from the front rows can be obtained from the side part of the balcony. If necessary, even without the permission of the management. I chance it every now and agian, propping my camera secretly on the edge of the balcony. If it is not too softly upholstered, it forms a useful substitute for a tripod. The most wonderful lens, even for choosing parts from the scene, is a longer focal length with a large aperture.

The later Leica models no longer emit an audible "click". This has now become so subdued that I cannot find an appropriate word for it. "Click" sounds too loud. Perhaps you will accept "muffled click" or "butter-soft click"! Nevertheless there are moments in the theatre where you could literally hear a pin drop; when, of course, one can also hear your Leica. People become annoyed, turn round, all their illusions are destroyed. It is difficult to take photographs in the theatre... but it is easier at variety shows and easier in the circus. For such occasions I always take my Summarit along because its f/1.5 aperture is twice as large as the Summicron's f/2.

The most important condition for successful theatre, circus, and variety show photography is knowledge of the performance or the programme and to have information about the sequence of scenes and climaxes.

Otherwise you will sometimes use up your entire film for the somewhat tedious elephants' number and find afterwards with consternation that the polar bears on bicycles were far more amusing and, in addition, better lit.

You should therefore watch the entire programme beforehand, noting its photographic climaxes! Perhaps you will on this occasion also find out which seat will afford you the best photographic views on your next visit.

In the circus I permit myself the luxury of a box, taking at the most only one companion with me. We try our charm on the lady at the cash desk to obtain a seat in the front row. I thus have only one stranger next to me to give me dirty looks for my camera antics, and do not run the risk of receiving accidental knocks from both sides.

Between $^1/_2$ and $^1/_{25}$ sec.

I take my tripod along but do not set it up, simply because there is no room for it. I only use it with its three legs closed, but somewhat extended, providing me with a rigid "unipod" which I can use sitting down for exposure times of $^1/_{10}$ or $^1/_5$ sec., easily possible for not too fast-moving scenes.

The ushers in their fancy uniforms (from the rank of admiral upwards) mostly show understanding for photo enthusiasts, closing both eyes while you slink behind the stalls around the ring during the performance in order to find different viewpoints for your camera. You must not forget to climb up to the back row, from where you can take – perhaps with a wide-angle lens – the half circle of the audience together with the brilliantly lit circle of the arena. Even if from a rigging support you expose at $^1/_2$ sec. then, certain unsharpnesses due to movement are not necessarily disturbing, because there will be atmosphere in the picture. Come on, have a go!

And remember: artificial light colour film only!

Of course, one could also suggest using the Hobby flash from the stalls. Up to about 17 feet (and closer) you can do without the flood lights, employing your own light source. However, this calls for daylight colour film! Although this will reproduce the background lit by the floodlights in a yellow colour, I for one do not find this objectionable. But to use flash in the circus it is absolutely imperative that you have permission from the management and the performers themselves beforehand.

It is astonishing that even with generous exposures we do not obtain total failures as quickly as we would with subjects in daylight. Naturally, a brightly-illuminated scene – some spotlights are able to pick out one figure alone – is bound to result in falsified colours. However, if ring or stage are reasonably uniformly lit, the transparencies, although considerably lighter, will not be useless for this reason.

I once saw a stage colour photograph in an American photographic magazine, shot from the top of the wings obliquely down on to the stage. A ballet, whose dancers gyrated in wide, billowing skirts in a waltz. In the centre, on tip-toe – the prima ballerina motionless in a dancing pose. The photographer had stopped down and exposed for a whole second without regard for the whirling dance of the other girls. The deliberate unsharpness of movement around the sharply-defined centre gave the photograph an attraction quite its own. Therefore, extreme sharpness is not always the most important factor.

Thunderstorm at night

Let me confess right away – I have not yet photographed a real flash of lightning. By this I mean lightning in the night sky, with many zigzags, just as a lightning flash should be.

Once, however, the great moment arrived, during our holidays (3 a.m. and apocalyptic fury outside). Again and again our bedroom was as light as day when the flashes writhed through the sky. I was immediately wide awake, jumped out of my bed and feverishly prepared my Leica and tripod. My wife protested desperately: one should never stand by an open window during a thunderstorm, this attracted lightning and was sheer suicide. While I opened the window undismayed, a lively dispute ensued about mortality rates of lightning strokes, old

peasant lore (according to which oak trees should be avoided, but beeches sought as shelters against the storm) and other dubious advice for nocturnal travellers in need of protection.

Outside the raging storm, behind me another one about to break – my attention thus divided unfortunately made me turn the iris of my Summicron down towards the right instead of opening it up towards the left. I wanted full aperture, instead I stopped down to the minimum! And in the end I had such lovely flashes bang in the centre of the field of view of my camera which was patiently waiting on its tripod

with, of course, its shutter open! Result: –0.000 – dark, black night – or "Egyptian burial chamber before its discovery".

To take photographs of lightning flashes during the daytime would be tantamount to attempting to attack in a dark wood with a pin an enemy who, similarly armed with a pin, groped his way towards you from a far distance. The chances of the points of the pins meeting in the dark are about the same as those of capturing a flash with your camera during daytime. Because it has passed long before you really saw it. Perhaps you might note that lightning flashes should only be

photographed at night, but with daylight colour film, with the camera, with its shutter open, pointing in the direction of maximum lightning activity. By this method you can "collect" several flashes.

Taking Photographs Economically

A colour film has 20 or 36 exposures. The short 20-exposure length is designed for the benefit of those amateurs who do not use their cameras a great deal and do not want to wait too long for the film to be finished. The long, 36-exposure film is really more economical as it yields almost double the number of pictures although it is by no means twice as expensive. It ought to be possible to squeeze 37 out of it – but the instructions for its use give the well-founded advice to make blank exposures on the first 2–3 frames, because there is no guarantee that a little light might not steal on to the film through the cassette mouth during its insertion into the camera. You will see it yourself when you look at the beginning of your developed colour film; often a brilliant red colour can be seen along the first inch or two of the film starting from its cut end – evidence that the film was inserted in bright light.

Load your camera in the shade

And this is the reason for loading your camera at least in the shadow of your own body and never in direct sunlight! Better still, loading should take place in a shady room and best, of course, in the darkroom, where pre-fogging is completely avoided, and the film can be exposed safely after one or two blank exposures only. Thus you may get 37 pictures out of your 36–exposure cassette.

A glance at the film counter of the camera shows when 36 pictures have been exposed. Some people do not notice this and turn the film on with determination. At last the cassette gives in to the force applied and the film is torn from the spool. Some continue merrily taking their pictures, pleased perhaps at the throught that the film manufacturers have wound a few more inches of film on to the spool to show their generosity. But at picture No. 45 at the latest, things begin to look alarming, and the awful discovery is made that when the rewind knob is turned nothing happens! A sign that something must have gone wrong inside the camera!

This happened to me once on a mountain tour where, needles to say, there was no darkroom within miles around. The film had been torn from its cassette, and it was lying open inside the camera. In order to insert a new one, I had to sacrifice it, throwing it with a deep sight over the yawning precipice. The day was too gorious to miss the opportunity of further pictures.

Helpful changing bag

For such cases we could with advantage take a changing bag along and operate inside its "sleeve". Rubber bands keep its entrance so tight, that with practised fingers we could repair the damage in the absolute darkness of this portable darkroom, while the rest of our body stays outside. Incidentally the black bag can also be put to excellent use as neutral background for close-pictures such as flowers. However, I am afraid you will have left this handy gimmick at home just when it will be most urgently needed. In an emergency you may perhaps ask your travelling companion (the world "fellow traveller" having a somewhat ambiguous ring these days) to lock you into a big wardrobe after the room has been blacked out. Or – but this is a question of breathing technique – you could crawl under a heavy blanket, which is then tucked in around you on all sides. I have been through all this!

Thank heavens it happens only very rarely that the colour film is torn from the cassette spool. If it does happen, I can only wish it will be after the last exposure of a sunset. The night will be your most efficient darkroom!

Be Nice to Each Other!

A tired extra in a film studio once told me that there are two kinds of film directors – good ones, and rude ones. At least this is how the actors see them. The rude ones rant and rave, and their spirit rapidly percolates through the whole studio down to the humblest lighting technician. And finally, the result of the general ill-temper comes home to roost with the impatient boss.

We amateurs, too, can learn a little from this example. Patience is a virtue benefitting photography in general – restlessness and hurry are often the culprits if the wrong lighting and faulty composition spoil an originally attractive subject.

Human beings, too, need to be treated with patience, even if they are members of your own family and your own children! They often serve – photographically speaking – as your models. And they have to, whether they happen to be in the mood for it or not!

If they are not, a photograph will betray in at once! They just refuse to "play ball" merely taking up their positions as ordered. One can really sense the compulsion, the "I don't want to, but I have to"!

Be nice to each other, then, always, if you can, and not only when you need friendly faces. The friendliness and high spirits of models who enjoy the whole procedure can inspire the amateur behind the camera. Good humour improves the pictures immensely; if you are in a bad mood, you had far better leave your camera alone.

Be nice also to the incidental models that you meet here and there. The good-natured stall-holder – perhaps you might buy a pound of apples from her before you "shoot" her – or the peasant behind his plough – a few friendly words, perhaps no more than a remark about the weather – will be enough to establish human contact.

Legal aspects

Some people do not want to have their photographs taken. Some even refuse it outright. Perhaps you are not aware of this "right to one's own picture" which exists in some continental countries. If, for instance, you publish a photograph showing a person who has refused permission for it, you may cause yourself a lot of trouble. Generally you must obtain the express consent of the person shown. Particularly, of course, if such a picture is to be used for advertising purposes.

There are subtle distinctions, though. A personality such as a well-known politician or artist in the centre of public interest cannot take you to court, no matter how unflattering the circumstances in which you have taken his picture (unless he is shown in an offensive manner). But Mrs. Jones with her shopping bag on her arm, of whom you took a snap when she was having a peaceful chat with her neighbour, can sue you for damages. Her claim would certainly be successful if the picture were to be used for advertising, and she was made to recommend a certain brand of detergent washing "whiter than white". However, enough of our pseudo-legal discourse. All I wanted to say to you was that friendliness, if it is not merely put on, but comes from the heart, generally opens all doors to you.

Calmness, the photographer's first need

Let me tell you, finally, that hustle and bustle are definitely detrimental to good photography, apart perhaps from unrepeatable snapshots. If you have become accustomed to a certain procedure for taking your

pictures, you will benefit from this when the need arises. For example:
– take the camera out of your pocket, or open the ever-ready case,
remove the lens cap (always slide it into the same trouser pocket),
measure exposure, set stop and exposure time – raise camera to your
eye, check picture area, measure the range. This would be my own se-
quence. And never hurry!

Again, being hustled either by your watch or by other people is fatal.
You must take your time and ignore other people. Sometimes they can
even be educated, once they have come to realize that there is a dif-
ference between "snapshooting" and "taking photographs".

Some thoughts about the finished slide

The storage properties of the slides

If you ask me whether your grandchildren will derive the same pleasure from looking at your slides as you I would answer "yes" – provided the slides are stored in a dry, cool, and dark place. So long as you do not emigrate to the tropics; in our temperate climate this will raise no difficulties.

The dyes used today in reversal films are considerably more stable than they were in the early days of colour photography. Slides taken in 1936–1939 have hardly retained their true colours today; mine are no exception – they had been evacuated to a damp cellar for many years.

Organizing your slide collection

A certain order among the yearly increasing numbers of slides is to be welcomed. A rough order is already enough; you can write the year on individual slide boxes or magazines, or the journeys or locations where they were taken. Magazines can be stacked and kept ready for use in cupboards or on shelves.

If your slide collection serves not only for occasional shows at home, but is used also for lectures on various subjects, classification in various subject groups will be advisable. As long as the slides are your own, these groups need not be subdivided too strictly.

Colour transparencies in cardboard mounts (slides)

The idea of the "slide", a transparency mounted in a cardboard frame, comes from America. Today any mounted transparency is a slide. It may be mounted without glass, when the transparency, held between cardboard or plastic frames, is freely exposed. This prevents

the occurrence of Newton's rings, a pain in the neck I shall presently describe. The disadvantage of this method is that the transparency is not firmly pressed into a plane but that it can "pop" out of the plane of sharpness. However, the manufacturers of plastic slides have meanwhile found ways of manufacturing their frames so that the warm transparency can expand in all directions within the frame during projection. This greatly reduces popping unless a powerful projector in which the slide is rapidly heated is used.

Glass-mounted colour slides

Cardboard- or plastic mounts are adequate if the slides are to be shown in magazines and automatic projectors because this almost precludes damage during transport or by accidental touching. However, if the transparencies are to be frequently projected during lectures, above all when they are to be individually inserted in the slide changer by hand, glass-mounting is recommended.

Obviously this does not mean that you should glaze each and every slide. It is enough to choose those transparencies which you often use on important occasions. All the others can safely remain unglazed. In many countries Agfacolor transparencies are returned inserted in strips in transparent sleeves, unless you expressly require slide mounting by enclosing a voucher. In such a case I cut out all the transparencies that meet with my approval and mount them temporarily in cardboard mounts which can also be bought. This is for "first nights and passing judgement" with myself the only viewer. Only during projection will you be able to see whether a picture is outstanding or indifferent. The indifferent ones I quickly weed out, not showing them to anyone else, not even to my wife. The good ones I first present to the closest family members, who are very critical. This means a progressive further weeding out. The pictures that remain as "the best" are immediately glass-mounted; they are "fit for lectures".

What happens to the others, not found worthy even of projection? If their colours have suffered because of over- or underexposure I quickly throw them away after diagnosing what I had done wrong. Indeed I burn them, so that not even the dustman will see what rubbish I have produced.

How to correct the picture area

If you want to preserve your very best slides safely, you will glaze them. Before you do this, lightly mount them in cardboard mounts; these are standard masks, white on one, black on the other side. Naturally their windows are a little smaller than the full 24 × 36 mm format, masking about 1mm on each side. This is very welcome, because it enables you to eliminate a large amount of disturbing detail along the margin, and above all to level a horizon line that may have slipped a little. Unlike the fully mechanized slide mounting in the developing stations, individual mounting allows many a correction of the picture area. Above all it leaves you free to alter the whole format occasionally; but you should do this only if it resuls in a real improvement and enhances the impact of the picture. Too many different formats make for a restless performance with the projector because of the continuous change in picture size and shape.

Prefabricated slide mounts

There are numerous slide mounts on the market that make glazing easier. More than 100 different designs are awaiting your pleasure. I must leave this difficult choice to you. Whatever you do, choose mounts supplied with anti-Newton glasses.

The nuisance of Newton's rings

Newton's rings are peculiar phenomena displaying all the colours of the rainbow inside glazed slides. During projection they often writhe in fantastic shapes, arousing the fascinated interest of your audience, but detracting from the pictorial impression. Newton's rings occur when microscopically thin films of air exist between two polished surfaces. They are so-called interference phenomena, which are also found with extremely thin transparent films, such as oil on water. If the polished surface of the coverglass to be placed on the shiny side of the film is roughened the Newton's rings will disappear. The coverglasses manufactured under the name of Newlo glasses etc. are che-

mically roughened and are eminently suitable for dealing with the nuisance of Newton's rings.

How to glaze transparencies

Do not take your film strips out of their protective sleeves until "the last moment". Transparencies left openly lying about easily collect dust. As dust free as possible a place should therefore be chosen for glazing. To eliminate dust it is also essential to use coverglasses that are perfectly clean. Old, previously used coverglasses must be thoroughly cleaned. Even glasses precleaned in the factory should be briefly brushed with a sable brush to remove dust that has settled on them at the last moment.

If the coverglass is held against a dark support every particle of dust

will show up. The same applies to the obliquely held transparency. During this procedure I always take a sable brush across all the surfaces immediately before I cover them with the glasses. Once the transparency is safely between them, you are "home and dry". But inspect it in transmitted light with a magnifier before you finally seal it. With a $\times 4$ magnifier you can survey the entire picture area. If you discover a disturbing particle, lift the glass on whose side it is lodged carefully, and brush the offender away.

My description makes this procedure perhaps more interesting than it is. It is a well-known fact that dust particles will show up only when they are lodged on uniformly bright, large picture areas, i. e. par-

ticularly in the sky. But not all slides include the sky or other large, bright areas. There are autumn woods and street scenes, group pictures and night views which contain no such uniform areas. And therefore reveal no dust. For the "dust game" I pick the most difficult transparencies first – those with much sky etc. – glazing the others, luckily the majority, is child's play.

Projection

Modern projectors use an illuminating system which consists of a lamp with reflector, condensers, and heat filter. The slide trans-illuminated by this system must be reproduced sharp and enlarged on the projection screen by the projector lens. Some projectors include a blower unit, which removes heat from the lamp by vigorously circulating the air.

Low-voltage lamps are gaining more and more ground for use in projectors, because their lighting efficiency is much higher than that of high-voltage ones at a given electrical consumption (watt). To put it more simply: they radiate more light. A 240 v lamp would have to have a considerably higher watt rating in order to reach the same per-

formance as the low-voltage lamp. Because of its low voltage, the latter has a higher current intensity and the glow of the filament is "whiter". The smaller dimensions of the filament have also made a redesign of various projectors possible.

All projectors offered as "fully automatic" are basically only semi-automatic; because "fully automatic" literally means "self-actuating": the slides would have to change automatically at certain time intervals, and above all, sharpness would be automatically readjusted. The conventional remote control from the comfortable armchair does therefore not yet constitute full automation. This only by the way.

Whether of semi-automation or manual operation, a perfect projector lens, in addition to a well-designed illuminating system, is the decisive factor. Its state of correction must be of the same high standard as that of a good camera lens. For what is the use of a perfectly sharp transparency (or indeed of a high-quality camera lens) if it will not be reproduced on the screen at its optimum sharpness because of the poor quality of the projector lens? This would really be saving in the wrong place. If you do not know what projector to buy, have your dealer demonstrate you several side by side. Test slides with printed texts are available that immediately show up any badly designed projector with a poorly corrected lens.

When you buy your projector you must also make up your mind about the focal length of its lens. You have a choice; this should be governed by the conditions of space in which you project your slides. The desired or possible size of the projected image, too, is decisive. You might usefully consult the little table below, which makes your choice easier. A square screen is essential for the projection of upright and horizontal pictures; its side length is given in the table.

Projection distance	Focal length of the projector lens				
	90 mm	100 mm	120 mm	150 mm	
3 m	1.15	1.05			
4 m	1.55	1.40	1.20		
5 m	2.00	1.80	1.50	1.20	screen
6 m	2.35	2.15	1.80	1.40	size
7 m	2.75	2.50	2.10	1.65	(square)
8 m	3.15	2.85	2.35	1.90	

I would advise you to choose a 1.8 × 1.8 m (6 × 6ft) screen for a medium-sized room with a high ceiling and permitting a projection distance of 6m (20 ft), and to use a lens of 120 mm focal length. This will enable you to project on to a relatively high screen above the heads of your audience. For smaller rooms, which will probably be in the majority, you had better be satisfied with a 1.5 × 1.5 m or 1.2 × 1.2 m (5 × 5 ft or 4 × 4 ft) screen and projection from a distance of 4–5 m (14–17 ft) with a 100 mm or 120 mm lens. I would recommend you to set up the projector behind the audience, if possible.

The projection screen

Here is a point concerning the projection surface.

I am talking about surface to allow for those amateurs who might wish to prepare their own white projection wall. These do-it-yourself fans might like to know that the wall should be completely smooth, i. e. even, and pigment paints should be used for it, such as barium sulphate, or magnesium oxide, with dextrin as a vehicle. An expert gave me this advice, but my better half put her foot down when I wanted to have my projection wall painted in our best living room. We have therefore compromised on a screen to be pulled down for use from the ceiling like a large wall map in a classroom. True, it is still visible when rolled up, but I feel entitled to somes small concession towards my grand passion.

Irrespective of its design the projection surface should be a neutral, light plane permitting perfect slide projection. Specially prepared plastic screens have recently come on to the market. The so-called bead screens reflect far more light than any other projection surface; but they reflect it mainly in the direction of the projector lens. Provided the audience crowds around and in front of the projector, all will see a brilliant, bright colour image. However, of a large group of people spread around the projection screen, only those sitting in the centre will enjoy this benefit; the falling-off of the image brightness towards the sides will be very noticeable. You should therefore decide beforehand whether you want to show your slides to a vast audience or to a narrow circle only.

Myconos

Picture page 189

A sparse little tree in the delicate shadow of a whitewashed wall, a reading girl leaning against the wall: here is the essence of the peace of a summer's midday in the sunny south; nothing stirs, not a breath of air, not a sound.

The girl reading is my daughter Sabine, and the sparse little tree grows at the back of a little basilica on Myconos, one of the Cyclade group of islands in the Aegean Sea.

Focal point of this summer snapshot is of course the human element, emphasized by the cool pink of the dress. The pictorial attraction of the colour, embedded in the large, white-grey expanse, is enhanced by the ornamental aspect of the tree with its branches and twigs growing in all directions. The tree encircles, as it were, the human figure, emphasizes tranquillity, restfulness.

This picture is meant to be no more nor less than an example how pure souvenir pictures of holiday events can be conceived so that they appeal not only to the people in the pictures, but also to those that not been with you at the time. And as you can see, there is no need for the scene to be crowded. The pictorial concept is the main feature.

Incidentally: this is a good example of shadows being softened by the neutral reflection of light from brighter surroundings. The sunlit rocks in the foreground largely cancel the lighting contrast. Thus even a close-up reading in the shadow leads to astonishingly short exposures, whose values, by the way, were the same with incident and with reflected light measurement. However, you are by no means obliged to use the stop f/8 measured for $^1/_{125}$ sec, because not much depth of field is required with this flat, rather two-dimensional subject. You can therefore ring the changes on your shutter speed/lens-stop couples with out difficulty; choose the camera-shake-proof $^1/_{250}$ sec and open up to f/5.6.

Leicaflex, 90 mm Elmarit, f/5.6, $^1/_{250}$ sec., Agfacolor CT 18.

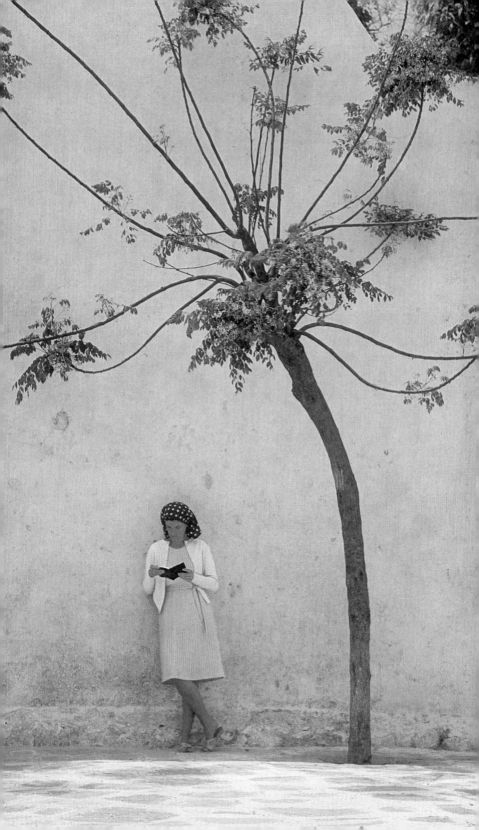

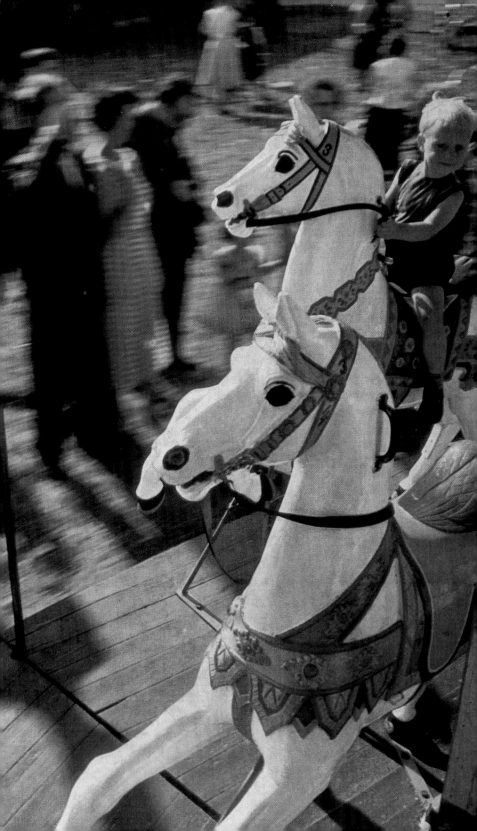

The Roundabout

Picture page 190

There is no better trick for conveying the impression of a moving roundabout than mounting it yourself and taking your photographs as you are being whirled around: the objects on the roundabout itself remain sharp, and the background appears blurred: this creates the impression of speed.

You will hardly be able to do this on a single trip: you will pay for two or three, and use the first for finding the right viewpoint. After all, the little hobby horses are lit by an illumination continuously and rapidly changing from frontal to side to contre-jour light and back.

Perhaps you will sit on your horse back to front; but it must be rigidly fixed to the platform; or you may want to stand in one of the tiny gondolas for the toddlers, with your arm around the brass centre post, which leaves both hands free to operate the camera.

What about the exposure? The rattling roundabout at full speed would normally require a shutter setting of $^1/_{500}$ sec, but you would then lose the blurred background, which is the main attraction of the whole exercise. You will therefore try to manage with $^1/_{125}$ sec, absorbing the shocks as best you can with bent knees, as if you took a photograph from a speeding railway train.

One thing is certain: the better, more credible, and livelier pictures are taken from the moving roundabout, not when you are standing beside it trying to catch your youngest with your camera as he is whizzing past you. The attraction lies in the contrast between sharpness and unsharpness.

Leica, 35 mm Summicron, f/11, $^1/_{125}$ sec., Agfacolor CT 18.

What is "negative after-image"?

You ought to observe a few rules for the arrangement and showing of your slides; they will contribute something to the success of your pictures. Avoid, for instance, the showing of subjects with large areas of intense colours before those with very delicate ones. A slide showing saturated deep red balloons will produce a "ghost image" on the succeeding slide with a physiologically induced cast of the complementary colour, i. e. blue-green. This ghost image is called "negative after-image" by the physicist. Although it rapidly fades during the projection of the next image it will be disturbing at the beginning.

This will teach you not to inflict this kind of experience on your audience. The same applies to the abrupt change from very bright to dark pictures, and from those of a very warm to those of a very cold character. You have already read elsewhere that the eyes adapt themselves fairly quickly, and if you show a number of slides with a strong blue cast in succession, soon nobody will notice the cast any longer (unless you break the monotony with a picture in completely different, warmer colours.)

Alphabetical Index

Absorption, p 82

is the "swallowing up" of light by a substance. The optical means of absorption, desirable or otherwise, are, for instance, light filters, the dyes in the layers of colour films, the camera lenses, but also fog, smoke, haze, etc. The use of filters takes advantage of absorption; the colour of the light passing through is altered.

Additive colour mixture

is the mixture of light of different colours. It can be obtained only by superimposed projection. Light of a certain colour is added to light of one or several others. This produces mixed colours, which are always lighter than each of the original ones. However, as far as colour photography on the basis of additive colour mixture is concerned only the special case is of interest in which the coloured lights consist of one third each of the visible range of the spectrum: the red, the green, and the blue third. If these coloured lights are projected on top of one another at the correct intensities, the mixed colour "white" will be produced. At lower intensities a mixture of these colours appears more or less grey. If the three colour components are projected on to a white wall at different intensities, any desired colour can be produced by means of additive colour mixture. Red, green, and blue are called the additive primary colours.

If two each of these additive primary colours are projected on top of each other at full intensity, a colour mixture is produced that consists of two thirds of the visible spectrum: blue + green = blue green (cyan); blue + red = magenta; red + green = yellow. It will be seen that a mixture of two additive primary colours produces one of the primary colours of the subtractive colour mixture.

"A dose of flash", p 136

Aerial perspective see p 76

This is the decrease of picture contrast as the object distance from the camera increases. It is the result of atmospheric conditions and pollution by dust particles.

Colour distribution, too, is influenced by aerial perspective. The distant parts of a landscape always appear bluish, whereas nearer objects show warmer colouring.

Aerial photography

If you take photographs through the window of an airliner you must expect a certain loss of brilliance, and often even some disturbing reflections. The most favourable altitude for amateur aerial photography is 900–1500ft because of the haze often found at greater altitudes; the best time to take your pictures is therefore soon after start or shortly before landing. Shutter speed: $^1/_{250}$ or $^1/_{500}$ sec. If you fly above the clouds, it is a good idea to include part of the wing in the picture in order to convey a feeling of space. A correction filter (UV or skylight filter) will be necessary here. Use of a lens hood is also essential. Aerial photographs are usually rewarding only in sunlight and when there is not too much haze.

Angle of illumination

of a flash is determined by the reflector and the position of the lamp socket inside it. Ordinary reflectors generally light up an angle of 30–60°, so that picture fields of standard objectives are fully illuminated. The flatter the reflector, the wider the angle of illumination.

Angle of view, p 122

is the "visual angle" of a lens. It indicates how much a lens covers of a subject lined up in the camera. Wideangle lenses have a wide, telephoto lenses a narrow angle of view.

Lenses whose focal length is roughly the same as the diagonal of the camera format are generally called standard lenses. The diagonal of a Leica transparency is 45 mm. The 50 mm lenses for the Leica have an angle of view of 47°.

Antistatic agents
have the task of neutralizing electrostatic charges of films, glass, plastic, and other insulating substances and of preventing further charging. They are available in the form of cloth, paper booklets, pastes, and sprays, as well as liquids. Coverglasses can be kept free from dust before the transparencies are glazed. Dirty backs of films, too, can be successfully cleaned by wiping them with antistatic agents.

Aperture calculator
Modern electronic flash units have practical aperture calculators engraved on the flash holder, which immediately indicate the correct stop after the sensitivity of the colour film and the flash distance have been set. These aperture calculators are very reliable and even allow for the effects of Reciprocity Law Failure. All you have to do is to base your readings on the fact that its data apply to ordinary interiors with the usual reflections from ceiling and walls.

Aperture step,
is the graduated change in aperture from the original setting.

Architectural photography (outdoors)
usually requires a wide-angle, sometimes even an ultra-wide-angle lens for total views. The correct architectural photograph demands almost without exception true verticals; diverging verticals are not acceptable.

Arranging the colours (in the picture space), p 104

Artificial light
is any kind of light from an artificial source irrespective of its colour, such as light from tungsten filament, quartz iodine, xenon-discharge, photoflood, and arc lamps, fluorescent tubes, and magnesium flares.
For colour photography the term "artificial light" is not a very apt choice, since the colour film uses generally only the radiation of sources similar to tungsten filament lamps for the exposure.
In colour photography, "artificial light" covers all light sources emitting light of colour temperatures between 3200 and 3400° K.

The well-known photofloods and the quartz iodine lamps are members of this class.

All the other sources of "artificial" light, such as fluorescent tubes, ordinary household lamps, etc. are, strictly speaking, not covered by the term "artificial light". Flash, too, constitutes a separate category of photographic light source.

Special artificial-light colour film is available for artificial light.

ASA

stands for American Standards Association, the equivalent British organization is BSI (British Standards Insitution), the German one DIN (Deutsche Industrie-Norm). ASA is used in the United States and Great Britain as an indication of film speed (although based on different principles, BSI values are the same as ASA values to all intents and purposes). Double the ASA value means twice the film speed, half the ASA value means half the speed (a 50ASA film is half as fast as a 100ASA one). Conversion between ASA and DIN is only approximate.

Assessment of colour films, p 21

At night outdoors

The possibilities of colour photography are very limited here. Flash illumination is very harsh because of the complete absence of all reflections. This reveals the important role reflecting walls play in flash photography of interiors. It becomes equally clear that the light intensity changes in inverse proportion to the square of the distance.

Auxiliary tripods see p 167 (table tripods)

"Available light"

is a somewhat unfortunate American expression; its meaning in photographic language is slightly distorted, denoting photography in very poor light. The attraction of such pictures lies above all in their typical, natural illumination which may often descend to the treshold of visibility. Only the pictorially important features are more or less distictly lit.

196

The subjects of available-light photography are thus outside the class of those that are brightly lit. Only a few years ago the colour photographer found it difficult to imitate his "black-and-white" colleague with "available-light" pictures. Only the possibility of exposing high-speed colour films through fast lenses has created the right conditions. With the usually slow instantaneous shutter speeds between $^1/_{30}$ and $^1/_8$ sec and slower, which in reportage conditions can rarely be taken from a tripod, occasional camera shake and movement blur is unavoidable. According to the yardsticks by which available-light colour photographs are judged these defects are not regarded as serious. Indeed, a certain amount of unsharpness owing to movement can even be a positive characteristic of such pictures, contributing much to the expression of their atmosphere. Flash can hardly be used in available-light photography, in fact, its "sobering" effect destroys its aims as well as its very definition.

Background colours see p 114

Basic density

In the colour reversal film the deepest obtainable black is called basic density. It is found along the margins and the unexposed film lead and can be measured.

None of the colour reversal films appears impenetrably black when viewed against the light. All colours tend more or less towards brownish, greenish, purplish, or mixtures of these lines, and are translucent when held in front of a very powerful light source. Complete opacity, however, is neither obtainable nor necessary. Nevertheless, the basic density should be great enough that no appreciable difference exists in projection between black parts of the image and the unlit part of the projection screen.

Batteries

are "stores" used in electronic flash units. They supply electrical energy, which is converted into a high voltage current in the generator part of the electronic flash unit. Whereas in the past lead accumulators were used exclusively, today the NiCd battery is gaining more and more ground. It has a longer life than the lead accumulator and needs little maintenance.

Birds eye view see p 109

Bleaching of transparencies, p 181
The dyes used in modern photochemistry are as stable as can be. On the other hand the absolutely light-fast dyes (such as indanthren etc.) are not suitable for photographic purposes. It is necessary to use those which have different properties such as resistance to diffusion, coupling ability etc. It is therefore important to store slides and colour film, and particularly colour prints, in such a way as to preserve the colours. Dry conditions and protection against prolonged exposure to light are the most important requirements.

Blue cast, p 73

Blue sky, p 74

Body colour
When light strikes an object, part of it will be absorbed, another part reflected. The reflected part will be visible as the body colours of the illuminated object. A black body, for instance, reflects almost no light, it absorbs the largest part and therefore appears "black". A green object absorbs all the light except green, which it reflects.

Brightness
The term "brightness" in photography means very little. The eye is unable to estimate brightnesses sufficiently well to result in correct aperture- and shutter speed settings.
Objects of little contrast are often called bright if no comparison is available with other "brightniesses". However, a chimney sweep lit by direct sunlight reflects, believe it or not, far more light than a snowman on a dull winter's day.
This realisation is important since only reflected light can be photographically effective.

Cable release
An important aid to releasing the shutter of a tripod mounted camera without camera shake, for manual release may cause slight vibration of the camera and tripod. A cable release is indispensable with long time exposures.

Cadmium sulphide (CdS) exposure meter see p 41

Camera extension, p 147
The expression was formed in the early days of photography and is derived from the bellows camera. We distinguish between single and double extension. The latter makes it possible to move the camera lens very close to the object, permitting photography at natural size.

Camera position
and angle of view of the camera lens determine the characteristic aspect of a photograph: pictorial perspective or view. Depending on the way the camera is directed at the subject we distinguish between several types of camera position: the "worm's eye view", the "waist level view", the "eye level view", and the "bird's eye view". Unusual camera positions and angles of view also produce unusual perspectives. Both are used by the creative photographer as means of pictorial composition (see also p 106)

Candles as light source see p 170

Cardboard slide mounts see p 181

Cast shadows
are deep, undiluted, or insufficiently softened, cast by a single, very powerful light source. In nature, this light source is the sun. If it shines from a clear, cloudless sky, the shadows it casts will be deep, because the blue sky cannot sufficiently soften them.
Cast shadows create a high object contrast (q.v.) through high lighting contrast (q. v.). They are softened by means of reflector screens or flash, which reduces both object and lighting contrast simultaneously.
Cast shadows are disturbing above all in portraits; especially when the light source was set up higher than the camera, nose and chin will cast deep shadows. Neither in portraiture nor in product photography will several cast shadows result in satisfactory pictures. In portraits particularly, two shadows of the nose are very ugly and betray the photographer's lack of experience. Exceptionally, bi-

zarre, harsh cast shadows are desirable in the background (effect), portraits, stage photographs, product photographs. Here, harsh light (spots) not too steeply from the top is chosen.

Central perspective
Here all rays diverge from a centre of projection. They "pierce" the projection or image plane in the image points and proceed to the correlated object points. This central perspective applies to photographic reproduction. Spatial objects are rendered so that nearer portions are shown larger compared with those farther away; this produces perspective foreshortening.

Changing bag see p 177

Childrens pictures see also p 144
If possible the position of the camera should not be higher than the child's face; the often thoughtlessly taken children's pictures from the grown-up's eye view tend to distort the proportions of a child's anatomy. Childrens' pictures should be unposed, and taken, if possible, during play and other occupations in order to obtain liveliness. A shutter speed of $^1/_{250}$ sec protects against camera shake and movement blur. A good trick is to focus on a certain distance (1.5 to 2m, 5 to 7ft) and to try to keep in focus, following the movements of the child without adjustment of the lens (see p 145). If you focus on the eyes in portraiture, your focusing will always be correct.
Daylight: unlike adults' portraits, children's portraits can stand somewhat harder lighting.

Church windows
Coloured church windows can be photographed very effectively. The difficulties are usually overrated.
Most church windows are at a relatively great height. If the camera is tilted upwards, mostly converging verticals and unpleasant distortions are obtained with the standard lens. It is therefore preferable to take them from a longer distance with a telephoto lens, because this reduces, or almost eliminates, the need for tilting the camera.
The colour rendering is little affected whether the sun shines directly

through the window or the sky is overcast or blue. The colours of old church windows are highly saturated, and variations in the colour of the light have little influence on them.

If possible a highly sensitive (CdS) exposure meter of a narrow measuring angle should be used to determine the exposure. If the angle just includes the window without taking in the dark surroundings that disturb the measurement, the reading can be used directly.

If it is impossible to take an exclusive reading of a high church window, the incident-light measurement outside the church in the direction of the sky can be used as a rough yardstick; you must correct it by opening up the lens by $1^1/_2$ stops. Assuming your outdoor reading was $^1/_{125}$ sec at f/8–11, experience has shown that the not too bright church window will be exposed correctly from inside at f/5.6. Here, too, several trial exposures are recommended at $^1/_2$ stop intervals.

Circle of confusion see sharpness.

Clear flashbulb
flashbulb with an untinted envelope. Unsuitable for daylight colour reversal film, as its colour temperature of 4000° K is too low, producing a yellow colour cast.

Close-up photography, p 146
It is of course well known that exposure must be increased for very close-up objects owing to the increase in camera extension. There is the additional need for the use of minimum apertures in order to increase the depth of field, which is often restricted to a few mm. All this is made more difficult because close-up photographs outdoors may become blurred by the slightest breeze (plants, flowers). Here electronic flash is really more intense than sunlight.

Clouds, p 74

CN 14, CN 17, CN 17S
Code designations for the Agfacolor negative films. Agfacolor CN14: ultra-fine-grain 35 mm colour negative film.
Agfacolor CN17: colour negative sheet-, roll-, and 35 mm film.

The Agfacolor CN films are unmasked and suitable for all types of light

Agfacolor CN 17S is masked. See p 27.

Coarse grain

Although all the silver is bleached out during processing, neither colour transparencies nor colour negatives are grainless. Under high magnification the dyes reveal a structure described as "graininess".

As a rule there is a relationship between film speed and graininess. As with black-and-white films, slow-speed material usually has finer grain than high-speed material.

In projection coarse grain is less disturbing if suitably large viewing distances are maintained. It is most clearly revealed in medium bright, large, and contourless areas. Graininess is not the same in all colours; thus in pure-yellow areas far less grain is observed than in blue and green ones. This is connected with the fact that the yellow of the colour film contributes least to the sharpness build-up of the picture.

Colour cast p 58

Colour cast is falsification of a colour picture caused by defects in the exposure or printing material. Colour cast occurs also when the type of light (the colour temperature) of the subject illumination strongly differs from the type of light for which the colour film has been designed, e. g. under a deep blue midday sky. It will also be found when the whole subject was lit only by the light from the blue sky, i. e. cast shadow of buildings, cloud obscuring the sun. If the blue sky alone illuminates only certain parts of the subject, only these parts will show blue cast. This is called a shift of the colours of individual portions of the object.

Colour differentiation (poor)

In practice this indicates that colours "merge" in reproduction, so that details of similar colours can hardly, if at all, be distinguished. Masking of colour negative films is an attemps to reduce this defect and to obtain a better separation of similar colours.

Colour duplicates, p 23

can be made of colour transparencies:

1. via an "intermediate negative"
2. by direct duplication on reversal film.

The intermediate negative, also called "interneg", is photographed at natural size (1 : 1) on colour negative film. Any number of duplicates can be made on special colour slide film of this negative, which may be masked in order to improve the colour rendering, after precise filter determination (electronic or manual).

In direct duplicating the transparency is photographed on colour reversal film. The best results are obtained on special duplicating film.

All this should be done by a colour processing laboratory unless you are the lucky owner of a well equipped darkroom and have some experience in this field.

Colourfinder, see also (Colour temperature)

A graduated special colour scale on exposure meters (Sixtomat, Lunasix). This finder reveals any appreciable differences between the existing subject illumination and that for which daylight colour film is balanced. However, the degree of deviation can only be roughly estimated.

Colour filters see p 82 (Filters)

Colour foil

is sandwiched with glass-mounted transparencies in order to reduce colour cast that affects the whole picture. The colour foil is transparent, and has a delicate tint. It is quite effective with moderate colour casts.

Colour processes

The modern processes of colour photography are built on the principle of subtractive colour mixture, i. e. the films absorb light in their three superimposed layers. Both Agfacolor negative and reversal films work according to this principle.

The additive process, on the other hand, builds up the colour picture from three separate colour pictures, projected on a screen on top of one another by three projectors. The full luminosity of the three

additive colours projected on the same area produces white. Conversely, the three fully saturated "subtractive" colours projected in superimposition produce black.

Coloured reflections see p 61

Colour reversal films see p 21

Colour shift

occurs when a colour or a part of the colours in individual portions of the picture is falsified by the wrong kind of lighting. It must not be confused with colour cast caused by the emusion (p 58) nor with the colour cast of the entire picture caused by the wrong colour of the photographic lighting (e. g. halfwatt light on daylight colour film).

The film has a fixed basic balance. Because unlike the eye it cannot adapt itself to the surroundings and to the colour of the illumination, a colour shift which is felt to be unnatural often occurs in reproduction. The bluish rendering of some parts of the subject under a deep blue sky, the blueness of the shadows – all this falls under the heading of colour shift, not colour cast.

Colour temperature, p 64

Colour temperature meter

A photo-electric instrument measuring the red and blue components of the light and expressing them numerically. They can be evaluated only by very experienced, usually professional, photographers. The colour finder (q. v.) can be used as a simple aid to the rough determination of the colour temperature.

Complementary colours, see p 25

Contrast see object contrast, lighting contrast

Contre jour lighting

Light coming from the semi-circle in front of the camera. It is always accompanied by shadows of varying length running towards the viewer. It is also called back lighting.

Contre-jour light see p 51 see Illumination

This is light incident in the direction of the camera lens. The parts of the subject facing the camera are in the shade. In colour photography contre jour light is not the easiest of subjects, often calling for compromises in exposure; at the same time it is one of the most attractive types of lighting also in colour photography.

Contre-jour light occurs in sunlight, but also with artificial light and flash indoors.

Conversion filter, see p 65

Converging verticals

If the verticals of an object are not parallel to the film plane because the camera has been tilted, the picture will show a deviation from conformity. This makes buildings seem to be toppling over. The phenomenon is called "converging verticals". Exceptionally they are acceptable as a special photographic means of expression, when a particular perspective is to be shown.

To avoid converging verticals, set up the camera absolutely horizontally.

Copying see p 151

Crystal bead screen

Projection screen whose surface consists of tiny glass beads. Its reflecting power is extremely high, but the brightness is confined to a relatively narrow angle. If you look at the screen from one side, the image will appear darker. Crystal bead screens are recommended above all for narrow-gauge cine-projection in rooms where the audience faces the screen centrally. For a powerful projector, ordinary (painted) projection screens will generally be adequate.

CT18, CK20

Code designation of the colour reversal films made by Agfa-Gevaert A.G.

CT18 is a daylight colour film, to be exposed as for 18DIN (50ASA),

CK20 is an artificial-light colour film, to be exposed as for 20DIN (80ASA).
Both types are available as 35 mm, roll-, and sheet film.

CT-Kopie, p 23

Special duplicating material made by Agfa-Gavaert A.G. Colour transparencies can be directly duplicated in colour (i. e. with the reversal process) on this material. User-processing, too, is possible. Transparencies of excessive contrast are unsuitable for this method.

Daylight see p 73

Daylight colour film see p 65

Decamired, p 65

Deep blue sky see p 73

Depth of field see p 113

Designation of colour films

Colour films have numbers and codes printed between the perforation holes and between the rows of holes and the outer edge of the film. The codes indicate the emulsion batch number, frame numbers, and type of film (daylight or artificial light).
It is essential to quote the emulsion batch number in cases of complaint.

Diffraction of the light

With very small stops, depending on the type and focal length of the lens, e. g. f/16 and smaller, light rays passing along the edges of the diaphragm leaves may be noticeably deflected from their path, i. e. "diffracted". This phenomenon is explained by the wave motion of the light. The result is a slight unsharpness, so that the assumption that very small stops improve the performance of the lens further is not correct. (Depth of field has nothing to do with the general sharpness rendering of a lens).
"Diffraction unsharpness" is made use of with soft-focus screens:

lens attachments in the form of gratings – also pieces of gauze – diffract the light rays and often the definition of the picture. Such soft-focus effects are occasionally employed also in colour photography, but do not play an important role.

Diffuser, p 51
Front attachment of milky-white material, usually hemispherical. It is mounted in front of the measuring window of the exposure meter, adapting the instrument for incident-light measurement.

DIN degrees, p 18

Distant views
are rewarding subjects for the camera only on clear days, because any haze in the atmosphere not only obliterates the detail, but also causes a more or less pronounced blue cast in the picture. Although it is possible to compensate this with a correction filter, in contrast with black-and-white photography there is no possibility of filtering the haze out to improve the distant view.
With distant views the inclusion of some foreground features is always recommended, in order to give the viewer a feeling for the distance (depth).
Pictures to be taken on colour reversal film must be exposed a little more generously than the exposure meter indicates, because the brigthness differences of subjects of this kind are usually small. See p 49.
A polarizing filter (p 85), too, can improve the distant view, because the rendering of the sky will be better when the sun appears on one side.

Distortion (perspective) see p 122

Double contours
appear more or less sharp; there may be more than two; their cause is camera shake during exposure, and when accidental knocks were received by the tripod during a time exposure. Double contours confined to a moving object in an otherwise sharp picture are called movement blur.

Double exposure

is two different exposures on the same piece of film. It is caused when an already exposed film is accidentally inserted in the camera a second time and exposed again. Double exposure can also be deliberate. Generally it is possible only with the aid of a lens cap, with time exposures from a tripod, since almost all modern cameras have an automatic double-exposure prevention mechanism.

Double shadows

of objects photographed in the light from two lamps of similar or identical brightness convey an unnatural impression. One light source should always be dominating, the other subsidiary or fill-in. Only one shadow should be clearly visible in the picture. The same applies to flash from several sources.

Drying agents

are used when films are to be stored in a container for prolonged periods in a very humid climate (tropics). Silica gel is such a substance. Blue gel is silica gel impregnated with a cobalt salt, which is blue in the dry state. When it takes up humidity, it turns pink. After it has been heated in a pan or on a stove it can be made to take up humidity again.

Duplicating colour transparencies
and colour duplicates, see p 23

Exaggeration, perspective, see p 122

Expiry dates

The manufacturers of colour films guarantee their products for a certain period, limited by the "expiry date" embossed on the cardboard box in which the film is sold. However, justified complaints are met only to the extent of replacement of the material complained of. A film manufacturer can, for instance, not be held responsible for loss of earnings or travelling expenses caused by faulty matrial or processing.

If a colour film is stored correctly it can as a rule be used even after the expiry date. If you have several such films you will be well ad-

vised to expose one film and have it developed first in order to make sure that you will have no unpleasant surprises with the rest of them.

Exposure, p 38

is the product of the light flux passing through the lens and the duration of its effect on the film. It is determined by the two magnitudes "lens aperture" and "shutter speed" (exposure time).
Exposure produces a "latent" image ("invisible to the eye"), which becomes a black-and-white (or colour) picture only after development.

Exposure errors, p 38

can be caused by the wrong handling or reading of the exposure meter. They can also be due to mechanical errors such as wrong settings of the iris diaphragm or of the shutter speed. They have the following effects:
Overexposure of reversal film = transparency too light
underexposure of reversal film = transparency too dark
overexposure of colour negative film = negative too dense
underexposure of colour negative film = negative too thin.

Exposure extension

is the correction of the data obtained with the exposure meter necessary in certain conditions. If, for instance, a polarizing filter is used the light reaching the lens will be weakened; the exposure must be increased beyond the value indicated by the exposure meter. The same applies to extreme close-ups with long camera extension. The exposure must also be increased for objects of very poor brightness contrast on colour reversal film.

Exposure factor

is a quantity which indicates by how much the measured exposure time must be increased. Such increases are particularly necessary in close-up photography. Thus an exposure factor of 4 is required for a close-up photograph at natural object size 1 : 1. A shutter speed determined as $^1/_{15}$ sec at f/11 will become $^4/_{15}$, for all practical purposes $^1/_4$ sec.
Factors for exposures through filters are called "filter factors" (q.v.).

Exposure latitude see p 38

Exposure measurement, p 40
 We distinguish between two main types of exposure measurement: reflected-light measurement (p 46) and incident-light measurement (p 51). With reflected light measurement in turn we must distinguish between:
 measurement from the camera position (integrated measurement)
 close-up measurement
 measurement of the subject contrast (with close-up readings) the substitution method (measurement of substitute objects).

Exposure meters, p 40

Exposure tables, p 40

Faithful colour rendering
 Object colours are reproduced correctly on the film. This demand cannot be completely met by any colour film, because no film material has dyes of ideal properties. However, the colour rendering obtainable today is faithful enough to achieve great similarity to the real subject.

Field of View
 Every lens has its field af view, but one must distinguish between the total and the useful field of view. Not everything is used even of the latter (e. g. a 6 x 6 cm film gate in a 6 x 9 cm camera).

Film insertion
 The camera should never be loaded and unloaded in direct sunlight. It is best to do this indoors or at least in the shade; even in the shade of one's own body. Neither the film cartridge nor the backing paper of roll film are absolutely light-tight.
 Protect the open camera against rain and cigarette- or cigar-ash during loading. Avoid the beach during wind or storm which might blow sand granules into the film guide.
 Protect exposed as well as unexposed film by keeping it in its container up to the last moment. Exposed 35 mm film in car-

tridge should be completely rewound after exposure, so that the film lead disappears through the slot; this avoids confusion with an unexposed film. However, the completely rewound films are more prone to fogging as the film lead no longer acts as a seal of the cartridge slot. If you prefer the lead of your exposed film to protrude from the cartridge – which also makes work easier for the processing station – you may slightly tear it to mark it as exposed.

Film plane

is the plane in which the film is situated during the exposure. It should coincide with the image plane. It is maintained with the aid of pressure devices such as a film pressure plate. The best plane position is obtained with perforated film.

Filter factors

Every filter absorbs a certain portion of the light passing through it. Whereas with very lightly coloured filters the loss of light is so small that it can be ignored for the exposure, this must be increased with denser filters. This increase is determined by the filter factor given in the form of a number by the filter manufacturer. With a factor of 2, for instance, exposure must be doubled, i. e. either the next slower shutter speed is set or the lens opened by one stop. If the depth-of-field conditions permit, it is better to allow for the filter factor by the choice of a larger aperture. This adjustment is preferable also because many shutters allow changes of the order of full light values only. Intermediate speed settings are not possible on all shutters; nor are they accurate enough. On the other hand, the diaphragms of well-designed cameras can be very accurately adjusted at $1/2$ and $1/3$ values.

Filters for flash photography

The light of blue-tinted flashbulbs as well as of electronic flash is balanced for daylight colour reversal film. Its spectral composition should correspond to that of mean daylight (i. e. the position of the sun most favourable to colour photography). Correction filters are generally not required.

Fingermarks on colour transparencies and negatives
can be removed with some care. Moisten (do not soak) a piece of cotton wool with carbon tetrachloride and wipe the film gently. The fumes are noxious; work by an open window only. Rub several times rather than too vigorously.

Fires
Generally, fires will hardly make a great show when photographed in full daylight. A large fire will naturally produce impressive pictures mainly on account of the multicoloured clouds of smoke; a deliberately short exposure will help to dramatize the glow of the flames. A better rendering is obtained in subdued daylight in the shade or under an overcast sky and above all in twilight. Fires, camp fires, the burning of stubble after the harvester etc. should be photographed in twilight if possible, because the contours of the surroundings will still be registered and the all-dominating glow of the fire will become photograhically most effective. The exposure is not easy to determine, because mostly a close-up reading of the fire is obviously ruled out. The integrated reading should therefore be used, and, if possible, 2 or 3 additional pictures taken at reduced exposure times even if this results in a certain degree of underexposure.

Flash
Bounce flash (q.v.) is most suitable particularly for small children, because of its soft modelling and above all because it permits the use of the same lens stop at various camera distances.
All the terms of flash technique important in colour photography are listed in alphabetical order.

Flood lamp
is a lamp with a large, shallow reflector. The shadows cast by objects lit with it are soft, especially when the light source is covered by a concave mirror cap, so that only the light reflected into the reflector can be radiated.

Fluorescent lamps
are only very rarely suitable for colour photography. Part of the spectrum is missing from their light, which also makes it impossible

to measure the light colour in °K. With much experience and after numerous experiments light from fluorescent tubes can be used for colour photography with suitable conversion- and correction filters, but a more or less faithful colour rendering will never be achieved. You will therefore have to accept that light from fluorescent tubes will appear yellow-green on daylight, and bluish on artificial light colour reversal film in indoor and outdoor subjects from which the light from such sources cannot be excluded.

Focal length
is the most important determinant of an optical system. It is the distance, in mm, between the focal point and the associated principal point (within the lens system).

Focusing bellows, p 146

Focusing plane
Lenses form a sharp image of the plane on which they are focused. In front of and behind this focusing plane sharpness falls off increasingly. Even at small apertures maximum sharpness coincides with the focusing plane, but transition to unsharpness is more gradual than at full aperture: the depth of field (q. v.) is greater.

Fog pictures see p 75

Follow pointer
Exposure meters built into the camera are coupled with the lens diaphragm by the movement of a follow pointer, which is adjusted to coincide with the instrument pointer after deflection. With cameras in the upper price range, such as single-lens reflex cameras, the follow pointer in visible next to the viewfinder image so that it can be adjusted while the camera is in the action position and the subject is being observed. In hand-held exposure meters the follow pointer is used for storing the measuring result.

Fresnel lens
is used for focusing screens and considerably brightens the screen image from corner to corner. It is fitted in some single-lens reflex

cameras such as the Leicaflex. In most cameras of this type the Fresnel lens is recognized by its fine concentric grooves.

Frontal light
Light reaching the object from the direction of the camera. In nature, light from the sun in the photographer's back.

Frontal lighting
comes from the semi-circle at the back of the photographer.

Front lens attachment
An additional lens attached to or screwed onto an ordinary camera lens, and increasing or reducing its focal length. Mostly used in close-up photography.

Glass
Untinted (clear) glass should be lit so that the contours are dark, revealing the shape and finish of the material better. This effect is obtained if the glassware is placed on a sheet of glass of sufficient size, below which lamps can be set up, or the objects can be lit obliquely from below by reflection from illuminated sheets of white paper or cardboard. The light must not strike the glass directly. The exposure is best determined by incident-light measurement (see p 51).

Glow lamp
An electronic flash can be fired even before this glow lamp lights up, but there is no guarantee that it will be at its full intensity.

Gold
The reproduction of gold is particularly successful on colour reversal film, because projection gives the image the necessary colour saturation for a beautiful rendering of gold tones. It is more difficult on paper prints from colour negative film, because the limited luminosity of the paper print is insufficient to simulate gold tones.

Golden Section
is the basis of a rule governing pictorial composition. It states that pictorial harmony is created when the ratio of the smaller dimen-

sions in the picture (areas, lines, shapes) to the larger ones is the same as that of the larger ones to those of the whole picture.

In practice this can be expressed by the numerical ratio 5 : 8; in photography, an estimate of 2 :3 will be sufficiently accurate. Thus, the sky may take up one third and the landscape two thirds of the picture or vice versa.

The modern trend of photography, however, tends to disregard this rule when special presentation is aimed at, i. e. when large features are to be overemphasized or something new is to be shown from a very unusual angle. We often find pictures by great masters completely negating the Golden Section in revolutionary protest against tradition.

Gradation

literally means "progress by steps". In photography it represents the rendering of detail of different brightness or colour in the original in corresponding tone-value steps in the photograph. This gradation applies to both grey tones and colour hues.

A film of so-called "steep gradation" produces more brilliant, but often also excessively hard pictures. A film of "soft gradation", although it effectively bridges contrast, will produce unsatisfactory, weak colours when the subject lacks contrast, above all in dull light, e.g. in dull weather, not to mention rain.

Compared with earlier ones, modern colour films have a medium to flat gradation. Their exposure latitude (p 38) is therefore relatively wide. In the negative/positive technique (contact prints or enlargements of colour negatives) it is important to have colour paper of normal gradation available for normal negatives, and of harder gradation for soft negatives. This allows control of the gradation of the colour print by the choice of the suitable paper grade.

Do not attempt to vary the gradation of colour reversal film by modifying the development; this may produce a colour shift.

Graininess, see Coarse grain

Grey card

is used for exposure measurement with the reflected-light method. It can be employed to determine not only the exposure but also the

lighting contrast, the light distribution, and the illumination of the background. It must be held as closely as possible in front of the object, with the grey side to be measured facing the camera. The reflecting power of the grey card is 18 %. Every grey card, available from film manufacturers, is accompanied by detailed instructions.

Grey filters

are neutral-grey taking filters that merely reduce the intensity of the light reaching the camera lens, without changing its colour. They are essential when, in order to restrict the depth of field, it is necessary to work with the largest possible apertures, but when the camera does not provide the very short shutter speeds these call for.

The grey filter is used mainly by professional photographers in creative (also fashion) photography.

Grey rendering

A colour film will be able to reproduce all colours (approximately) faithfully only if it is able to reproduce the grey tones in neutral grey, i. e. without a trace of colour, throughout their brightness range. This condition raises considerable difficulties in the manufacture of colour film. Agfa succeeded in producing, in their Agfacolor CT18, a film which renders grey as perfect grey and therefore meets the most stringent demands.

Group pictures

The group as a souvenir photograph pure and simple is very popular, although it usually appears stiff, arranged, posed. After all, everybody should be easily recognized, which is the ultimate purpose of the group picture, in colour no less than in black-and-white.

With small groups it will not be difficult to surprise the members in some activity or other (taking tea, playing cards, pursuing hobbies, etc.). Keeping a large group busy in order to inject more life into the picture is an almost impossible task.

When groups are taken with flash, the members should not be arranged in any depth, because those in front would be over-, those at the back of the group underexposed.

Bright sunlight is unfavourable for group pictures. The soft light of

a dull day is preferable, because it avoids harsh shadows and does not make the people squint.

The background should form a contrast with the group. It should be dark when people are dressed in light, and light when they are dressed in dark colours.

Guide number

Important factor in flash technique. To convert a guide number based on metres into its equivalent in feet, multiply it by 3.

In flash photography the guide number plays an important part. It saves the photographer the use of an exposure meter, which in any case cannot respond to flash, and of exposure tables. The guide number is a value fixed for a type of flashbulb or a type of electronic flash, indicating the power of the flash. By dividing the guide number of a colour film by the flash-object distance you will obtain the lens aperture. Example: let the guide number for Agfacolor CT18 be 28, the distance between flash and object 5 m: $28 \div 5 = 5.6$ (f/). Conversely $28 \div 5.6 = 5$ (m, flash distance). If we reckon the flash distance in feet (17ft in our case), the guide number would be 95: $95 \div 17 = 5.6$.)

Haze filter p 83

Haze filters absorb ultra-violet light, cut down the blue cast of the picture in haze, and their effect generally corresponds to that of an ordinary colourless UV-absorbing filter.

Hazy weather, p 75

Highlights

are the brightest portions of a photograph. They must neither be "blocked" (too dense) nor lack detail (be burnt out).

In the negative the highlights should still be translucent and their detail well differentiated. Here they are the portions of maximum colour density.

In the reversal film, as in a print of a negative film, they are the portions of maximum transparence and of most delicate detail. To prevent both their blockage and burning out, colour reversal film must be exposed with much greater care than colour negative film.

A special type of highlight are the lamps, the glitter of specular surfaces, reflections of a rippling sheet of water, as well as all manner of flickering, scintillation, glistening, glittering and sparkling. Since most of these highlights are minute, and even in reality lack detail, they need not show detail in the picture either. They usually occur as star-shaped flares, adding a peculiar attraction to the pictures they enliven.

High key
is a special photographic style based on illumination within a bright, high tone range. A colour subject should be confined almost exclusively to the lightest of pastel colours, the background, too, should be bright, sometimes even pure white. But very small portions of deep black should also be included, for it is they which form the main attraction of a high-key picture: in a portrait, the eye lashes, eye-brows, hair, jewellery, etc.
For studio photographs only soft photoflood lamps are used.
High-key photography is a domain of the very advanced amateurs and above all of the professional photographers.

High mountains see Mountain photography

Hoarfrost see Iceferns

Home pictures
In the narrowest sense pictures of life at home. In daylight they can be taken near the window without any supplementary lighting.
Whereas colour photographs taken indoors can suffer from colour shift (reflections from wallpaper, blueness of shadows, etc.) and filter corrections to be successful require a great deal of experience, work with photofloods (q.v.) or flash (q.v.) produces more reliable results; however, this requires that the windows are blacked out as long as there is daylight about.
If the window is to be included in the picture, it is best to use daylight colour film and electronic flash. The light should reach persons obliquely from above, if possible, because pure frontal light mostly produces flat, expressionless faces.

Ice ferns

are best photographed in the direct contre jour light passing through the affected window. Obviously, the sun must not shine directly into the lens, but should be on one side. Often the light is dispersed and sparkles in many colours. The near-focusing range is essential, and the ice ferns should be taken, if possible, not further away than 50 cm 20in), with the standard lens. The greatest appeal of this subject lies in its display of delicate detail.

Since ice ferns on windows have little object contrast, certain corrections of the reflected light measurement will be indispensable (open up the stop or choose a slower shutter speed) when colour reversal film is used. Any too generous exposure, on the other hand, would obliterate the finest detail. It is therefore urgently recommended to take a sequence of 2–3 exposures at $^1/_2$ stop intervals

Incident light see p 45

Method of exposure measurement concerned with the light illuminating the object instead of the object itself.

Incident-light measurement see p 51

Indirect flash

also called "bounce flash" means that the flash is first directed at a reflecting surface, from where it reaches the object as diffuse reflected light. This softens the flash considerably compared with direct flash, but obviously weakens its light power.

"Infinity"

The symbol for infinity (∞) on the distance scale indicates the setting of the camera lens at which distant objects will now be "sharp" on the film.

Instantaneous shutter speed

Strictly speaking all the shutter speeds of fractions of a second should be classed as instantaneous. Im practical usage, the term is confined to those speeds which, when used with the camera handheld, give some assurance of avoiding camera shake: $^1/_{30}$ sec and faster.

Intensity of illumination

In order to be photographed, every object must be struck by light, i. e. illuminated. The intensity of this illumination is completely independent of the kind of object, it remains the same even if the object is replaced by any substitute object, such as a grey, white, or coloured reflector. The intensity of illumination is determined by measurement of the light.

Interference

If a microscopically thin layer of air is included between two polished surfaces, interference phenomena can be observed. The irritating Newton's rings (see p 183) are manifestations of interference, which also occur on very thin transparent films, e. g. of oil on water. The coloured reflections on coated lenses, too, are interference phenomena.

Intermediate negative

This becomes necessary when an enlargement of appreciable size on colour paper is to be made of a colour transparency. Masked intermediate negatives ensure effective colour differentiation.

Intermediate rings

are screwed between the camera and the lens for close-up photography.

Internal reflection, p 133

usually shows up as star-shaped light patches or more or less dense coloured fog. It is caused by reflection of the diaphragm leaves within the individual elements of the camera lens when brightly shining lights, e. g. in contre jour subjects, water reflections, night pictures with powerful light sources in dark surroundings, reflections of flash from specular surfaces, are inside the picture area. The more closely these strong light sources are situated to the margin the stronger the possibility that ghost images of the iris diaphragm will occur in addition to the reproduction of the light source itself. Internal reflection occurs rarely, if at all, at full aperture.

Interiors:
Flash is also eminently suitable for the lighting of interiors. Even if the room receives daylight, strong lighting contrasts usually exist, which cannot always be accommodated by the exposure latitude of the colour film. A slight lightening of the dark portions is advisable but their shadow character must not be completely destroyed.

Iris diaphragm
is used in order to regulate the "relative aperture" of a lens or to obtain a greater depth of field. The aperture stop numbers have been internationally standardized:
f/1 – 1.4 – 2 – 2.8 – 4 – 5.6 – 11 – 16 – 22 – 32 – 45 – 64.
Their progression has been arranged so that each next larger number calls for a doubling of the shutter speed(exposure time). Only half as much light as at f/1.4 passes through a lens that has been stopped down to f/2. The smaller the number in the aperture scale, the larger is the lens aperture. In photographic practice the iris diaphragm is used mainly to control the depth of field. Its importance in controlling exposure is only secondary.

Kelvin degrees see p 64

Landscape pictures see p 105

Latent image
Latent means "hidden", "invisible".
When a film is exposed, no image can be detected at first. The light-sensitive substances are merely prepared for development by the exposure. This existing, but invisible, image is called the "latent image". It will recede unless it is developed within a reasonable time after exposure. Exposed colour films should therefore be developed without undue delay.

Lens hood (see p 89)

Lens speed
In photographic usage a term denoting the "relative aperture" of a camera lens. It always describes the maximum aperture. The larger this is, the "faster" the lens, the more light will reach the film.

Picture page 223

This contrast between the shabby, crumbling shacks and the festive group of happy people is one of the most impressive experiences of my brief visit to India. This was one of the rare occasions when, quite unexpectedly, out of the blue, I was confronted by a scene, of which I was able to take one of the few pictures I would consider a real success.

The sun had just set. Delhi was sweltering under its characteristic canopy of dust and haze. Dusk quickly followed, the photographic day seemed at an end. My camera was already stowed away, a taxi was taking me from the centre of the city to my hotel. It was sheer accident that took me past this Hindu wedding.

With a quick glance I saw this great photographic opportunity, but I also realized that it would be pointless to take my pictures amidst the throng of noisy revellers; for within a few seconds I should have been surrounded by a swarm of children, and the chance of any unposed pictures would have been irretrievably lost. What would have been an even greater hazard was a possible invitation from these most hospitable and simple people to a table which to me was as unaccustomed as it appeared strange to my eyes. It would not have been my first experience of this kind, with deplorable after-effects.

A bridge on high piers led across the street immediately next to the scene. I thought that I might be able to get a more compact and undisturbed picture from up there. The taxi driver saw my quandary. The minutes it took him to reach the bridge through turning and twisting back alleys seemed to me like eternity in the fading light. At last I was able to push my camera carefully on to the stone parapet, which also served as a support for the unavoidably slow shutter speed. As quickly as I could I varied my shutter settings several times, changed from the horizontal to the upright camera position, and used several focal lengths. (When you are faced with something unique, unrepeatable, you do not stint on film).

This is how I obtained a very typical but also very extraordinary picture of India. On the right the group of women in their colourful saris, on the left the men in their blue and white dhotis. And in the centre of

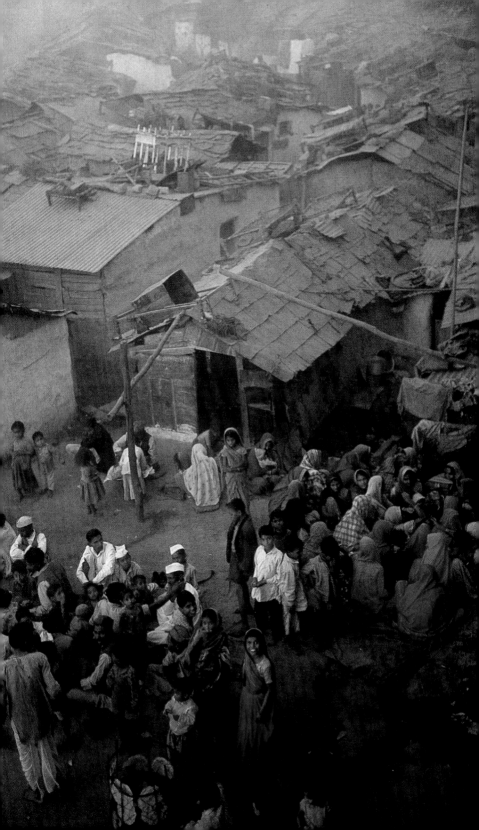

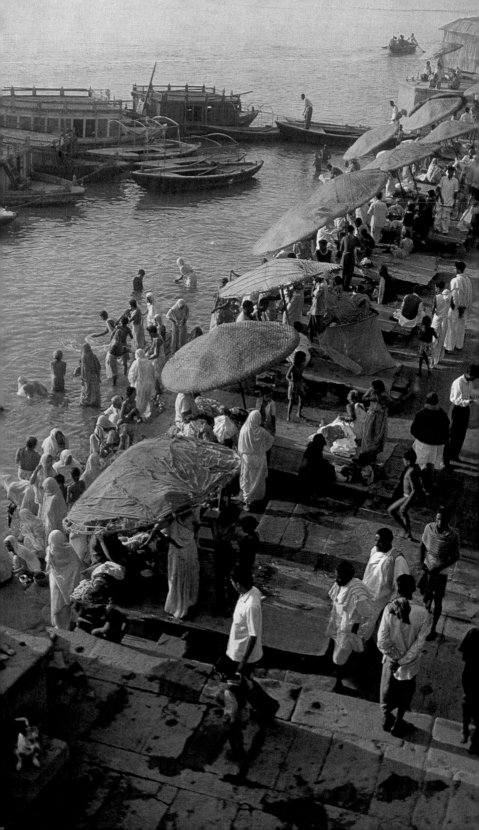

the picture a luminous accent in colour: the single woman in delicate, cool pink.
The neutral grey-blue rendering of the surroundings is evidence of the unsurpassed colour quality of the Agfacolor film.

Leicaflex, 50 mm Summicron/ f/2.8, $^1/_{15}$ sec., Agfacolor CT 18.

By the River Ganges, Benares

Picture page 224

Benares on the holy Ganges – religious centre of the Hindu faithful. Pilgrims arrive from near and far in order to entreat the divine powers in silent prayer and with ritual baths to grant them happiness and mercy.
They enter the water in the early morning before the scorching heat of the day bears down on the colourful melee of their busy lives.
The tourists, too, are up and about before sunrise in order to watch this spectacle, as fascinating as it is strange.
The long shadows and the tendency towards yellow in the picture reveal that it is early in the day; the picture was taken less than an hour after sunrise. If you observed the usual rule of waiting two hours after sunrise before taking colour photographs you would miss the climax of all the hectic activity.
The picture of the cooling sunshades was taken on one of the flights of steps, the ghats, leading from the river bank high up to the former Maharajahs' palaces. They offer the very welcome raised camera positions and eliminate the intersections, unavoidable from the usual eye level view. This also makes it possible to concentrate the viewfinder field on the pictorially important elements, and to eliminate the horizon. From this viewpoint, a diagonal composition suggests itself almost automatically.

Leicaflex, 90 mm Elmarit, f/11, $^1/_{60}$ sec., Agfacolor CT 18.

Lens stop correction

For flash pictures in ordinary rooms the lens stop calculated with the guide number or indicated by the aperture calculator can generally be used directly. A correction will be required for work in large spaces without strongly reflecting ceilings and walls. This applies particularly to night shots outdoors.

Lens stop correction is particularly important when the light power is distributed through several flash tubes, because this halves instead of increases the luminous intensity of the flash.

Light

is above all a sensory impression conveyed by the eye. We perceive light when we look at a (self-luminous) light source. If this source irradiates a surface, the latter will reflect, depending on its reflecting power, more or less light. The light from it originates elsewhere. In photography we almost invariably record light of this nature. If a body reflects little of the incident light, we find it "dark", if it reflects much of it, we find it "bright". Bright and dark are subjective terms of little use to the photographer. The light is evaluated objectively by the exposure meter.

Whether light is regarded as white depends completely on the "mood" of the eye: from its adaptation to the prevailing dominant colour or type of the light. Thus the eye is also unable to assess the colour quality of the light unless most accurate comparisons are available.

Light box

is a device for judging the colour of transparencies. It consists of a box, housing either fluorescent tubes or filament lamps, and covered with a sheet of opal glass.

When 35 mm transparencies are viewed, they should be masked all round to avoid glare from the much greater brightness of the surrounding opal glass.

Lighting, p 38

Every colour photograph requires a certain illumination. We distinguish between the various types of illumination according to:
 the type of light

the direction from which the light reaches the object

the colour of the light, usually expressed in "colour temperature".

Regarding the type of light we distinguish between diffuse and parallel light and forms intermediate between the two extremes.

Diffuse light is found under a veiled sky without sunlight, in dull weather, in the shade, and in the photographic studio with large, wide-angle and soft-light photofloods. Diffuse light does not produce much modelling. But it is eminently suitable for the illumination of subjects to be taken in "High-key" (q. v.). Parallel lights is harsh, i. e. it casts deep shadows and emphasizes the shapes of objects, without, however, creating soft transitions. Sunlight, too, is strongly parallel, but usually softened by reflection from clouds, rocks, walls, etc.

Depending on the position of the light source we distinguish between front, side an back lighting.

Lighting contrast

is the difference between the intensities of the various lights falling on an object. In daylight, lighting contrasts are usually present; almost all objects are illuminated e. g. by the sun as well as by the sky. For instance, that part of a face not lit by direct sunlight receives only the diffuse and weaker light from the sky. This produces a lighting contrast with the sunlit portion. White clouds in the blue sky reflect the sunlight more strongly, reducing the lighting contrast. In an overcast sky the light falls on the object from all sides, and the lighting contrast is therefore very low. Here the object shows contrast only by virtue of the different reflecting powers of its various parts. This type of contrast is called object contrast.

Lighting contrast is particularly high in contre jour light without fill-in. One of the methods of softening the shadows consists in the use of natural reflectors such as the beach, light walls, light stone floors etc.).

Light parallax

When a flashlamp is mounted directly on the camera in close-up photography, it will no longer illuminate the object frontally, but from above or obliquely from above. Therefore it is not the full light cone that reaches it, but only its edge, which has not the same lighting intensity as the centre.

It is therefore advisable to tilt the flash lamp at the object at distances of 50cm and below to correct this.

Light value

A value defined by the lens stop and the shutter speed and not to be confused with the guide number of flash units. The step from one light value to the next corresponds to that from one lens stop to the next or from one shutter speed to the next on the shutter speed scale.

Low key

A print whose tone values are predominantly in the dark range is in low key. Low-key pictures, even in colour, are often sombre, melancholic in character, and suitable for conveying depressing moods.

A low-key picture is the result of a certain kind of illumination, not just of deliberate underexposure. Subjects for low key are: city streets at night, ships by the quayside at night, interiors with a night atmosphere, highlights on the faces of persons photographed at night, photographs by candlelight or in the glow of an open fire.

Mallory batteries

are midget mercuric oxide batteries in a flat, round metal casing; they are used as current sources for CdS exposure meters, for the automatic control of exposures, and for special cable releases with little lamps. Their life is about 2 years. Their voltage remains constant almost until they are exhausted.

"Masks" see p 28

"Masks" see p 28

M-contact

This is a synchro-contact establishing full synchronization between flash lamps and the camera. The M-contact is provided in cameras with a between-lens shutter for the use of flash, where it closes the firing circut a short time after the shutter is released (exactly 0.016 sec before the shutter leaves have opened to half the total aperture of the shutter). Hence the flash is fired within the period of maximum shutter opening. Since the flash duration of the lamp is longer than the effective shutter action, the exposure time is determined

solely by the shutter. It is therefore possible to synchronize all the shutter speeds, even the highest.

Attention: If electronic flash is accidentally triggered with the M-contact, the film will not be exposed, because the flash was fired in advance of the shutter action. See X-contact.

Memory colours

Colours whose properties are accurately recollected. They are colours always rigidly associated with a certain occurrence in nature, such as the red of a tomato, the yellow-green of the unripe as well as the yellow of the ripe lemon, the blue of the deep sky, the colour of a face etc.

Colours of object of our domestic surroundings (fabrics, wall paper etc.) are not memory colours. (see also p 60 "The eye can be deceived").

Messuring angle

This is the conical section of space covered by the light-sensitive element (photo-cell or photo-resistor). The parts of the subject within the measuring angle are covered by the exposure meter either individually or wholly, depending on its measuring angle. In selenium cell instruments this is about 50–60°, in instruments with photo-resistors about 30°. The narrow measuring angle permits more accurate measurement from a given position than a wider one. The most accurate close-up readings can be taken with it, indeed, subject details can be measured from the camera position in order to determine the object contrast (q.v.).

Mixed lighting

A mixture of several types of light of different colours. This can be disturbing in colour photography. There is no means of filtering mixed light out with a filter in front of the camera lens. Only when the various types of light can be switched on and off individually and matched with each other will a mixture be possible that corresponds to the wishes of the photographer. Examples: daylight and artificial light, electronic flash and artificial light. Except for some specially desired effects, mixed lighting is unsuitable for colour photography.

Mired see p 65 (Colour temperature)

Mirror pictures
are photographs of persons or objects via a mirror. The mirror is set up obliquely to the camera, and the object to be reflected set up at the same angle to the mirror surface. Mirror pictures come into their own with self-portraiture or when double portraits or double aspects of a person from different sides are required. For self-portraiture posture and facial expression can be closely observed in the mirror. If the camera is not to appear in the picture it will have to be set up on a tripod so that it will be seen at the very edge of the mirror, which can subsequently be masked on the transparency, or trimmed off during enlargement of the colour negative film. A long cable release must be used for releasing the shutter. Mirrors, which must of course be spotlessly clean and as plane as possible, can also be used to increase the camera distance (the object distance). If with an interior subject the distance is insufficient for a direct photograph, a mirror can be suspended and its images of the interior (furniture etc.) photographed – round the corner, as it were.

Monochrome
means "of one colour", so that the term is seemingly unimportant in colour photography. However, so-called "monochrome" subjects can be very attractive in colour photography, even if their hues are confined to a single colour or colour mixture.

Moonlight see p 156

Mountain photography
The higher the mountains, the more attractive the subject. Their effect is less striking in frontal lighting, only side lighting or contre jour will really show mountains at their most impressive. An interesting foreground is very important, because this is essential to giving a feeling of depth and an idea of the size relationships. Experience has shown that the more convincing photographs of high mountains are taken from valleys with suitable foregrounds; from high up, usually with bare foregrounds, they look less impressive.
Clear days, typical of the autumn, are ideal for mountain photogra-

phy. Furthermore, this time of the year is particularly favourable to colours of the trees. The risk of blue cast during midday is also reduced.

Distant views should, if possible, be photographed only in clear weather and with long-focal-length lenses. Here, too, a colourful foreground will enhance the impression of depth. A UV filter is recommended at altitudes of 2000 m (6500 ft) and above.

During climbing and tiring treks, the shutter speed should not be slower than $^1/_{250}$ sec., $^1/_{125}$ sec. at the very slowest, in order to avoid camera shake caused by increased heart activity.

With long-distance shots on colour reversal film the exposure should be increased by $^1/_2$ stop beyond the measurement, because these are subjects of low contrast. The exposure meter must be pointed at the distant scene in order to exclude dark foregrounds from the measurement (see also p 46 Exposure Measurement).

Especially snowscapes and glaciers require a more generous exposure of colour reversal film than the reflected light measurement indicates (see also p 49).

Natural size
Reproduction at natural size means that the image of the object on the film has exactly the same dimensions as the original. The technical term is R/R (reproduction ratio) 1 : 1.

Neutral grey see Grey scale

Newton's rings see p 183

Negative after-image
After prolonged viewing of a strongly coloured area the eye sees a complementary-coloured image in the same area. This is important when transparencies in different strong colours are projected in succession (see also p 192).

Night pictures see p 161

Nude photography
is a very difficult branch of colour photography, especially in the

studio. The amateur is advised to take such pictures outdoors, where the natural atmosphere can be enhanced by a skilful choice of surroundings. Sand, surf, rocks, summer meadows etc. are particularly suitable backgrounds and surroundings. Movements should be relaxed; the female body in repose has the greatest aesthetic appeal.

Object brightness
depends on the intensity of the incident light (the so called intensity illumination) and the reflecting power of the illuminated object. Only the product of the intensity of illumination and of the reflecting power of the object gives information about object brightness.

Object contrast
denotes the difference between the object details of maximum and minimum reflecting power. Thus the object contrast of a landscape, for instance, is determined by the extremely high reflecting power of a white cloud, and the low reflecting power of a tree trunk. Object contrast therefore exists even when the object is illuminated by completely uniform light; it is an exclusive feature of the object and has nothing to do with the lighting contrast.

Object plane
Plane in front of the camera lens, containing the picture elements of main interest (in a portrait, for instance, the eyes). If the lens is focused so that maximum sharpness is in the object plane, this will also be the "focusing plane".

Open flash
With the open flash method the camera shutter remains open not only throughout the entire period of the flash, but even longer. While the shutter is open either a single (long-duration) flash or any consecutive number of flashes can be fired.
This method is used in large interiors that cannot be fully illuminated by a single flash. While the shutter of the tripod-mounted camera is open the operator walks around the room with the flash holder, firing one flash after annother from positions hidden from the camera (behind columns, corners, etc.). However, this method requires some experience. The open flash method can be successful even with

still objects (copying of large paintings): the flash is fired first from one, then from the other side. (See p 152)

Optical printing
The reproduction of a negative or transparency with the aid of condensers and enlarger lenses (i. e. not in contact) at natural size, reduced, or (part-)enlarged. It is used mainly in the duplication of colour transparencies (see also p 23).

Optimum colour rendering
This term, often used in advertising, indicates the maximum colour realism obtainable in given conditions.

Parallax
In photography this is the difference between the viewfinder image and the picture on the film. It is caused by the difference in the position of the viewfinder and the camera lens. Above all in close-up photography the viefinder therefore shows more of the top of the object than the camera lens can cover. This means cut-off heads in portraiture. With subjects at distances of 3m (10ft) and longer, parallax is no longer noticeable.
Cameras in the upper price range have a built-in automatic parallax compensation eliminating the difference between the viewfinder image and the picture area. Only single-lens reflex cameras and attachments converting a rangefinder camera into s.l.r. are completely free from parallax.

Part enlargement see p 97

Pastel colours
contain much white, and are therefore light and unsaturated. They are "descendants" of the saturated colours. Their effect is particularly pleasing in a photograph when they are in contrast with a very luminous colour, whose area must, however, be small.

Perspective see p 118

Photo-cell p 41

This is a device which during light measurement generates an electric current even without the application of a potential; the current intensity can serve as a measure of the lighting intensity (q.v.) or indicate the lens aperture to be set.

The photocell is, as it were, the classical component of the photoelectric exposure meter. It is also found in "semi-automatic" cameras, in which it actuates a pointer; the lens aperture is set with a follow pointer. Modern and ultra-sensitive exposure meters and automatic cameras are equipped with a CdS photo resistor.

Photographic lamps

are specially designed for use with the camera typical examples being photofloods. With colour photography all the lamps used must emit the same type of light, and be of the same age, because with increasing age the colour of their light shifts slightly towards yellow. However, this difference in illumination usually remains within acceptable limits. Daylight colour reversal films can be adapted for photographic lamps by means of a blue filter (B12), but because this calls for an increase in exposure it is advisable to use special artificial light colour film (CK20). The chief advantage of the photographic lamps over flash is that the effect of the light can be accurately judged and determined before the exposure according to aesthetical and technical aspects.

The latest development in photographic lamps is the quartz iodine lamp, which has a high luminous intensity and a long life, during which the colour of the light remains constant.

Photography in twilight, p 166

Photography of fireworks

is comparatively simple if you use a tripod. Set the lens at ∞, and the shutter at "B" (time exposure), and mount the camera on a tripod. Keep the shutter open, if possible with a cable release, until one or several rockets have been fired. You can thus "collect" several rockets in one picture. Too many rockets, however, are confusing and make the photograph appear too bright. For Agfacolor CT18 the diaphragm can be set between f/5.6 and f/8. A reflecting foreground,

such as a calm sheet of water, increases the lumious power and avoids "dead", i. e. dark areas in the picture. Usually the upright format is more suitable.

Daylight or artificial-light colour film can be used as desired. Artificial-light film reproduces the dark blue of the sky with residual daylight in a deeper hue than does daylight film. Be generous with film, because as you "collect" your rockets you cannot know beforehand how many of them, and in which direction and to what height they will rise. Experience has shown that a particularly impressive picture will certainly be found among several shots.

Photo-resistor

This utilizes the property of certain materials of changing their electrical conductivity (resistance) under the influence of light for the measurement and evaluation of the light. The cadmium sulphide (CdS) resistor is the best known. For the operation of this measuring instrument a current source in the form of small Mallory battery (of very long life) is necessary.

Pictorial perspective, p 118

Perspective literally means "distinct vision". In photography and the art of drawing it is the reproduction of a three-dimensional element in a plane. The two-dimensional picture of a body formed in the plane is to convey the impression of three-dimensionality. Usually it is also the aim of perspective rendering in photography to form a picture of the subject which corresponds as closely as possible to the visual impression of the person who saw it.

Pink filter see p 83

Polarizing filter see p 85

Portraits

It is difficult to obtain good colour portraits with a single flashlamp. Direct light produces harsh cast shadows; these can be softened with a diffusion screen mounted in front of the reflector. The lose of light must be allowed for with a correction of the lens stop.

Cast shadows appearing on walls behind a "flashed" sitter can be

eliminated if the sitter is posed at some distance from the wall, and the flash fired obliquely from above.

Another possibility of considerably softening flash illumination is the use of "bounce flash" (q. v.). Only the distribution of the flash power of two or more lamps opens up all the possibilities of good portrait lighting. In any case, bright room lighting should be switched on during work with flash; if not, the pupils of the sitters's eyes will be large, since they widely dilated in darkness.

Primary colours

We distinguish between additive and subtractive primaries. In colour photography with the tripack-colour film, which dominates the scene completely, we are interested only in the subtractive primaries. They make up the picture while being formed during the development of the colour film; their mixture directly produces the colour image in the colour reversal film. The three subractive primary colours are yellow, magenta, cyan. The mixture of these colours at full saturation produces the impression of "black" in transmitted light or during projection.

The three additive primary colours are blue, green, and red. If during printing these colours are projected on top of one another at correctly balanced light intensities, the colour "white" is produced.

Projection see p 184

Pseudo colour cast

is a colour falsification in parts of the picture caused mainly by large expanses of colour outside the picture area which reflect light onto nearby picture details (e. g. portrait in a meadow).

Quartz iodine lamps

have the conventional tungsten filament, but in a very small quartz envelope filled with iodine. The small size of these lamps has made the design of extremely light internal-reflector lamps and extremely efficient reflectors possible. This means very handy, portable photographic lighting equipment. Light flux and colour temperature (3200° and 3400° K) of these lamps are practically constant throughout their life. Compensating filters are not necessary for the

mixed use of conventional photographic lamps and quartz iodine lamps.

This type of lamp is now also used in projectore. It is extremely practical because of its constant light colour throughout its life.

Rain see p 76

Rainbow see p 53

Reciprocity law failure, see also Schwarzchild effect.

This phenomenon does not occur with normal photographic exposure times. Its effect will become evident only at extremely high shutter speeds (from about $^1/_{1000}$ sec) or exposures longer than 1 second. It is based on very complex relationships concerning the production of the image and the influence of the developer and development. Unpredictable colour deviations may occur through it.

Red see p 108

Red eyes

the sitter's eyes encloses a very narrow angle with the optical axis, i. e. the line between the camera lens and the object. This occurs particularly often with small flash units mounted in the accessory shoe directly above the camera lens. To avoid this effect, detach the flash if possible and hold it separately from the camera.

Reduction of the field of view

The field of view at close-up settings is smaller than at the infinity setting. This is caused by the increase in the extension of the lens (through belows or helical focusing mount), which also increase the image distance, and at the same time narrows the angle of view compared with that at the infinity setting.

Reflected-light measurement see p 46

Reflecting screens

White sheets etc., which diffusely reflect the light in any desired direction. A white wall, too, can act as a reflecting screen. See also p. 77.

Reflections

of the flash in windows, mirrors, oil paintings, polished furniture, spectacles etc. can be easily avoided if the light is directed at such objects at an angle of about 45 ° with the optical axis of the camera lens, i. e. if the flash holder is held at one side or raised above the camera.

Reflector

Any flashbulb or -tube without a reflector emits its light uniformly in all directions. The luminous intensity of a flash falling on an object is greater if the flash is backed by a reflector, which bundles the light emitted in all directions so that the illumination is confined within a certain angle in space. The formerly smooth, mirror-like reflector surfaces are now grained or roughened in the interest of softer and more uniform illumination.

Retouching colour transparencies

can only be done by specialists, because the magnification required in projection will show up every stroke of the brush. All that you can do is cover disturbing small bright spots such as lamps breaking up a dark portion of the transparency, by dabbing them lightly with a fine brush dipped in retouching dye.

Recycling time of a flash

is the time an electronic flash unit needs to be ready for firing the next flash after a flash has been discharged. The readiness is indicated by the lighting up of a glow lamp.

Reversal development

directly produces a transparency. See p. 21.

Room reflection

plays an important role in flash photography. Thus it is expressly stated that lens stops calculated on the basis of the guide number apply only to "normal rooms", in which a white ceiling and light-coloured walls reflect the light from the flash. Room reflection is noticeably reduced in large rooms and halls, but also in smaller ones with panelling or dark furniture. Coloured wall paper and walls also cause a colour cast.

The light from highly reflecting walls will be noticeable even out-side its special significance in flash photography. Its intensity increases proportionately as the square of the distance between the light sources (photofloods, spotlights) and the wall decreases.

Russel Effect
The light-sensitive substances of colour films, too, can be made de-velopable by the effect of pressure, which acts like an exposure. In transparencies light patches are the result. The pressure can be caused by foreign particles on the film pressure plate or in the film guide.

Scattered light see Stray light

Schwarzschild Effect
This is an exposure phenomenon, called after its discoverer, which affects both black-and-white and colour material. In practical pho-tography its evidence becomes disturbing only with long and ex-tremely short exposure times. It causes both a clear loss of emul-sion speed and disturbing colour casts. In order to compensate for it both more exposure and, especially with colour reversal film, filter-ing of the subject illumination is necessary. Strictly speaking a spe-cial colour filter matching the type of film in the camera should be used.
The Schwarzschild Effect – more commonts know as the Reci-procity Effect does not occur with the ordinary and mostly used exposure times. In photographic practice this means that shutter speeds between 1 and $1/250$ sec will create no difficulties at all and do not call for any special precautions. In theory, changes should already occur at higher shutter speeds such as $1/500$ sec, but they are so negligible as to be hardly noticeable. Only from $1/1,000$ sec on-wards should the lens be opened up by about 1 stop in order to com-pensate at least for the exposure effect of reciprocity.
The effect with long exposure times seems to be of greater impor-tance to the photographer.
It will become noticeable particularly if only extremely low inten-sities of illumination are available for the exposure, e. g. inside churches, chapels, museums, etc. Even though it will occasionally be possible to keep the exposure time to 1 sec by the choice of a large

aperture, this value will without doubt mostly be exceeded when stopping down is necessary. This applies particularly to night (moonlight), as well as to close-up photography calling for long camera extensions and minimum apertures.

The following table contains a few examples of the extension of the exposure time for the compensation of the Reciprocity Effect with long exposure times:

Exposure time measured (sec)	Correction factor	Necessary exposure time (sec)
1	None	1
2	1.4	2.8
4	1.6	6.5
6	1.8	11
10	2.2	22
15	2.3	35
20	3.5	50
60	3.5	$3^1/_2$ min
120	4.25	$8^1/_2$ min

To a photographer who only occasionally strays into the range of long time exposures it may be reassuring to know that on Agfacolor CT18 a noticeable colour shift does not yet become evident at exposure times from 1 to 8 seconds. However, those who have frequent occasion to use long time exposures will find a special correction filter indispensable.

With colour negative film correction during the printing process is possible except in extreme cases. Where demands of quality are high, here, too, filters should be used already at the exposure stage, because major colour deviations require high filter densities at the printing stage, which in turn can upset the filter balance.

Scratches on transparencies and negative films
Invisible repair of scratched transparencies is difficult. You can try to smooth the scratched surface by applying film varnish, such as

Repolisan. Scratches can never be completely removed, all you can hope for is to reduce their effect during projection.

Selective focusing see p 116

Self-timer
A device which can be set so that the shutter is released automatically only after a few (mostly 10) seconds delay. It is a small clockwork mechanism, either built into the camera or available as an accessory to be coupled with it at any time.
A built-in self-timer is also eminently suitable for releasing the shutter at the slow instantaneous speeds without causing camera shake. Even with the greatest care, the releasing finger cannot operate the button as smoothly as the mechanism of the self-timer.

Shadow softening see p 80

Shadow pictures see p 40

Sharpness
Absolute sharpness in the mathematical sense does not exist in photography, because it is not possible to obtain a point-shaped image of a point. A negative is classed as sharp when the diameter of the circle of confusion does not exceed $^1/_{1000}$ of the focal length of the taking lens. For the 35mm format $^1/_{30}$mm has been adopted as the diameter of "permissible unsharpness". However, this value is inadequate with critical subjects and material of high definition; here $^1/_{60}$mm must be adopted.
As a rule, colour reversal film has a considerably higher definition than colour negative film.
The sharpness of a picture further depends on a steady grip on the camera, and on subject movement.
At all lens apertures, optimum sharpness will be found in the plane on which the camera lens has been focused. However, when the lens is stopped down the depth of field can be extended to the front and rear far enough to create the impression of continuous sharpness from fore- to background.

Shutter setting
The M-contact serves for firing flashbulbs whose flash duration is longer than the time the between-lens or the focal-plane shutter is open. Here the shutter "picks out" part of the flash duration for the exposure. All shutter speeds can be synchronized here right up to the performance limit of the between-lens shutter ($^1/_{500}$ sec).

Side lighting
Light falling on the object from either side, from any level. It has a pronounced modelling effect and is also used as a fill-in (shadow-softening) light.
Strictly speaking this term should cover only light from a horizontal direction; in nature this is confined to light from a very low sun. However, since the sun shines obliquely from above most of the time, the side lighting, so popular and often recommended in photography, is actually oblique top lighting, which could also be called modified front lighting when the sun's position is not strictly frontal. True side lighting, if used as the main light, would not be favourable to pictorial composition, because the shadows would run right across the picture. In portraiture, softening of the shadow side of the face will be essential.

Silica gel see Drying agent

Slide mounting, p 181

Slides see p 180

Slide viewers
are small gadgets with a single or double magnifier and an opal glass plate for the transillumination of slides; either daylight or artificial light is used.
It is not easy, however, to obtain a valid assessment of the colour quality of a slide and its appearance in projection, because the colour rendering usually is too cool in daylight, too warm in artificial light. In projection, on the other hand, lamps emitting white light are used.

Slow instantaneous shutter speeds

In photographic usage speeds between $^1/_{30}$ and $^1/_4$ sec. Exposures at speeds slower than $^1/_4$ sec are classed as time exposures. They are generally made with the shutter set at "B". Exposures at the slow instantaneous speeds can easily be blurred. It is best to use a tripod or at least a support propping up the photographer's arms if the camera is hand-held.

Skylight filter see p 83

Snapshots

are unposed pictures from all walks of life, i. e. usually of moving subjects. If possible a shutter speed of $^1/_{250}$ sec should be chosen and the lens stop adjusted accordingly. The camera distance should be as close as possible; the more forceful will be the message of the picture.

Snapshots indoors are most successful with electronic flash, whose light records even the fastes movements, because the flash duration is as short as $^1/_{1,000}$ sec.

Snow

is one of the low-contrast subjects (see also p 49 and object contrast). Owing to its universal reflection of the light it also shows little lighting contrast (q.v.). It is commonly described as a "light" subject. As with all such subjects, if the reflected-light method is used for exposure measurement corrections have to be made.

It must be borne in mind that the structure of the snow will be brought out only by glancing side light or contre jour light. Pictures with frontal light show snow mainly as a structureless white mass. Snow pictures in dull weather are usually disappointing.

Softening of shadows, p 80

is useful in subjects of strong contrast. Artificial reflectors serve this purpose, e. g. white sheets or cardboard, silver and gold foil reflectors (screens) or natural ones such as white walls, sand, the beach, terraces, etc. Flash, too, is an effective softener, but its type must be matched with the colour film in the camera.

Sound-coupled slide show

Slide show prepared with a commentary and mostly also music on tape. It is possible to let the tape run continuously with a non-automatic projector; the time for changing the slide is indicated by a slight knocking sound on the tape.

In an automatic projector the tape takes over the slide change. For this an additional slide control unit is required, which transfers the impulses, electronically preset on the tape, to the changing mechanism of the projector.

Spectrum

The light perceived as white by our eyes is composed of many colours. This can be clearly demonstrated when a beam of light is dispersed by means of a glass prism. The spectra of day- and of half-watt light consist of the colours violet, blue, green, yellow, orange, and red. These two types of light have continuous spectra, which means that all the colours are present in the light, without any gaps. Every radiation emitted by a body raised to a high temperature such as the sun and lamp filaments has a continuous spectrum. The colour of the emitted light can be expressed in "colour temperature" (see p 65), which is a measurable quantity.

The spectral composition of the exposure light can be changed with the aid of colour filters in front of the camera lens. With the filters for black-and-white films, unsuitable for colour film, entire parts of the spectrum are cut out: certain spectral regions associated with certain colours are prevented from passing through the filter.

The films used in colour photography consist of three photo-sensitive layers each responding to only one third of the entire visible spectrum.

Spotlights

are lamps fitted with a condenser lens, or Fresnel lens spots with an optical attachment, which is practically a lens of long focal length. In this, the construction of a spotlight resembles that of an enlarger, because the lens can also be stopped down in order to regulate the intensity of the illumination. Any kind of mask can be inserted between the condenser and the lens, even recessed stops with any desired pattern; this is projected on persons, objects, and walls in or-

der to enliven the lighting effects. Ordinary Fresnel lens spots in which a tube narrows the illuminating beam are not spotlights in the accepted sense.

Spot measurement see p 46
Taking close-up readings of various parts of the object of high contrast, the results of which may give the optimum mean value, is one method; the other method is based on exposure meters of narrow measuring angles with which to take readings of individual portions of the object. Exposure meters of 30° measuring angle already allow spot (or aimed, or detail) measurement; the so-called spot meters are even more efficient; at measuring angles between 2 and 5° one can take reading of details of a flower, e. g. of the cattyx separately from the petals.

Spot meter
Special exposure meter of very narrow measuring angle with which the photographer can measure distant objects without having to approach them. It is also especially suitable for the measurement of smallest detail of close-up objects.

Spring-back diaphragm
Device for improving the action-readiness of single-lens reflex cameras. It is wound before shutter release, and "springs back" to the pre-selected stop when the shutter button is pressed.

Stamps
make excellent colour photographic subjects. They are usually taken at natural size (1 : 1); the measured exposure must be multiplied by 4. See also p 150 (Copying).

Storage properties of colour films see p 59

Storage of colour film see p 59

Standard lens
Lens of a focal length equal or similar to the diagonal of the camera format. (see also p 18)

Static charge and discharge

In certain conditions (which may be climatic) electrostatic charges may accumulate also in colour film. This risk occurs above all during very rapid film transport and rewind. This occasionally leads to electric discharges manifesting themselves in the shape of branching patterns or rows of dots. These structures are light in colour reversal, dark in colour negative film. See Antistatic agent.

Stray light

can occur in many places in photography: on the object itself, but also inside the lens and in the camera, during printing and enlarging, and during slide projection.

Stray light is light diffusely reflected by an object. Snow, sand, and light walls diffusely reflect light incident upon them, i. e. almost uniformly in all directions. Here it has the effect of softening shadows and is therefore photographically very useful. Stray light outside the angle of field proper can produce flat pictures if it enters the camera lens. Hence the need always to have the lens hood in position. Dusty front and rear surfaces, as well as finger marks on the lens, also produce stray light.

Subtractive colour mixture

For the better understanding of the differences between subtractive and additive colour mixture here is a comparison between the functions of the two methods:

Subtractive	Additive
Each primary colour transmits $2/3$ of the spectrum	Each primary colour transmits only $1/3$ of the spectrum
Image projected by a *single* source (projector)	Projected image can be obtained only by means of *three* light sources (projectors)
All three colours together add up to *black* (simultaneously in one projector)	All three colours projected on top of one another (3 projectors) add up to *white*

Subtractive	Additive
Colour negatives can be made. Printing and projection as well the production of colour separations for reproduction is easy	No colour negatives can be made. Therefore copying only is possible. Projection difficult and expensive. No originals for reproduction.
Picture produced by single exposure	Picture can be produced only with three differently filtered exposures (black-and-white separations = 3 negatives)

Super slides
American term for 38 x 38 mm transparencies. The external dimensions of the mounted transparency, the slide, are also 5 x 5 cm (2 x 2 in), so that it is accepted by the slide changers of ordinary 35 mm projectors.

Sun positions (sunset), see p 65

Supplementry flash see p 138

Synchro-cable (flash) see p 139

Synchronized flash
Events are synchronous when they occur simultaneously. In modern flash photography the release of the shutter and the firing of the flash must be synchronized: the camera or lens shutter, activated by pressure on the release button, closes the trigger circuit via the synchro contact, thereby firing the flash.

System camera
is a type of a camera whose range of operation can be extended in all possible directions by a large selection of different accessories. The main characteristics of the system camera are the interchangeability of the lenses and that close-up focusing devices can be attached to it.

Table top
Term for "mini-still life". Usually scenes built of wire, paper, glass and other materials and set up on a table for close-up photography. Table tops are popular in advertising photography.

Table tripods see p 167

Telephoto lenses see p 23

Testing of colour films see p 56

Theatre photography see p 170

The human face (skin tones)
The colour of the face is one of the most important memory colours (q. v.). Even the slightest falsification of the complexion towards yellow, yellow-green, or green immediately reveals the colour cast (see p 61) lying over the entire picture. The same applies to a falsification of the colour of the face towards blue. If the picture does not include persons, the same colour cast is much less, if at all, evident on other features. Remedy for colour casts: use of reflectors or flash for shadow softening. (p 77)

Thunderstorms see p 173

Time exposure
Shutter setting at "B", enabling the photographer to determine the shutter action himself. All exposure times than longer second are generally classed as time exposures.

Top lighting
It is the illumination with which we are familiar from the Old Masters: light falling on the subject from obliquely above.

Trains (photographing from)
If you are keen on colour photographs from moving trains, take them obliquely in or against the direction in which the train is moving (i. e. towards the front or the rear). This "slows down" the

movement of the train. The recommended shutter speed is at least $^1/_{250}$ sec, better still $^1/_{500}$ sec, in order to reduce the danger of unsharpness. Such pictures will be particularly rewarding if, in a sharp curve, you succeed in including both the scenery and the long line of coaches.

Travelling see p 59

Ultra-violet radiation see p 83

Ultra-wide-angle
Lenses of an angle of field wider than about 85 ° are called ultra-wide-angle lenses. Their complicated design necessarily leads to vignetting of the picture corners; this can be partly cured if the lens is stopped down.

Underexposure see Wrong exposure

Underwater photography
is a branch of photography which has become popular together with skin-diving; colour film can be used. Either special underwater cameras or ordinary cameras (usually 35 mm or medium format) built into water- and pressure-proof housing are used; they permit normal control of shutter release, shutter speed, lens stop and focusing distance. Colour pictures at a depth of 3 m (10ft) and more suffer from blue cast, because the water absorbs the red portion of the daylight. Artificial light sources, above all electronic flash in a waterproof housing, are therefore necessary.

Unique
are transparencies on reversal film, because in the absence of a negative no further absolutely identical prints can be obtained.

Universal film
A colour negative film balanced for a colour temperature halfway between sunlight and halfwatt light so that it can be used for both types of light. Not only colour enlargements, but also black-and-white prints and enlargements on ordinary bromide paper can be produced of this film.

Univeral lens see Standard lens

UV-absorbing filter see p 83

Viewing distance
Certain rules exist for the distance from which a photograph should be viewed; their observation may considerably affect the impact of the picture. If, for instance, you want to obtain a perspective impression similar to shat of the photographer when he took the picture you must view the picture from a distance which is the product of the focal length of the lens used and the reproduction scale. Of a 35 mm picture taken with a 50 mm lens a 50x enlargement, i. e. a projected image measuring 1.2 × 1.8 m, would be viewed correctly from a distance of 2.5 m. It should be borne in mind, however, that the perspectively correct view of such screen images does not always ensure good perception and judgement of the formal pictorial composition.

Wide-angle lens see p 122

Wide-angle perspective
Exaggerated perspective foreshortening, resulting in an considerable apparent difference in the dimensions of objects of the same size but a different distances from the camera.

Worm's eye view
Term for a very low camera position producing e.g. persons and architectural objects at a seemingly large scale. In landscapes, too, the worm's eye view sometimes reveals unusual aspects. In portraiture this view should be used with care, because with short-focal-length lenses perspective can becom distorted and feet and legs too large.

Wrong exposures
of colour reversal film
Overexposure = transparency too light, washed-out colours, without detail (burnt out)
Underexposure = transparency too dark, colours blackened; i. e. they appear mixed with black and muddy

Stray light: Especially at the beginning of the film, and when the loaded camera was accidentally opened, the normally dark margin will be bright. Entry of strong light through the cassette slot (film loading in direct sunlight) produces red bands running through the first few pitures.

Exposure of colour reversal film to unsuitable subject lighting, too, can be classed as wrong exposure. The transparencies will be bluish when artificial-light colour film has been exposed to daylight, yellowish-orange when daylight colour film has been exposed to artificial light. See also Exposure errors.

X-contact

We distinguish between X- and M-contacts. Cameras incorporating only X-contacts are partly, those with both contacts are fully synchronized.

The X-contact is designed mainly for firing electronic flash. With between-lens shutters the contact is made when the shutter leaves are at maximum aperture. With focal-plane shutters the entire film area must be exposed, i. e. the slit must be as wide as the film window. In most focal-plane-shutter cameras today this is possible at up to $^1/_{50}$ sec, in the Leicaflex at up to $^1/_{125}$ sec.

My Dear Friends,

I already told you elsewhere that it is hardly possible to cram into this book everything that can be said about colour photography without expanding in into a veritable tome, a photographic encyclopaedia as it were.

All the same, my conscience is not unduly disturbed as I now say good-bye to you. I know that you are by now familiar with the basic principles of colour photography, and that you can carry on under your own steam.

If you have come unstuck and in spite of careful study are at your wit's end I will only be too pleased to help you further along. Do not hesitate to let me have your questions through the publishers. But please don't be cross if you have to wait a little for my answer, because I am often away on my lecture tours where I meet my friends, the photo-fans.

It would be nice if we were to meet there one day – your pictures and your questions will be welcome!

Yours sincerely

Walther Benser